WORKBOOK

Illustration ~ Spring 2012

Publisher/Owner ~ **BILL DANIELS**

Advertising Sales Director ~ **SUZANNE SEMNACHER**

Advertising Sales ~ **LINDA LEVY**
BOB PASTORE

Design Director ~ **ANITA ATENCIO**

Director of Production ~ **PAUL SEMNACHER**

Online Portfolio Manager ~ **KIRSTEN LARSON**

Social Media Manager ~ **WILL DANIELS**

Directory Manager ~ **ANGELICA VINTHER**

Directory Marketing Manager ~ **JOHN NIXON**

Directory Verifiers ~ **AURELIO FARRELL II**
DAVID PAVAO
ANGELA PERKINS
JORDAN LACEY

Technology ~ **JIM HUDAK**
STEPHEN CHIANG
RYAN ADLAF

Finance ~ **ALLAN GALLANT**
EDUARDO CHEVEZ

Security ~ **MR. "T"**

see the workbook on the go
MOBILE.WORKBOOK.COM

download the iPhone app at
WORKBOOK.COM/IPHONE

participate in our
BLOG

follow us on
TWITTER

like us on
FACEBOOK

connect with us on
LINKEDIN

workbook.com/social
in print. online. workbook works.

~ **Contents**

~ Index

*Artist's Representative

*Artist's Representative

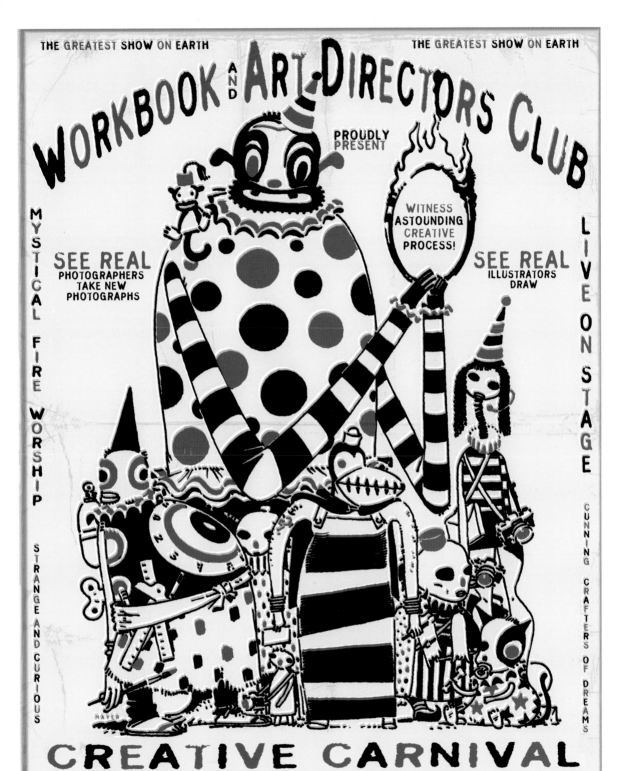

Lettering ~ Logos ~ Design

NatureSun
NATURSOL

FaRm Rich
RICH SEA PAK

jAzz

Crear. VAIO. Sólo para ti.
SONY

Holly Dä

Life lives here.
CALIFORNIA CLOSETS®

SUNDAE
CRUNCH
WELLS DAIRY

There's
NOTHING
to love
about those
LOVE
HANDLES

Seek comfort often.
GIVAUDAN

"TAKE"
10

Tentación®
ALICORP

eat a little. love a lot. Kraft Foods
KRAFT

Beauty Cravings

Ambra
EUROPEAN DAY SPA

Pampers
P & G

I LOVe you MADLy

ckens.com

312.280.0777 holly@hollydickens.com

You deserve it!
ALLSTATE

Just don't expect to see him drinking it
with his Pinkie sticking out.
WISCONSIN CHEESE

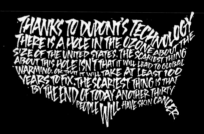

THANKS TO DUPONT'S TECHNOLOGY THERE IS A HOLE IN THE OZONE THE SIZE OF THE UNITED STATES. THE SCARIEST THING ABOUT THIS HOLE ISN'T THAT IT WILL LEAD TO GLOBAL WARMING OR THAT IT WILL TAKE AT LEAST 100 YEARS TO FIX. THE SCARIEST THING IS THAT BY THE END OF TODAY ANOTHER THIRTY PEOPLE WILL HAVE SKIN CANCER

GREENPEACE

JAMUSA.COM
JAM PRODUCTIONS

intel inside

What if your life flashed before your eyes?
FIRST HEALTH

The World's Finest

Roméo Et Juliette

La Traviata

LAKEMONT

NEPTUNUS
Spiced Rum
REX

The World's Finest

Alaska Airlines

Compagnie Internationale

Creative

Ghost Bridge

HUGGies

Deli'Fresh

Flexees by maidenform®

No matter how you feel GET UP, DRESS UP, and SHOW UP.

808.333.5048 www.JohnBurnsLettering.com burns@sonic.net

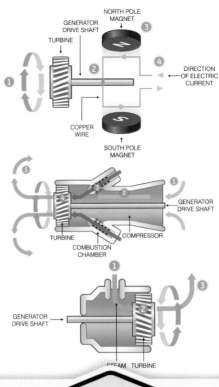

GENERATOR DRIVE SHAFT

TURBINE

NORTH POLE MAGNET

1 2 3 4

DIRECTION OF ELECTRIC CURRENT

COPPER WIRE

SOUTH POLE MAGNET

5 4 3 2 1

GENERATOR DRIVE SHAFT

TURBINE COMPRESSOR

COMBUSTION CHAMBER

1 2 3

GENERATOR DRIVE SHAFT

STEAM TURBINE

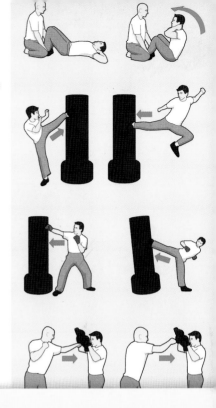

RS TO LINGERING QUESTIONS ABOUT FUKUSHIMA

PRONOUNCED
ERN
AN
S OF
DAI

FU KU SHE MA DA EE

SENDAI POPULATION
OVER 1 MILLION

EARTHQUAKE
MARCH 11, 2011
MAGNITUDE 9.0

THE EARTHQUAKE INITIALLY KN
POWER TO THE COOLING SYST
DIESEL GENERATORS CAME ON-
WERE THEN KNOCKED OUT BY T

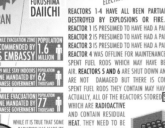

REACTORS

ELECTRIC COOLING SYSTEM G

JAPAN

FUKUSHIMA DAIICHI

50 MILE EVACUATION ZONE RECOMMENDED BY US EMBASSY	POPULATION 1.6 MILLION
12-19 MILE STAY INDOORS ZONE MANDATED BY JAPANESE GOVERNMENT	POPULATION 62 THOUSAND
12 MILE EVACUATION ZONE MANDATED BY JAPANESE GOVERNMENT	POPULATION 77 THOUSAND

WHILE IT IS TRUE THAT SOME RADIATION HAS MADE ITS WAY AS FAR EAST AS **CALIFORNIA** EXPERTS INSIST THAT IT HAS BEEN SO DISPERSED AS TO NOT BE DANGEROUS TO HUMANS.

REACTORS 1-4 HAVE ALL BEEN PARTIALL' DESTROYED BY EXPLOSIONS OR FIRE.
REACTOR 1 IS PRESUMED TO HAVE HAD A PART
REACTOR 2 IS PRESUMED TO HAVE HAD A PART
REACTOR 3 IS PRESUMED TO HAVE HAD A PART
REACTOR 4 WAS OFFLINE FOR MAINTENANCE,
SPENT FUEL RODS WHICH MAY HAVE BEE
AIR. **REACTORS 5 AND 6** ARE SHUT DOWN AND
ARE NOT DAMAGED BUT THERE IS CONC
SPENT FUEL RODS THEY CONTAIN MAY HAVE
ACTUALLY, ALL OF THE REACTORS STORED SP
WHICH ARE **RADIOACTIVE** AND CONTAIN RESIDUAL **HEAT.** THEY NEED TO BE KEPT COOL CONSTANTLY

IF THE **POOLS** IN WHICH THEY ARE KEPT BECOME DEPLETED, THE SPENT FUEL RODS WILL BE EXPOSED TO AIR. THIS CAN CAUSE THE RO **RADIATION, OVERHEAT, AND C**

ONE OF THE BY-PRODUCTS OF ACCIDENT SUCH AS THIS IS

ERNATIONAL ATOMIC ENERGY UCED THE INTERNATIONAL ADIOLOGICAL EVENT SCALE

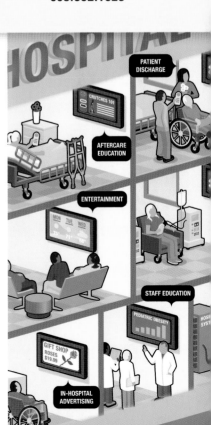

HOSPITAL

PATIENT DISCHARGE

CRUTCHES 101

AFTERCARE EDUCATION

ENTERTAINMENT

STAFF EDUCATION

PEDIATRIC OBESITY

GIFT SHOP ROSES $19.99

IN-HOSPITAL ADVERTISING

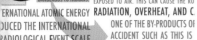

INFORMATION DESIGN
THAT MAKES THE
COMPLEX CLEAR

608 828 0280

FUNNEL
INCORPORATED

FUNNELINC.COM

INFOGRAPHICS | INSTRUCTIONS
DATA VISUALIZATION | MAPS
CHARTS & GRAPHS | ICONS

Chart for annual food report | Client: NASFT

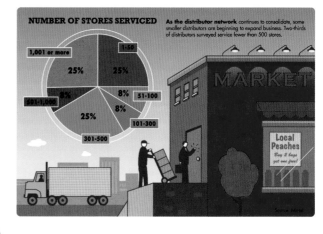

NUMBER OF STORES SERVICED

As the distributor network continues to consolidate, some smaller distributors are beginning to expand business. Two-thirds of distributors surveyed service fewer than 500 stores.

- 1,001 or more — 25%
- 1-50 — 25%
- 51-100 — 8%
- 101-300 — 8%
- 301-500 — 25%
- 501-1,000 — 8%

Illustration on trade show etiquette | Client: *GO Magazine*

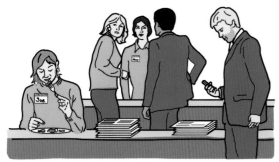

Instructions for bike hub maintenance | Client: Saris Cycling Group

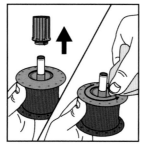
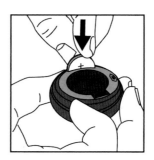
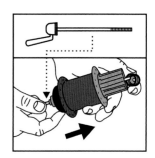

Charts for vinyl siding brochure | Client: Interrupt | Brand: CertainTeed

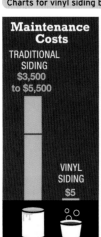

Maintenance Costs

TRADITIONAL SIDING
$3,500 to $5,500

VINYL SIDING
$5

PAINT

SOAP & WATER

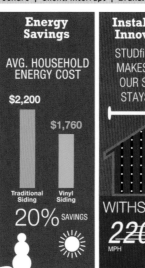

Energy Savings

AVG. HOUSEHOLD ENERGY COST

$2,200

Traditional Siding

$1,760

Vinyl Siding

20% SAVINGS

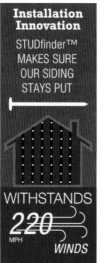

Installation Innovation

STUDfinder™ MAKES SURE OUR SIDING STAYS PUT

WITHSTANDS

220 MPH

WINDS

Charts about housing data | Client: Hanley Wood

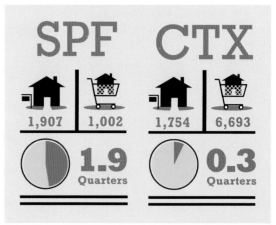

SPF

1,907 — 1,002

1.9 Quarters

CTX

1,754 — 6,693

0.3 Quarters

INFORMATION DESIGN
THAT MAKES THE
COMPLEX CLEAR

608 828 0280

FUNNEL
INCORPORATED

FUNNELINC.COM

INFOGRAPHICS | INSTRUCTIONS
DATA VISUALIZATION | MAPS
CHARTS & GRAPHS | ICONS

Infographic for selling CDs online | Client: Murfie.com

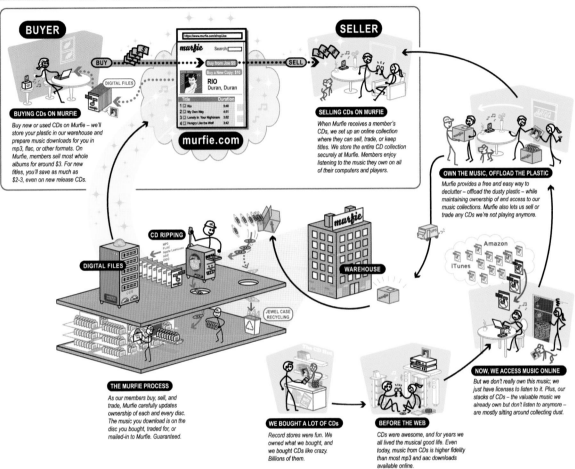

BUYER

SELLER

BUY

https://www.murfie.com/shop/Joe

murfie Search

Buy from Joe $5

Buy a New Copy: $10

RIO
Duran, Duran

Title	Duration
1 ☐ Rio	9:46
2 ☐ My Own Way	4:51
3 ☐ Lonely In Your Nightmare	3:52
4 ☐ Hungry Like the Wolf	3:42

murfie.com

SELL

DIGITAL FILES

BUYING CDs ON MURFIE
Buy new or used CDs on Murfie – we'll store your plastic in our warehouse and prepare music downloads for you in mp3, flac, or other formats. On Murfie, members sell most whole albums for around $3. For new titles, you'll save as much as $2-3, even on new release CDs.

SELLING CDs ON MURFIE
When Murfie receives a member's CDs, we set up an online collection where they can sell, trade, or keep titles. We store the entire CD collection securely at Murfie. Members enjoy listening to the music they own on all of their computers and players.

OWN THE MUSIC, OFFLOAD THE PLASTIC
Murfie provides a free and easy way to declutter – offload the dusty plastic – while maintaining ownership of and access to our music collections. Murfie also lets us sell or trade any CDs we're not playing anymore.

CD RIPPING
MP3
FLAC
Apple LossLess
AAC
OGG

DIGITAL FILES

WAREHOUSE

Amazon

iTunes

JEWEL CASE RECYCLING

THE MURFIE PROCESS
As our members buy, sell, and trade, Murfie carefully updates ownership of each and every disc. The music you download is on the disc you bought, traded for, or mailed-in to Murfie. Guaranteed.

WE BOUGHT A LOT OF CDs
Record stores were fun. We owned what we bought, and we bought CDs like crazy. Billions of them.

BEFORE THE WEB
CDs were awesome, and for years we all lived the musical good life. Even today, music from CDs is higher fidelity than most mp3 and aac downloads available online.

NOW, WE ACCESS MUSIC ONLINE
But we don't really own this music; we just have licenses to listen to it. Plus, our stacks of CDs – the valuable music we already own but don't listen to anymore – are mostly sitting around collecting dust.

Icons for banner ad | Client: Y&R | Brand: Dell

Campaign icons | Client: Hill Holiday | Brand: Dunkin' Donuts

Power grid icons | Client: National Rural Electric Cooperative Association

Natural Gas Plant

Geothermal Plant

Nuclear Power Plant

Advanced Coal-Fired Plant

Anaerobic Digester

NESTLE

PHILLIP MORRIS

move in. Get MORE.

WOK KING

YOPLAIT

FRITO LAY

LOGO DESIGN+LETTERING T 773.525.2081 C 312.531.2700 E mstroster@earthlink.net

FERNANDEZ STUDIO
ILLUSTRATION + DESIGN

cloud**woot**

MEDPOINT
HEALTH PARTNERS

COURTNEY
CONSTRUCTION

SIMA
FINANCIAL GROUP

MojoLingo

freal

DIAMOND REEF

Ocean Products

HESCHEL
DAY SCHOOL

w FERNANDEZSTUDIO.COM e CARLOS@FERNANDEZSTUDIO.COM t 512.619.4020

Piña Colada

Grasshopper

mojito

Chocolate Martini

Rum & Coke

gin fizz

Old Fashioned

DAIQUIRI

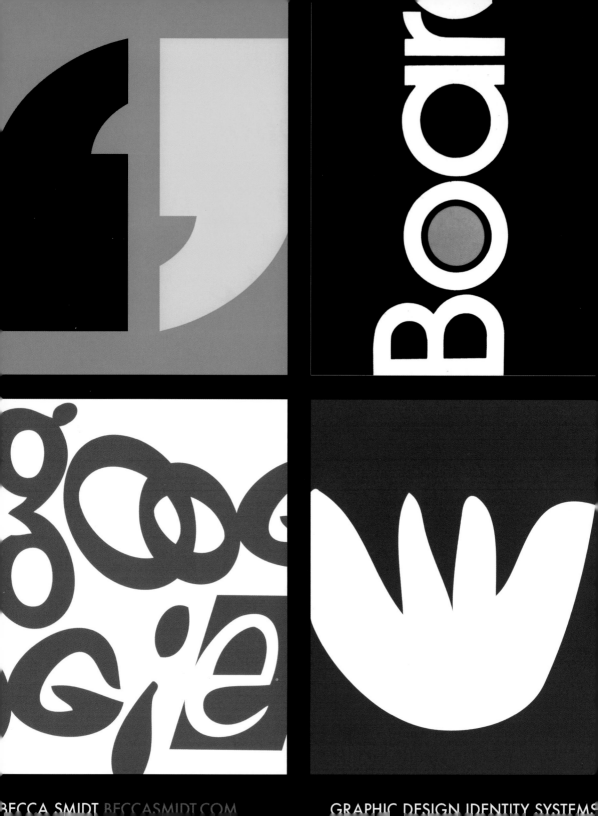

PARKING GARAGE ELEVATOR, PALO ALTO SAMSMIDT.COM SAM SMIDT

Breadcrumbs

free spirit rider

Ziploc

Holla back!

Shop in Style

Ziploc

Ziploc

imuse

Ziploc

Fairies at Bedtime

Ziploc

Di Bruno

Ziploc

Kim Woods
MAKEUP ARTISTRY

Ziploc

Jadenlam

Great Dad!

Ziploc

Ziploc

Buddha at Bedtime

Fruit Twists

Ziploc

Jill Bell Brandlettering

913.649.4505 jill@jillbell.com
fax 815.377.2566 www.jillbell.com

Lettering, logos, icons,
typeface design and modification.

Unique, ownable lettering solutions

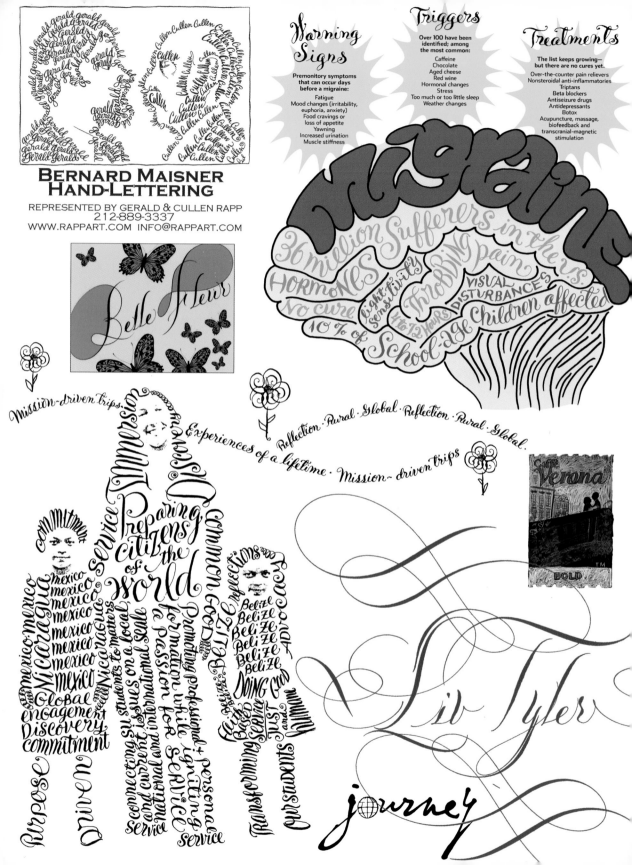

BERNARD MAISNER
HAND-LETTERING

REPRESENTED BY GERALD & CULLEN RAPP
212-889-3337
WWW.RAPPART.COM INFO@RAPPART.COM

Belle Fleur

Warning Signs

Premonitory symptoms
that can occur days
before a migraine:

Fatigue
Mood changes (irritability,
euphoria, anxiety)
Food cravings or
loss of appetite
Yawning
Increased urination
Muscle stiffness

Triggers

Over 100 have been
identified; among
the most common:

Caffeine
Chocolate
Aged cheese
Red wine
Hormonal changes
Stress
Too much or too little sleep
Weather changes

Treatments

The list keeps growing—
but there are no cures yet.

Over-the-counter pain relievers
Nonsteroidal anti-inflammatories
Triptans
Beta blockers
Antiseizure drugs
Antidepressants
Botox
Acupuncture, massage,
biofeedback and
transcranial-magnetic
stimulation

Migraine

36 million sufferers in the U.S.
HORMONES
light sensitivity
THROBBING pain
VISUAL DISTURBANCES
No cure
4 to 12 hours
10% of School-age Children affected

Mission-driven trips.
Reflection · Rural · Global · Reflection · Rural · Global.
Experiences of a lifetime · Mission-driven trips

Caffè Verona
BOLD

Commitment
Mexico
Nicaragua
Global engagement
Discovery
commitment
PURPOSE
driven
Preparing citizens of the WORLD
Service
IMMERSION
DISCOVERY
Common Good
connecting SU students to matters and current issues on a local, national and international scale
Promoting professional + personal formation while igniting a passion for SERVICE
Faith Based
Transforming SERVICE
JUST
OUR students
HUMANE
Belize
DOING GOOD
reflections
ADVOCACY

Liv Tyler

journey

BERNARD MAISNER
HAND-LETTERING

The Animal Rescue Fund of the Hamptons
presents
The 2011 Beach Ball

Magic under the *Moonlight*

PARTY

enchantment
EXCITEMENT
TIMELESS
Legendary

LOVE

WOW

macy's
150
FUN
cool
EAST FUN

MAGIC SPARKLE
unique
FRESH

EPIC

plum
Hamptons™

Sir · Elton · John

Joy Hope Giving
Happiness Peace
Peace Love Joy Hope Giving
Giving Happiness Peace
Joy Hope Giving Hope
Peace Love
Giving
Sir
Elton John
Holiday

30

The year was 1929. Herbert Hoover took office and the world was thrown into the despair of the Great Depression. In the midst of worldwide economic calamity, two German immigrants founded a small mill in Bally, PA to manufacture men's hosiery. In tribute to their new home and the dream therein, they named it Great American Knitting Mills. In such trying times they desired to create socks that would wear better and last longer. The answer was found in a gold reinforcing yarn sewn in the toe. The Gold Toe® brand. For 80 years the Gold Toe® brand has represented a commitment to crafting socks that are uncommonly comfortable and reliable, resilient. It is a vigorous standard of quality that has come to stand the test of time.

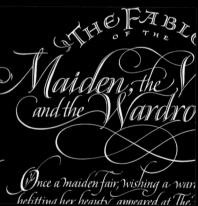

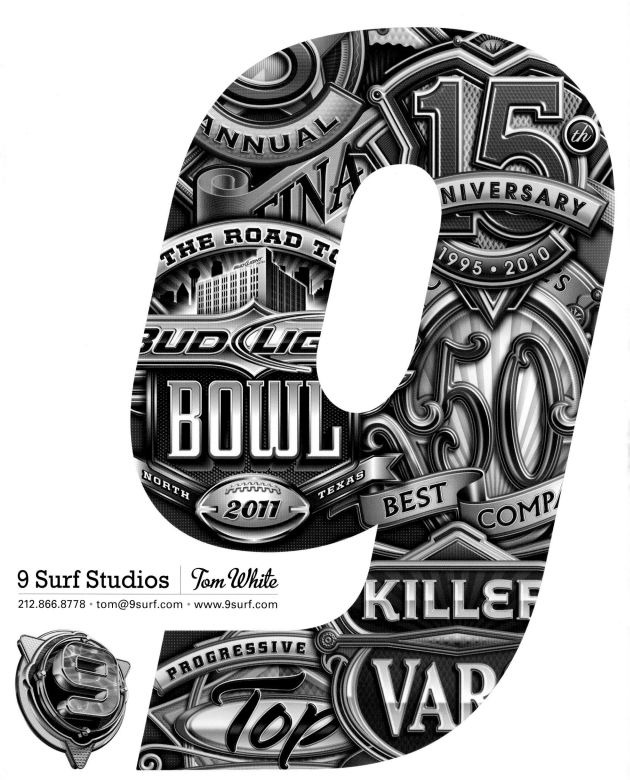

9 Surf Studios | *Tom White*
212.866.8778 • tom@9surf.com • www.9surf.com

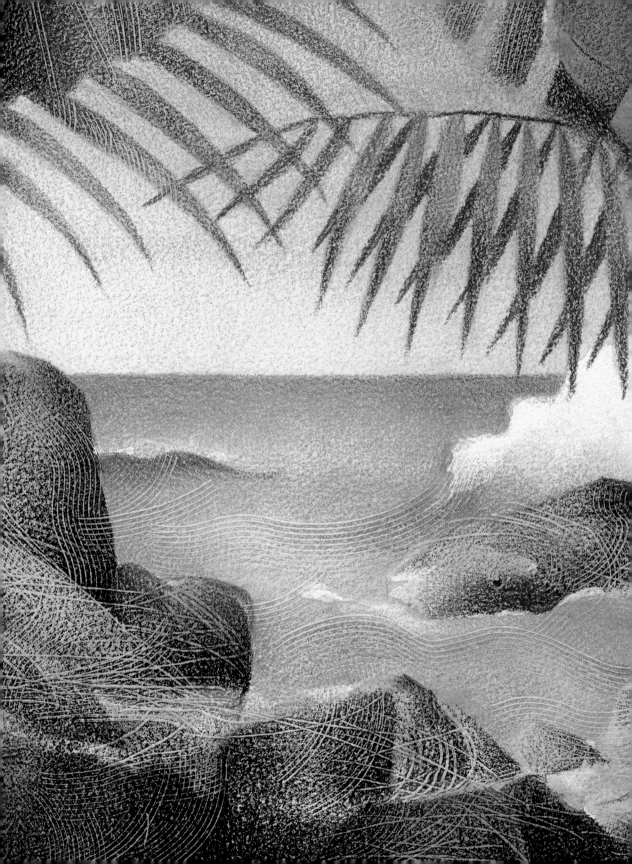

~ Illustration

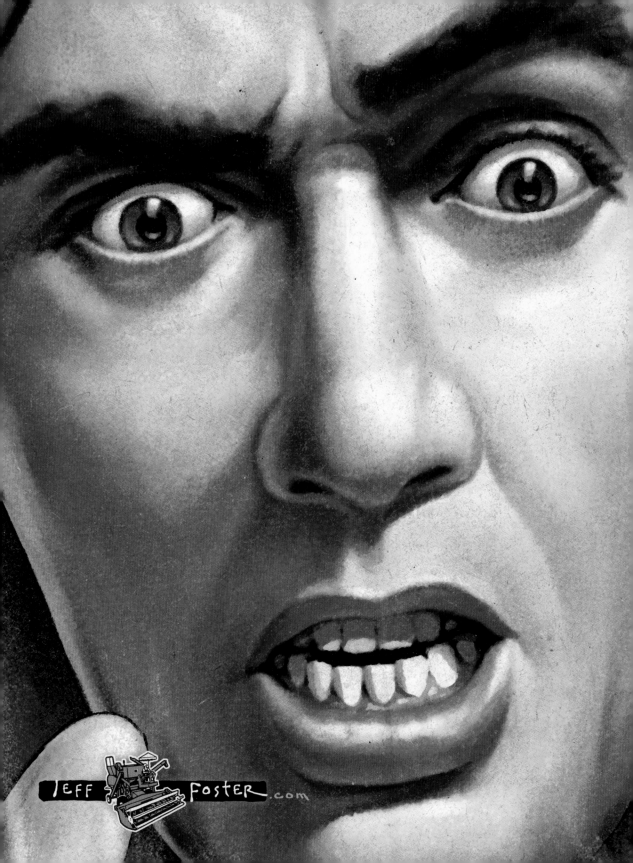

Out here, you need a truck that's built to take it.

STUART HIGHWAY

NORTHERN TERRITORY **AUSTRALIA** The **DEPARTMENT of NEVER QUITS**

Power, durability and a never-say-die attitude.

HOOVER DAM BYPASS

ARIZONA • NEVADA The **DEPARTMENT of BRUTE FORCE**

GUY BILLOUT

guy@guybillout.com www.guybillout.com

Robert Neubecker

neubecker.com neubeckerbooks.com

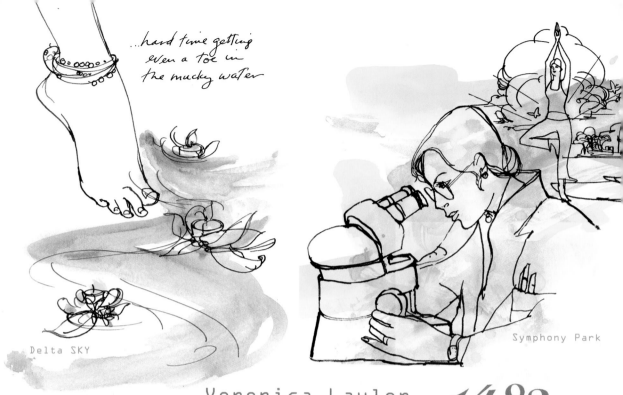

...hard time getting even a toe in the mucky water

Delta SKY

Symphony Park

Veronica Lawlor
illustration
www·studio1482·com/veronica
veronica@studio1482·com
917-449-9425

1482
studio 1482

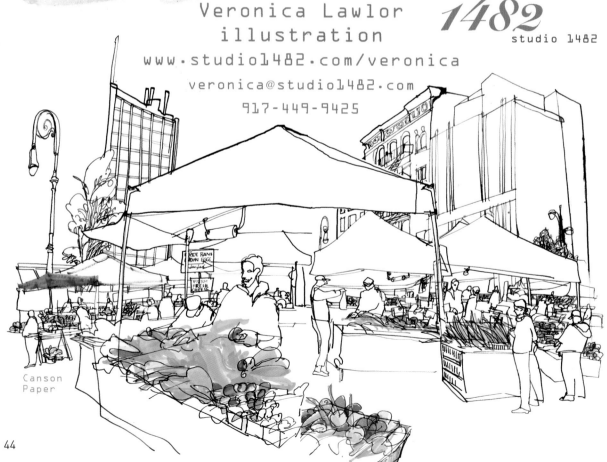

Canson Paper

44

Raphael Montoliu

www.montoliustudio.com raphael@konocti.net 707 263 6143

Neal Aspinall

AQC GOES TO
CANADA

HACKWORTH & COMPANY
INSURANCE BROKERS
CLASSIC BOAT INSURANCE

TUGBOAT

VENTURES

TUGBOAT

WORKS

PLAN C

ASPINALL
DESIGN

WWW.NEALASPINALL.COM

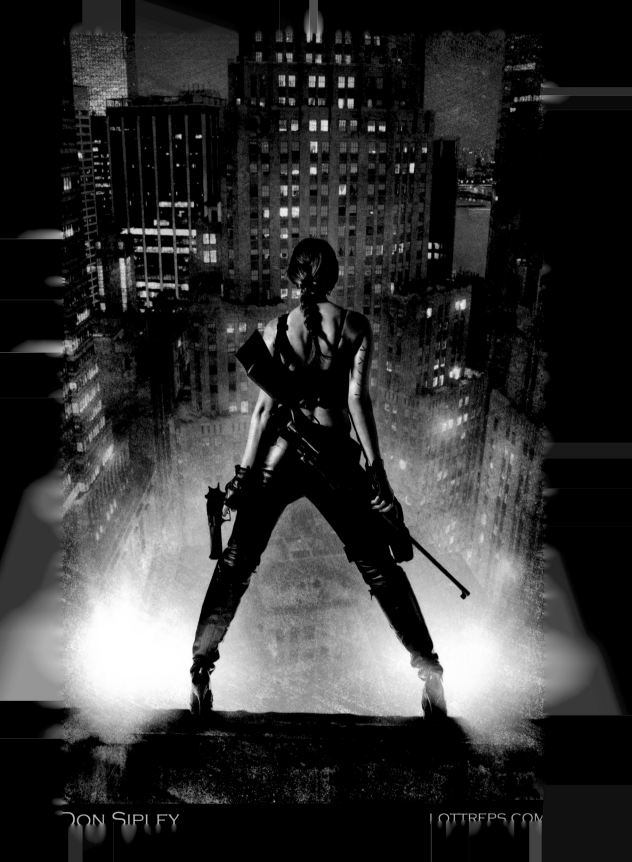

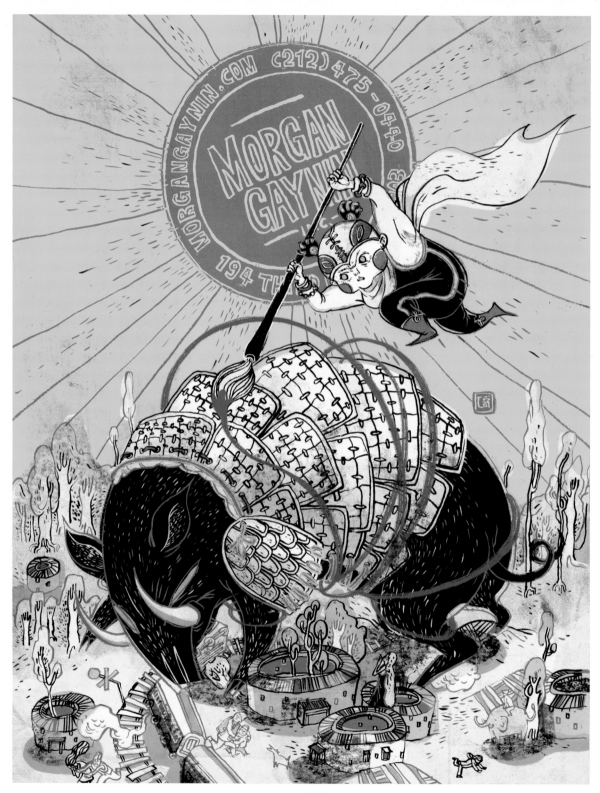

VICTO NGAI

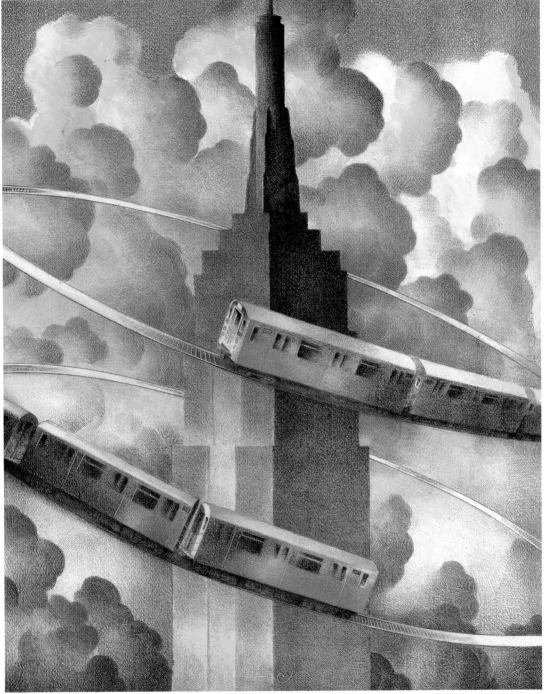

RAÚL COLÓN

49

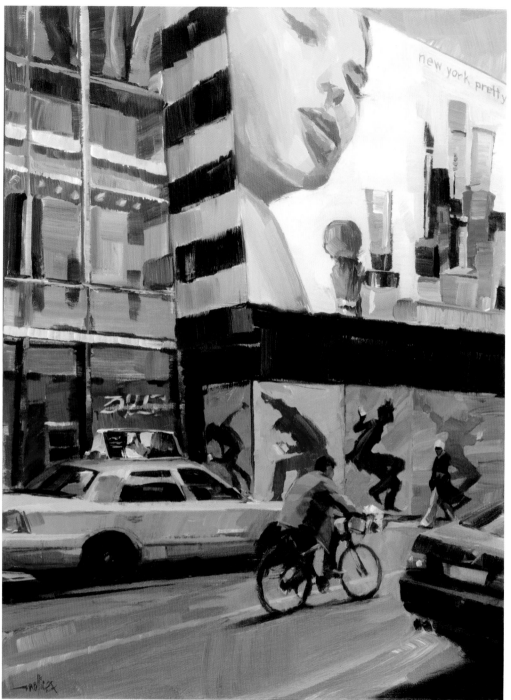

PATTI MOLLICA

50

JOSÉE BISAILLON

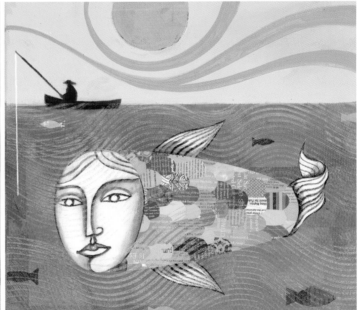

ELIZABETH ROSEN

194 THIRD AVE NYC 10003 (212)475-0440

MORGAN GAYNIN
INC
MORGANGAYNIN.COM

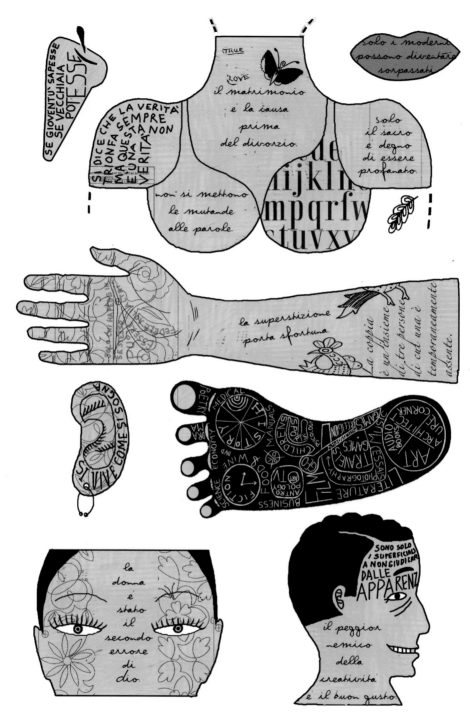

BEPPE GIACOBBE

SUSAN GAL

A. RICHARD ALLEN

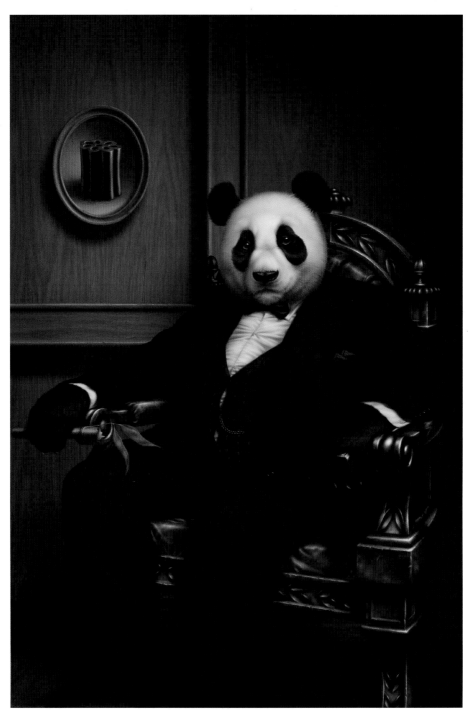

RENÉ MILOT

54

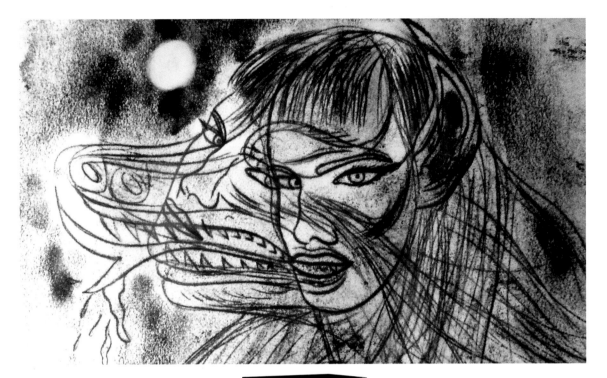

ANSON LIAW

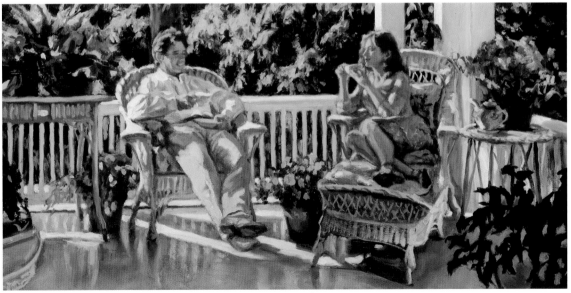

NANETTE BIERS

194 THIRD AVE NYC 10003 (212)475-0440

MORGAN GAYNIN INC.

MORGANGAYNIN.COM

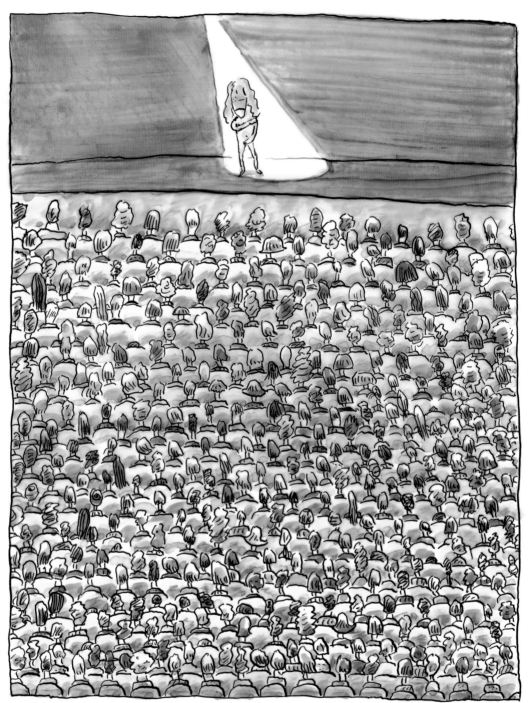

BONNIE TIMMONS

VALERIA PETRONE

CARLO STANGA

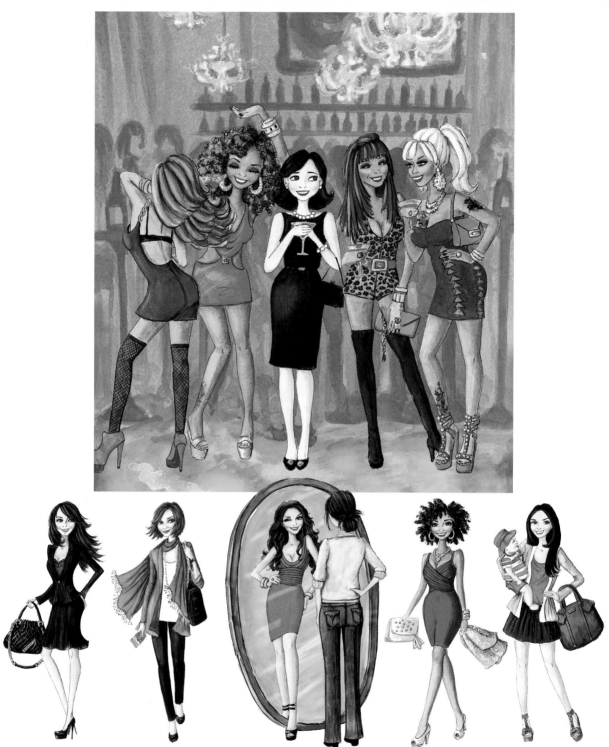

Meghann Powell

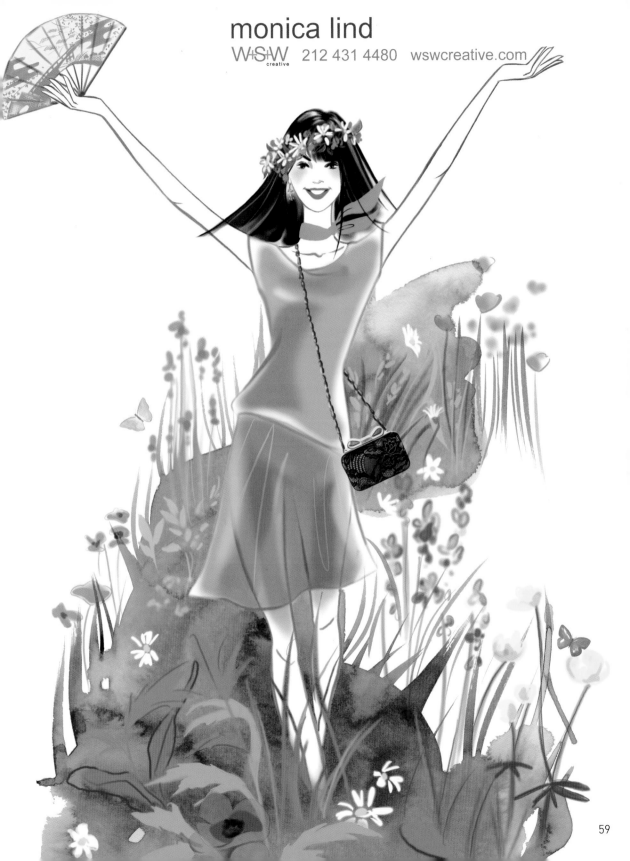

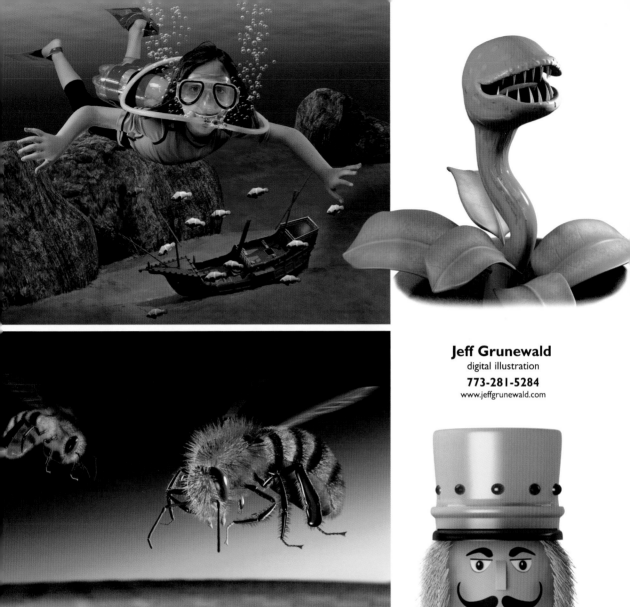

Jeff Grunewald
digital illustration
773-281-5284
www.jeffgrunewald.com

▶ Penguin U.S.A.

▶ ThreshDance.org

▶ General Growth Properties

▶ Penguin U.S.A.

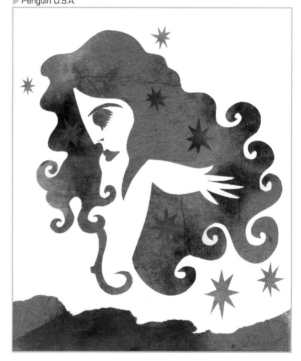

TOM LYNCH
tom@havocmedia.com

www.havocmedia.com
HAVOC Media Design
718.494.0118

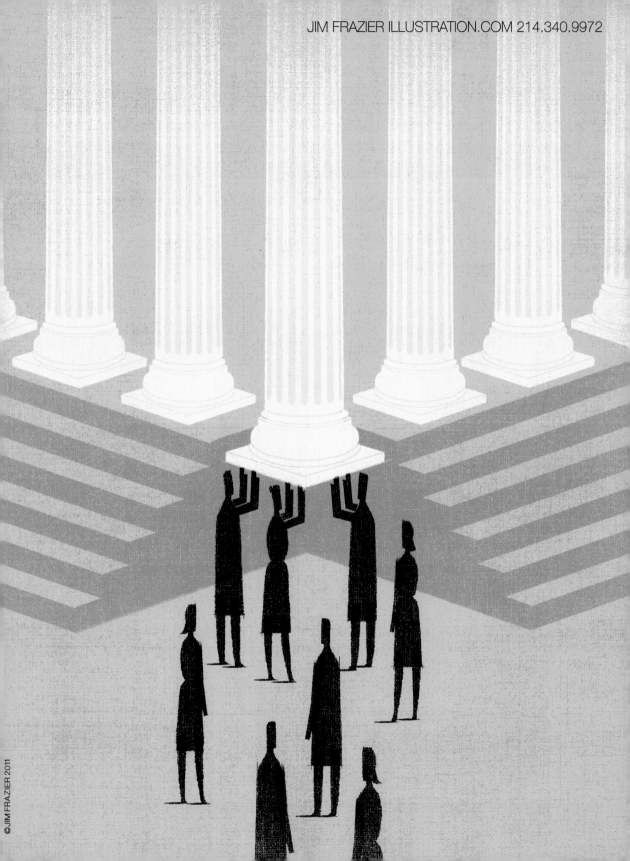

The art of MARTY BAUMANN

Genuine CARTOON SUPERPOWER!

BOOKS • MAGAZINES • GAMES • POSTERS • PACKAGING

WWW.MARTYBAUMANN.COM

WELCOME TO CAMP

SUPPLIES

Contact JOHN BREWSTER • 203-226-4724

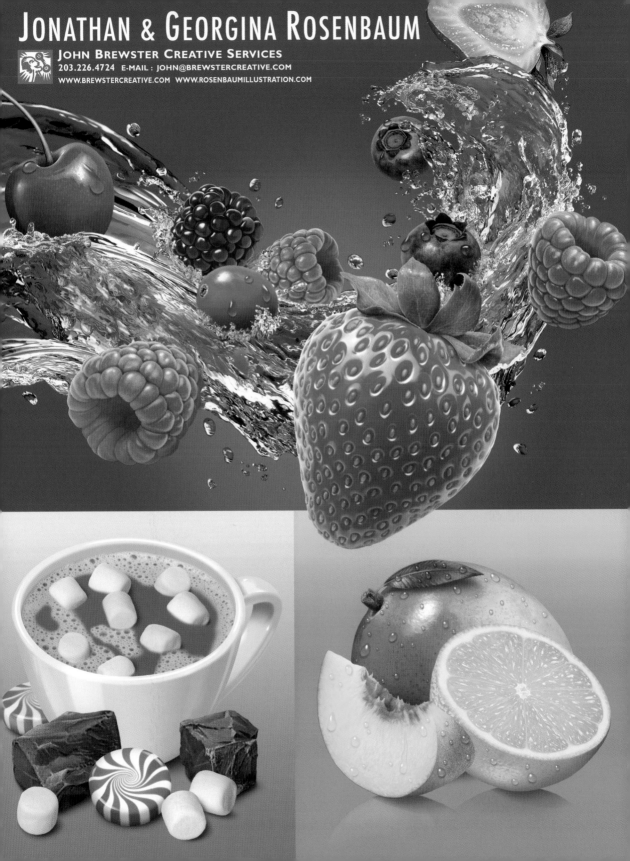

JONATHAN & GEORGINA ROSENBAUM

JOHN BREWSTER CREATIVE SERVICES

203.226.4724 E-MAIL : JOHN@BREWSTERCREATIVE.COM
WWW.BREWSTERCREATIVE.COM WWW.ROSENBAUMILLUSTRATION.COM

Doron Ben-Ami

Storyboard, Animatic and Finished Illustration

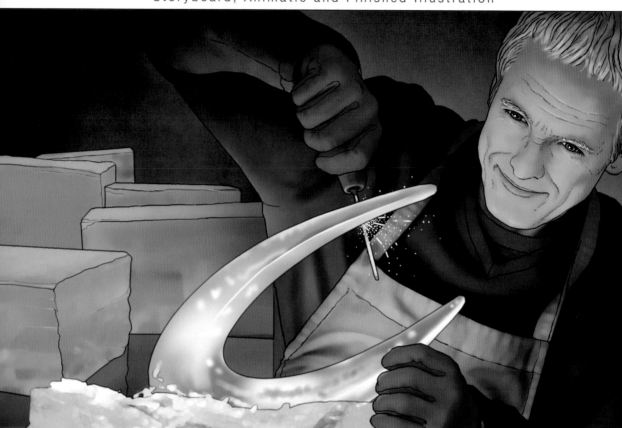

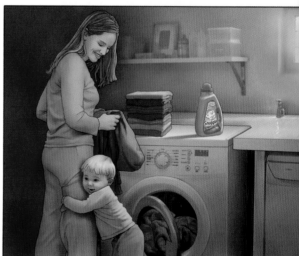

John Brewster Creative Services 35 Franklin St. • Westport CT 06880

Ph: 203.226.4724 • Fx: 203.454.9904 • www.brewstercreative.com • john@brewstercreative.com

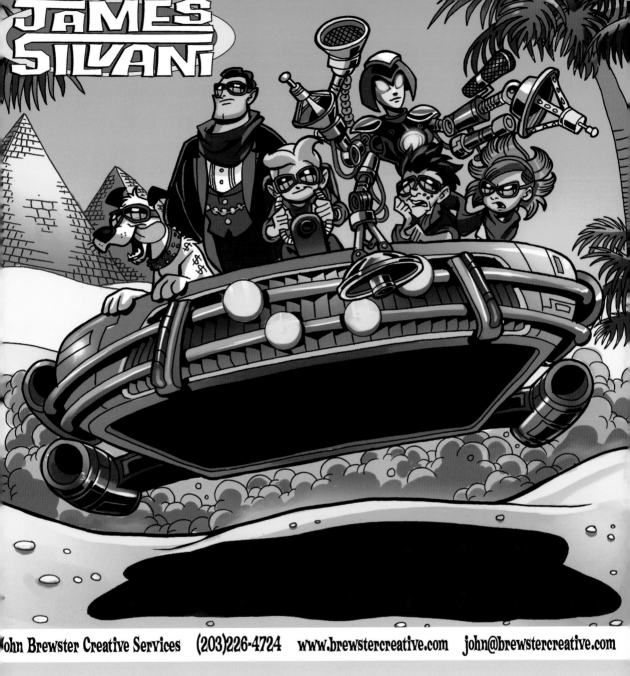

James Silvani

John Brewster Creative Services (203)226-4724 www.brewstercreative.com john@brewstercreative.com

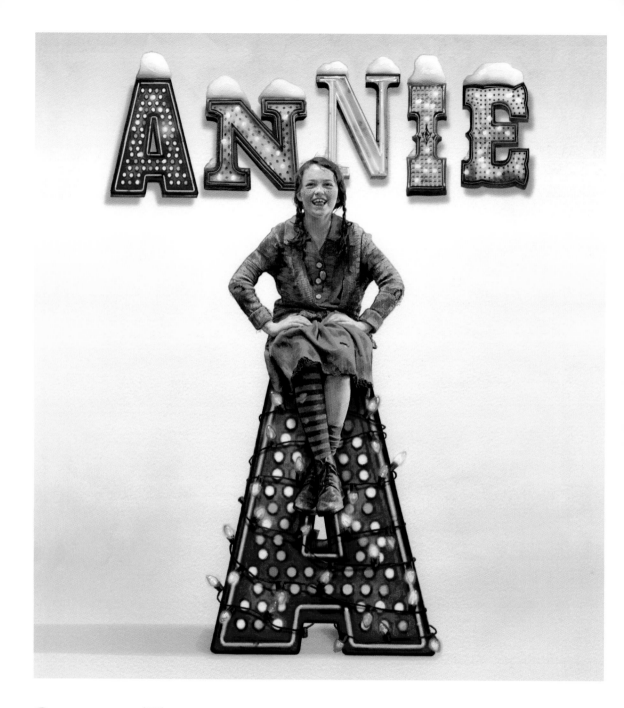

SHARIF TARABAY

JOHN BREWSTER CREATIVE SERVICES
PHONE: 203.226.4724 WEB: BREWSTERCREATIVE.COM
E-MAIL: JOHN@BREWSTERCREATIVE.COM

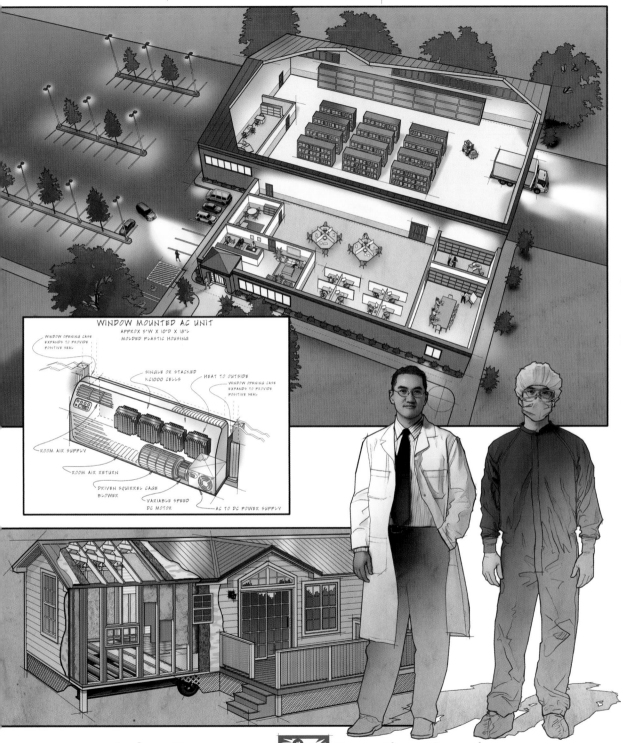

LANE DU PONT

WINDOW MOUNTED AC UNIT
APPROX 9"W X 10"D X 18"L
MOLDED PLASTIC HOUSING

WINDOW OPENING CASE
EXPANDS TO PROVIDE
POSITIVE SEAL

SINGLE OR STACKED
KC1000 CELLS

HEAT TO OUTSIDE

WINDOW OPENING CASE
EXPANDS TO PROVIDE
POSITIVE SEAL

ROOM AIR SUPPLY

ROOM AIR RETURN

DRIVEN SQUIRREL CAGE
BLOWER

VARIABLE SPEED
DC MOTOR

AC TO DC POWER SUPPLY

John Brewster Creative Services
Phone 203.226.4724 Fax 203.454.9904
John@brewstercreative.com www.brewstercreative.com

Elvis Swift – doodles and other stuff

Joanie Bernstein ART rep joanie@joaniebrep.com (239) 403-4393

JACOB THOMAS Joanie Bernstein, Art Rep 239-403-4393 www.joaniebrep.com

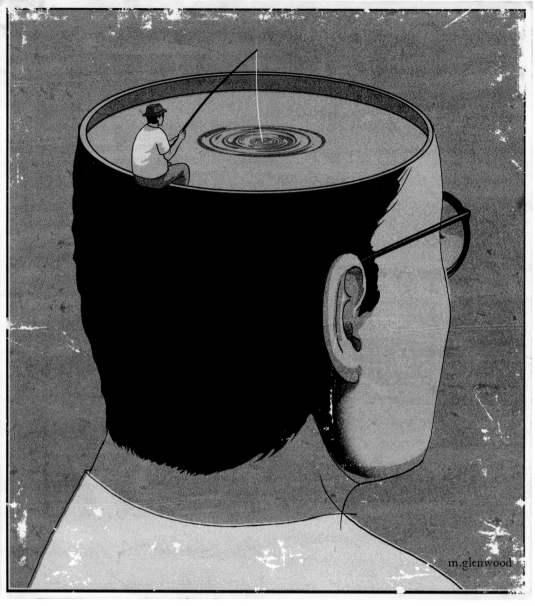

all artwork ©Michael Glenwood Gibbs

JOHN BURGOYNE

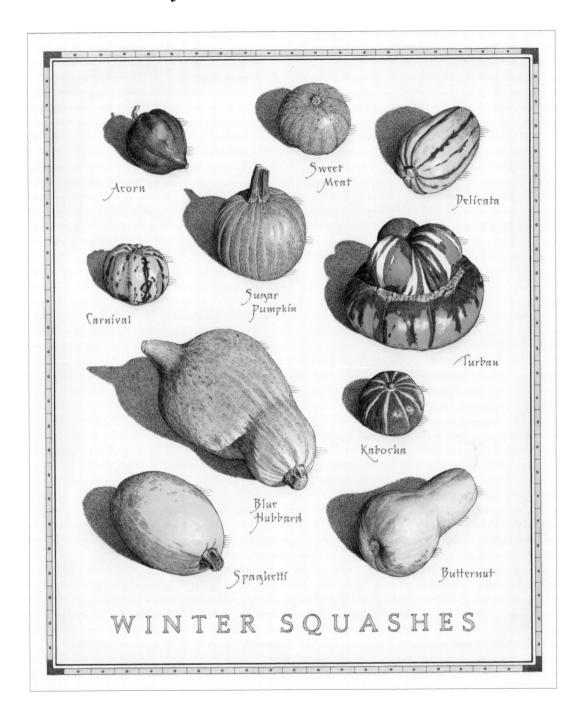

WINTER SQUASHES

Acorn
Sweet Meat
Delicata
Carnival
Sugar Pumpkin
Turban
Blue Hubbard
Kabocha
Spaghetti
Butternut

Comm. for Ted Baker Eyewear.

Comm. for Coin.

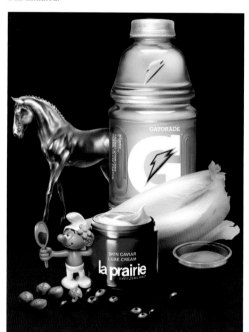

Arno

début **art** • Illustrators, Photographers and Fine Artists Agents. 30 Tottenham Street, London, W1T 4RJ. United Kingdom
Tel: 01144 20 7636 1064. Fax: 01144 20 7580 7017. **The Coningsby Gallery** • Tel: 01144 20 7636 7478

email: **info@debutart.com** • **www.debutart.com**

début **art** • Illustrators, Photographers and Fine Artists Agents

30 Tottenham Street, London, W1T 4RJ. United Kingdom

Tel: 01144 20 7636 1064. Fax: 01144 20 7580 7017

The Coningsby Gallery • Tel: 01144 20 7636 7478

email: **info@debutart.com** • **www.debutart.com**

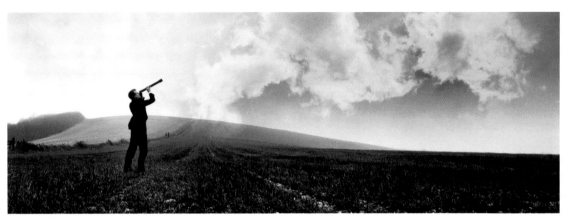

Since 1985, *début* **art** (based in London, England and now with offices in New York and Paris) has proactively sought out leading contemporary image-makers & clients who create original, progressive and commercially successful media material. Today, *début* **art** and the highly artistic illustrators it promotes, are widely regarded, both in the UK and around the world, as representing one of the finest and most contemporary talent groupings in the field of illustration.

début **art** and the illustrators it markets have successfully undertaken assignments worldwide for very many companies that are leaders in their fields including: Microsoft, Apple, Coca-Cola, Proctor and Gamble, Samsung, Levi's, Nokia, Rolls-Royce, BP, Shell, Nike, The Chicago Mercantile Exchange, The NYSE, The London Stock Exchange, Bloomberg, American Express, Barclaycard, HSBC, IBM, British Airways, Unilever, Harrods, Selfridges, Macy's (New York), Topshop, Verizon, Lucas Inc, The Royal Opera House (London), Universal Music, Sony, Miller, Burton, Harper Collins, The Wall Street Journal, The New York Times, The Times (London), Le Monde, The Economist, The Financial Times, Vogue, Cosmopolitan and National Geographic Magazine.

Full portfolios for every artist can be reviewed and requested via our web site at **www.debutart.com**

The Coningsby Gallery stages some 30 exhibitions per year by selected leading illustrators, photographers and fine artists. Review of previous exhibitions, a look at upcoming shows and a photo tour of the gallery itself can be accessed at **www.coningsbygallery.com**

Contact: Andrew Coningsby, Samuel Summerskill, Jonathan Hedley, Rhiannon Lloyd and Arnaud Mayet

Airside	Marta Cerda	Frazer Hudson	Harry Malt	Steve Rawlings	Dominic Trevett
Alan Aldridge	Matthew Dartford	Drawn Ideas	Stephane Manel	Nick Reddyhoff	Alex Trochut
Arno	Paul Davis	Ilovedust	Sophie Marsham	The Red Dress	Jim Tsinganos
Andrew Baker	Carol del Angel	Infomen	Kim McGillivray	Redseal	Vault49
Istvan Banyai	Pierre Doucin	Jacey	Vince McIndoe	Cath Riley	Stephanie von Reiswitz
Gary Bates	Barry Downard	Jackdaw	Wesley Merritt	Craig Robinson	Jeff Wack
Jon Berkeley	Katie Edwards	Sarah Jones	Justin Metz	Kerry Roper	Stephan Walter
Chris Bianchi	El Señor	Alan Kitching	Gabriel Moreno	Saeko	Neil Webb
Raymond Biesinger	Tim Ellis	Eley Kishimoto	Patrick Morgan	Serge Seidlitz	Jane Webster
Jacquie Boyd	Jo Fernihough	Viktor Koen	Morten Morland	Seripop	Joe Wilson
Norm Breyfogle	Flatliner	Ronald Kurniawan	Huntley/Muir	Shape & Colour	Oscar Wilson
Jon Burgerman	Peter Grundy	Christina K	Chris Nurse	Craig Shuttlewood	Alex Williamson
Oliver Burston	Sarah Hanson	Yuko Kondo	Kevin O'Keefe	Michel Streich	Tina Zellmer
Benedict Campbell	Ars Thanea	Kolchoz	Martin O'Neill	Sroop Sunar	Jurgen Ziewe
Danny Capozzi	Jethro Haynes	La Boca	Alex Pang	Tado	Vasili Zorin
James Carey	Sarah Haywood	Chris Labrooy	Mac Premo	James Taylor	
Celyn	Matt Herring	Yann Legendre	Pietari Posti	Ars Thanea	
Russell Cobb	Oliver Hibert	Neil Leslie	Chris Price	The Studio	
Matthew Cooper	Nanette Hoogslag	Lie-ins & Tigers	Paul Price	Yehrin Tong	
Peter Crowther	Sarah Howell	Andy Lovell	Peter Quinnell	Sophie Toulouse	

'Beauty is truth, truth beauty'
John Keats

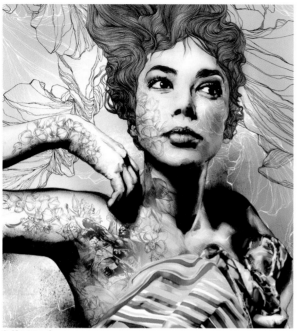

Self-initiated.

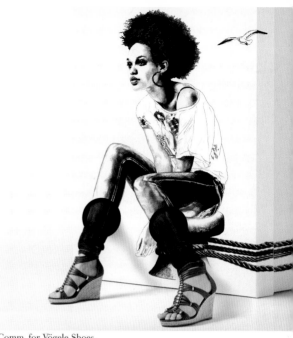

Comm. for Vögele Shoes.

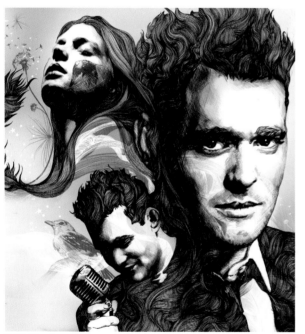

Self-initiated.

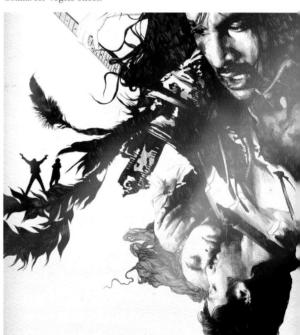

Comm. for Rockstar.

Gabriel Moreno

début **art** • Illustrators, Photographers and Fine Artists Agents. 30 Tottenham Street, London, W1T 4RJ. United Kingdom
Tel: 01144 20 7636 1064. Fax: 01144 20 7580 7017. **The Coningsby Gallery** • Tel: 01144 20 7636 7478

email: **info@debutart.com** • **www.debutart.com**

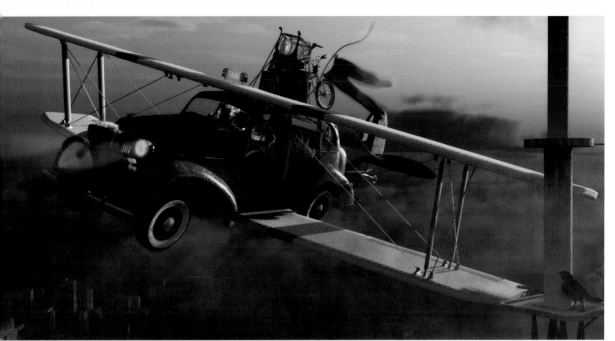

Self-initiated.

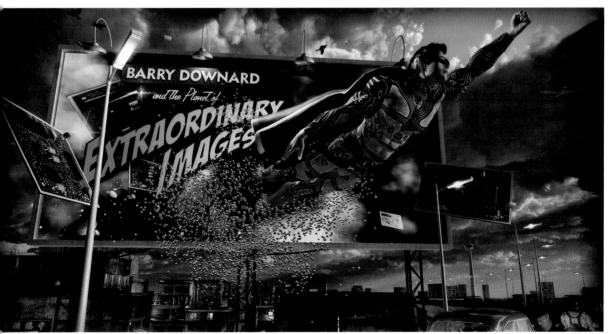

Self-initiated.

Barry Downard

début **art** • Illustrators, Photographers and Fine Artists Agents. 30 Tottenham Street, London, W1T 4RJ. United Kingdom
Tel: 01144 20 7636 1064. Fax: 01144 20 7580 7017. **The Coningsby Gallery** • Tel: 01144 20 7636 7478

email: **info@debutart.com** • **www.debutart.com**

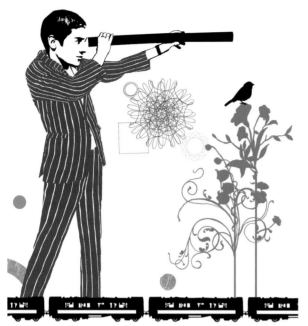

Comm. for the StopGap Employment Group.

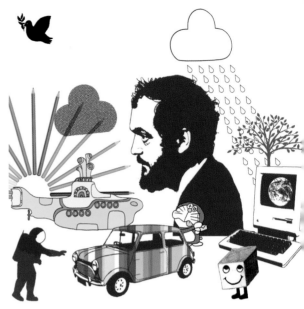

Comm. by Digit Magazine.

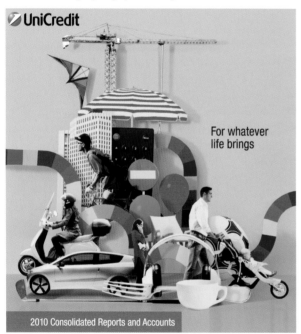

Comm. for UniCredit.

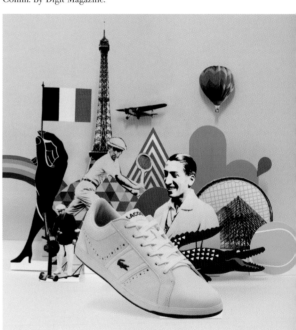

Comm. for Lacoste.

James Taylor

début **art** • Illustrators, Photographers and Fine Artists Agents. 30 Tottenham Street, London, W1T 4RJ. United Kingdom
Tel: 01144 20 7636 1064. Fax: 01144 20 7580 7017. **The Coningsby Gallery** • Tel: 01144 20 7636 7478

email: **info@debutart.com** • **www.debutart.com**

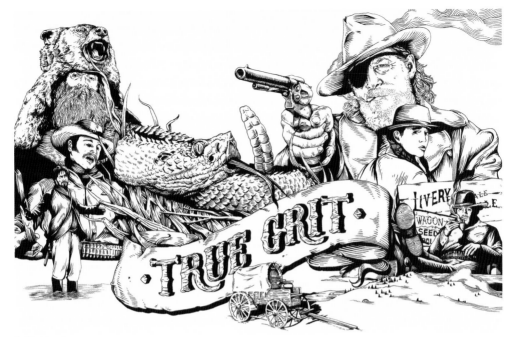

Self-initiated.

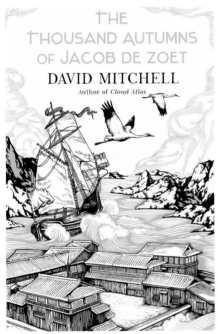

Comm. by Hodder & Stoughton.

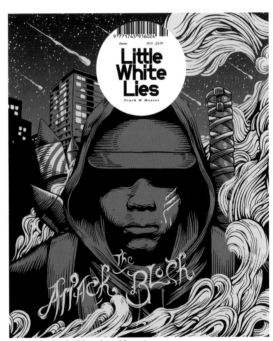

Comm. by Little White Lies Magazine.

Joe Wilson

début **art** • Illustrators, Photographers and Fine Artists Agents. 30 Tottenham Street, London, W1T 4RJ. United Kingdom
Tel: 01144 20 7636 1064. Fax: 01144 20 7580 7017. **The Coningsby Gallery** • Tel: 01144 20 7636 7478

email: **info@debutart.com** • **www.debutart.com**

début art

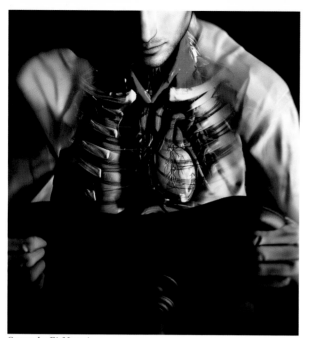

Comm. by F1 Magazine.

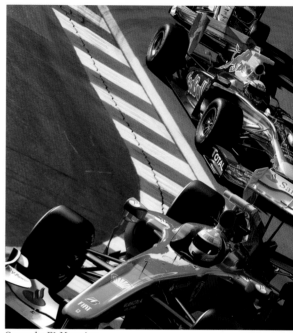

Comm. by F1 Magazine.

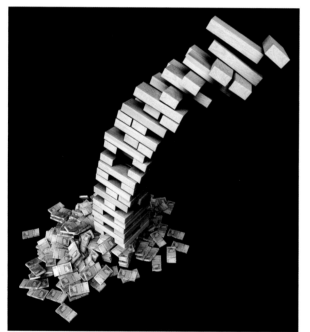

Comm. by People Managment Magazine.

Comm. by Little, Brown Book Publishing..

Peter Crowther Associates

début **art** • Illustrators, Photographers and Fine Artists Agents. 30 Tottenham Street, London, W1T 4RJ. United Kingdom
Tel: 01144 20 7636 1064. Fax: 01144 20 7580 7017. **The Coningsby Gallery** • Tel: 01144 20 7636 7478

email: **info@debutart.com** • **www.debutart.com**

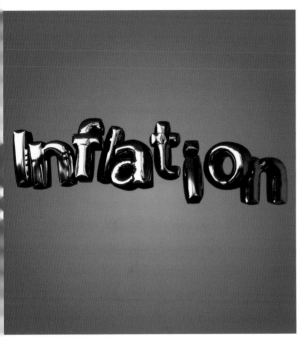

Comm. by Supply Managment Magazine.

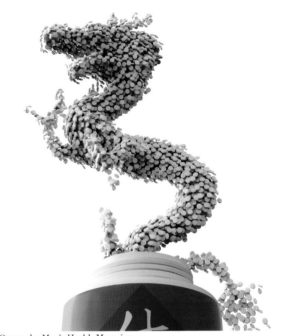

Comm. by Men's Health Magazine.

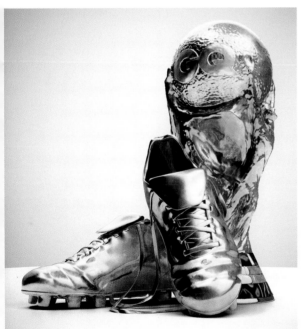

Comm. by GQ Magazine.

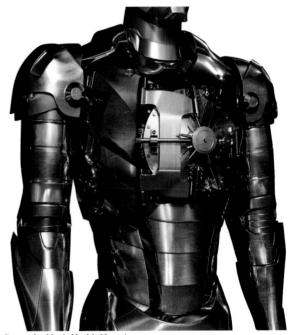

Comm. by Men's Health Magazine.

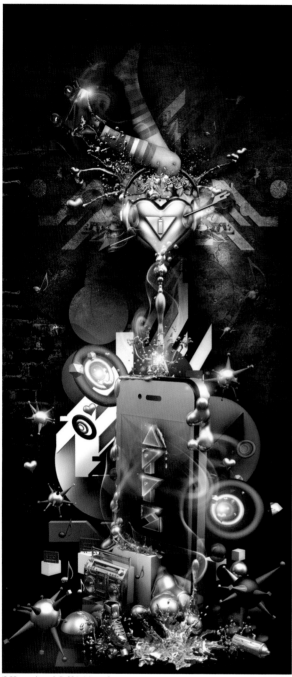

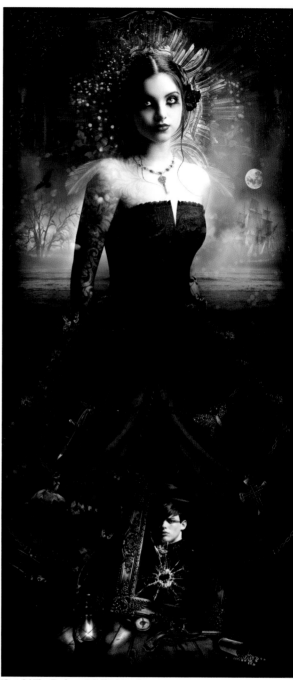

'I Heart Appz'. Self-inititated.

'Out Of The Darkness'. Self-initiated.

Jacey

début **art** • Illustrators, Photographers and Fine Artists Agents. 30 Tottenham Street, London, W1T 4RJ. United Kingdom
Tel: 01144 20 7636 1064. Fax: 01144 20 7580 7017. **The Coningsby Gallery** • Tel: 01144 20 7636 7478

email: **info@debutart.com** • **www.debutart.com**

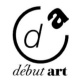

84

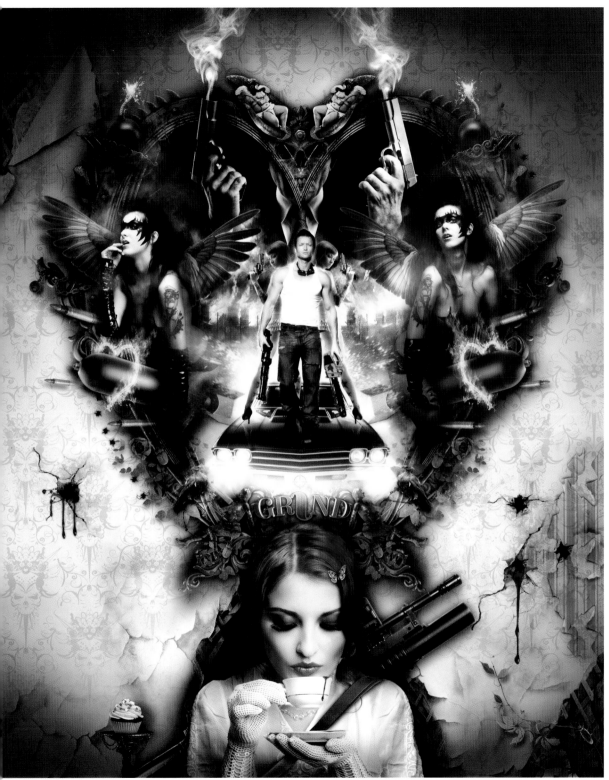

'Grind'. Self-initiated.

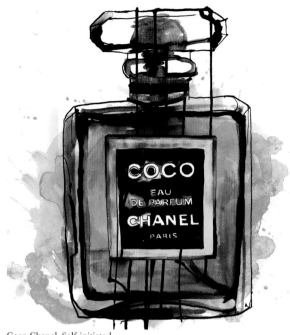

Comm. for Adidas.

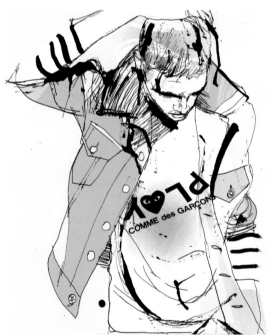

Coco Chanel. Self-initiated.

Comm. for Hewlett Packard.

Comm. for Comme des Garcons.

Patrick Morgan

début **art** • Illustrators, Photographers and Fine Artists Agents. 30 Tottenham Street, London, W1T 4RJ. United Kingdom
Tel: 01144 20 7636 1064. Fax: 01144 20 7580 7017. **The Coningsby Gallery** • Tel: 01144 20 7636 7478

email: **info@debutart.com** • **www.debutart.com**

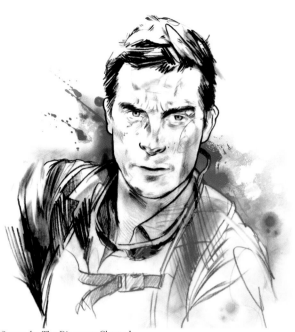

Comm. by The Discovery Channel.

Comm. by Men's Journal Magazine.

Comm. by Mondo.

Comm. by The Red Bulletin Magazine.

James Carey

début **art** • Illustrators, Photographers and Fine Artists Agents. 30 Tottenham Street, London, W1T 4RJ. United Kingdom
Tel: 01144 20 7636 1064. Fax: 01144 20 7580 7017. **The Coningsby Gallery** • Tel: 01144 20 7636 7478

email: **info@debutart.com** • **www.debutart.com**

début **art**

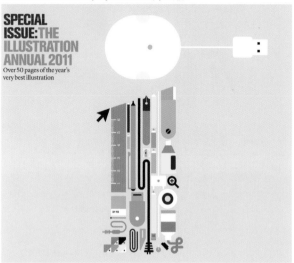

Comm. by Creative Review.

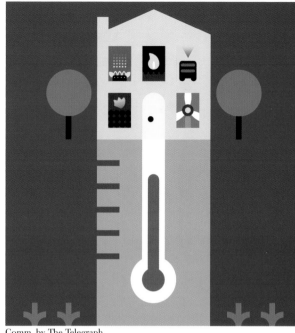

Comm. by The Telegraph.

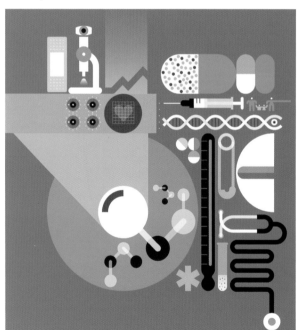

Comm. for Osborne Clarke Solicitors.

Comm. for Osborne Clarke Solicitors.

Peter Grundy

début **art** · Illustrators, Photographers and Fine Artists Agents. 30 Tottenham Street, London, W1T 4RJ. United Kingdom
Tel: 01144 20 7636 1064. Fax: 01144 20 7580 7017. **The Coningsby Gallery** · Tel: 01144 20 7636 7478

email: **info@debutart.com** · **www.debutart.com**

Comm. for Wilson Financial Services HTM Investment Group.

Comm. for Atlantic Review Magazine.

Comm. by Bladonmore.

Alex Williamson

début **art** • Illustrators, Photographers and Fine Artists Agents. 30 Tottenham Street, London, W1T 4RJ. United Kingdom
Tel: 01144 20 7636 1064. Fax: 01144 20 7580 7017. **The Coningsby Gallery** • Tel: 01144 20 7636 7478

email: **info@debutart.com** • **www.debutart.com**

début **art**

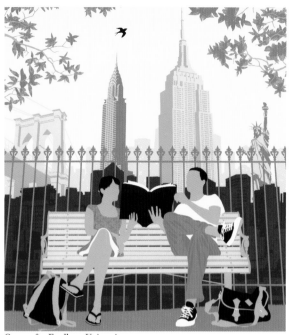
Comm. for Fordham University.

Comm. for Medicom.

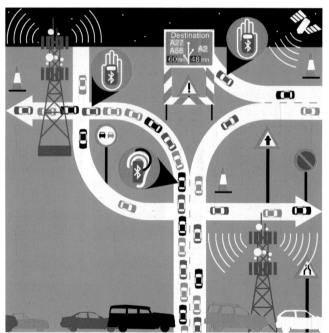
Comm. for New Electronics Magazine.

Comm. by IATA Magazine.

Neil Webb

début **art** • Illustrators, Photographers and Fine Artists Agents. 30 Tottenham Street, London, W1T 4RJ. United Kingdom
Tel: 01144 20 7636 1064. Fax: 01144 20 7580 7017. **The Coningsby Gallery** • Tel: 01144 20 7636 7478

email: **info@debutart.com** • **www.debutart.com**

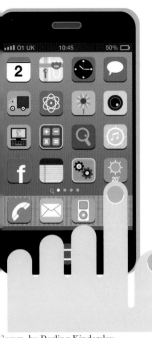

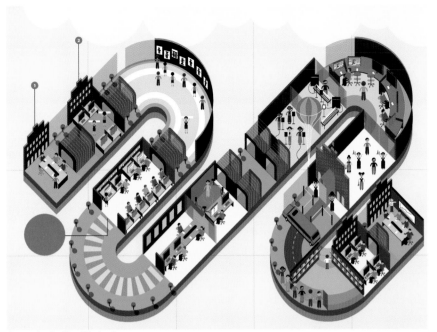

Comm. by Dorling Kindersley.

Comm. by Dorling Kindersley.

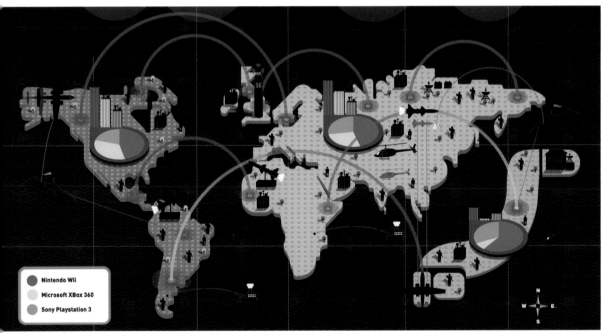

Nintendo Wii
Microsoft XBox 360
Sony Playstation 3

Comm. by Dorling Kindersley.

Infomen

début **art** • Illustrators, Photographers and Fine Artists Agents. 30 Tottenham Street, London, W1T 4RJ. United Kingdom
Tel: 01144 20 7636 1064. Fax: 01144 20 7580 7017. **The Coningsby Gallery** • Tel: 01144 20 7636 7478

mail: **info@debutart.com** • **www.debutart.com**

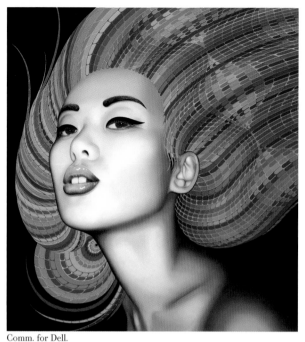
Comm. for Dell.

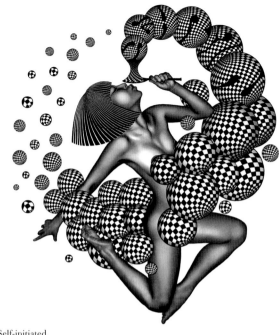
Self-initiated.

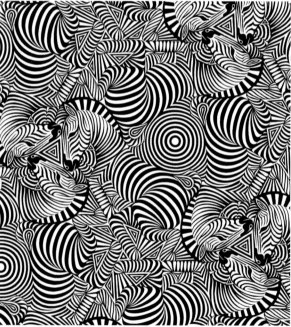
Comm. for Apple.

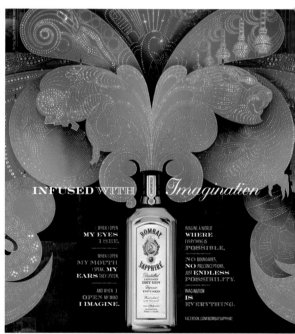
Comm. for Bombay Sapphire gin.

Yehrin Tong

début **art** • Illustrators, Photographers and Fine Artists Agents. 30 Tottenham Street, London, W1T 4RJ. United Kingdom
Tel: 01144 20 7636 1064. Fax: 01144 20 7580 7017. **The Coningsby Gallery** • Tel: 01144 20 7636 7478

email: **info@debutart.com** • **www.debutart.com**

Comm. by Liquid Agency.

Comm. for Faltu Films.

Jackdaw

début **art** • Illustrators, Photographers and Fine Artists Agents. 30 Tottenham Street, London, W1T 4RJ. United Kingdom
Tel: 01144 20 7636 1064. Fax: 01144 20 7580 7017. **The Coningsby Gallery** • Tel: 01144 20 7636 7478

E-mail: **info@debutart.com** • **www.debutart.com**

début **art**

93

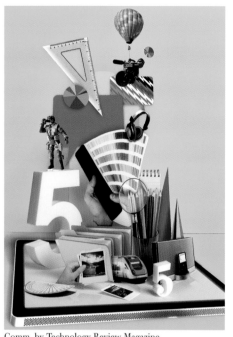

Comm. by Technology Review Magazine.

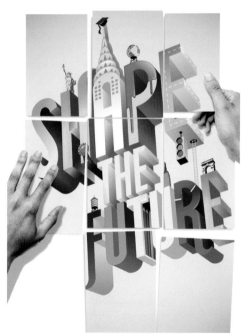

Comm. by Fortune Magazine.

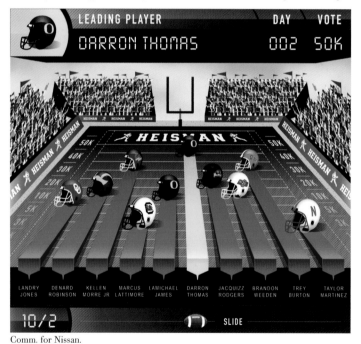

Comm. for Nissan.

Comm. by NYU.

Vault49

début **art** • Illustrators, Photographers and Fine Artists Agents. 30 Tottenham Street, London, W1T 4RJ. United Kingdom
Tel: 01144 20 7636 1064. Fax: 01144 20 7580 7017. **The Coningsby Gallery** • Tel: 01144 20 7636 7478

email: **info@debutart.com** • **www.debutart.com**

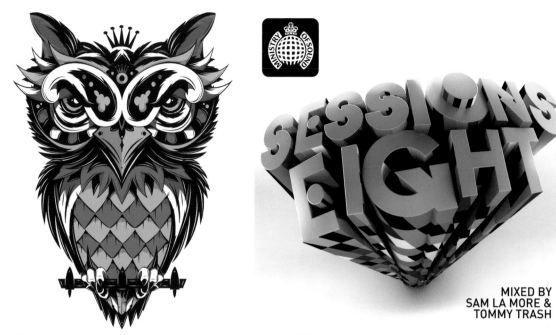

Self-initiated.

Comm. for Ministry of Sound.

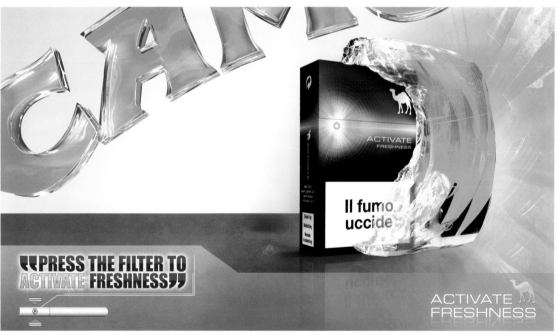

Comm. by Camel.

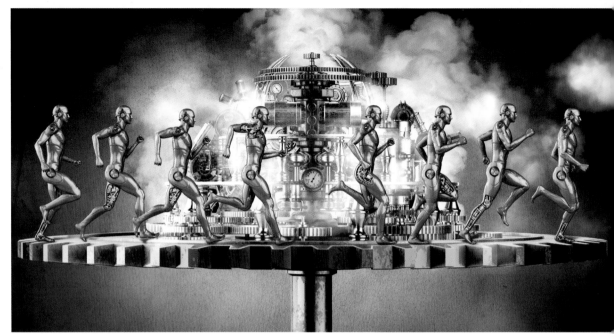

Comm. by Men's Health Magazine.

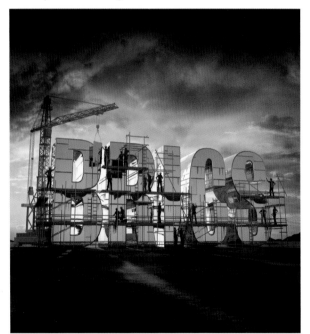

Comm. by This Is Africa Magazine.

Comm. by Darwin Magazine.

Oliver Burston

début **art** • Illustrators, Photographers and Fine Artists Agents. 30 Tottenham Street, London, W1T 4RJ. United Kingdom
Tel: 01144 20 7636 1064. Fax: 01144 20 7580 7017. **The Coningsby Gallery** • Tel: 01144 20 7636 7478

email: **info@debutart.com** • **www.debutart.com**

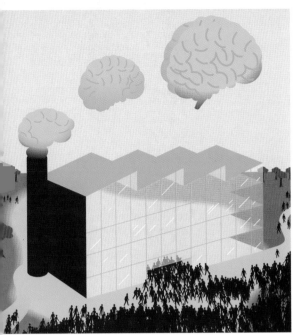

Comm. by The Economist.

Comm. by The Guardian.

Comm. by King's College London.

Andrew Baker

début **art** • Illustrators, Photographers and Fine Artists Agents. 30 Tottenham Street, London, W1T 4RJ. United Kingdom
Tel: 01144 20 7636 1064. Fax: 01144 20 7580 7017. **The Coningsby Gallery** • Tel: 01144 20 7636 7478

email: **info@debutart.com** • **www.debutart.com**

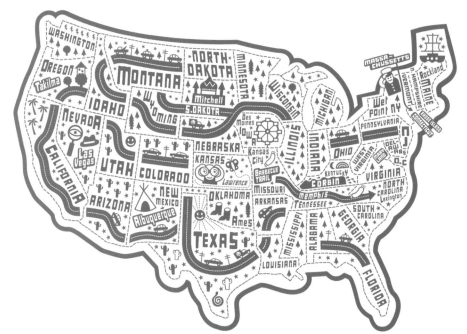

Comm. by Women's Day Magazine.

Comm. by Educational Insights.

Comm. by Key Club Magazine.

Serge Seidlitz

début **art** • Illustrators, Photographers and Fine Artists Agents. 30 Tottenham Street, London, W1T 4RJ. United Kingdom
Tel: 01144 20 7636 1064. Fax: 01144 20 7580 7017. **The Coningsby Gallery** • Tel: 01144 20 7636 7478

email: **info@debutart.com** • **www.debutart.com**

'Spaceship Earth'. Self-initiated.

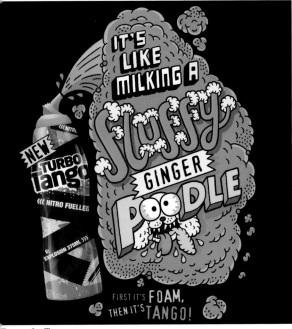

Comm. for Tango.

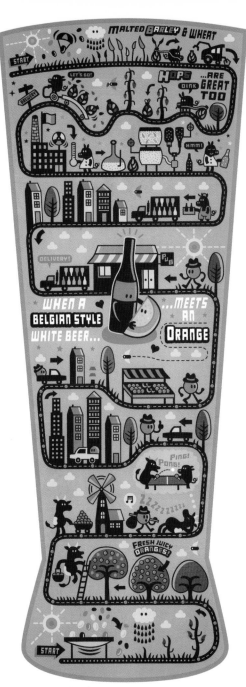

'Belgian Orange Beer'.

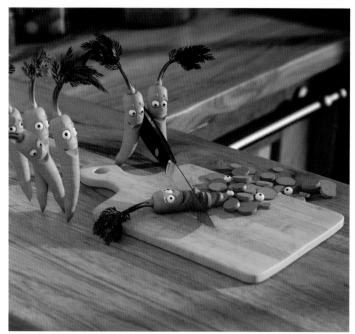

Comm. for Ristorante Cantina.

Comm. for Oasis.

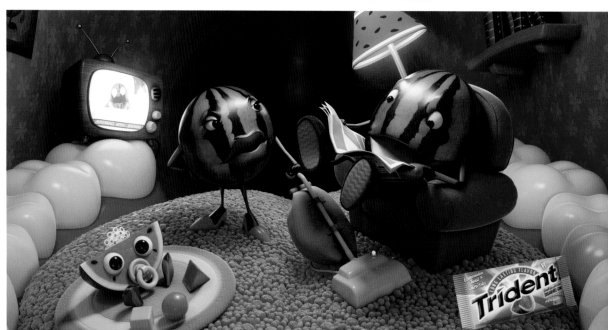

Comm. for Trident.

Matt Dartford / Flip CG

début **art** • Illustrators, Photographers and Fine Artists Agents. 30 Tottenham Street, London, W1T 4RJ. United Kingdom
Tel: 01144 20 7636 1064. Fax: 01144 20 7580 7017. **The Coningsby Gallery** • Tel: 01144 20 7636 7478

email: **info@debutart.com** • **www.debutart.com**

Comm. for Gulf Airlines.

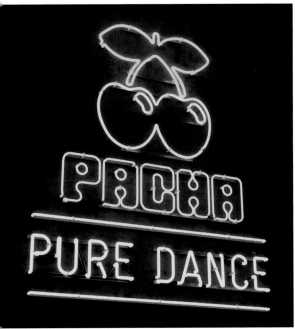

Comm. for Pacha Recordings.

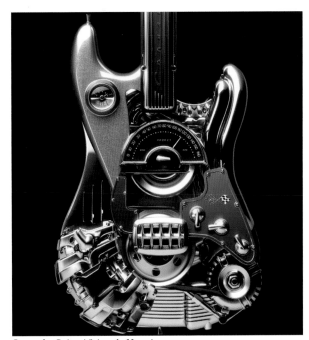

Comm. by Guitar Aficionado Magazine.

Comm. for 9/11 Group Show.

Comm. for Hansberger Investments.

Comm. for Anheuser-Busch.

Comm. for Focus Magazine.

Vince McIndoe

début **art** • Illustrators, Photographers and Fine Artists Agents. 30 Tottenham Street, London, W1T 4RJ. United Kingdom
Tel: 01144 20 7636 1064. Fax: 01144 20 7580 7017. **The Coningsby Gallery** • Tel: 01144 20 7636 7478

email: **info@debutart.com** • **www.debutart.com**

ENERGY STATION SAMEDI 23 MAI DE 19h00 A 03h00

MONACO
LA SOIRÉE

Comm. for Redbull Racing.

THE MYSTERY OF THE MARTINI

PLYMOUTH

Comm. for Martini.

Pinet

Self-initiated.

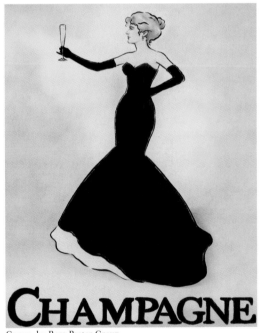

CHAMPAGNE

Comm. by Ross Poster Group.

début art

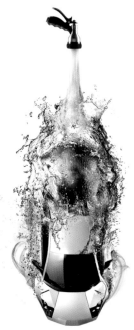

Comm. for Prestone Car Wax.

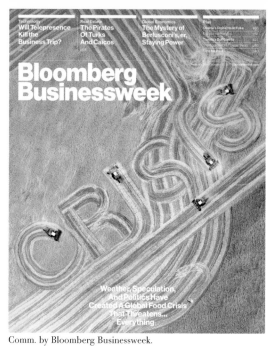

Comm. by Bloomberg Businessweek.

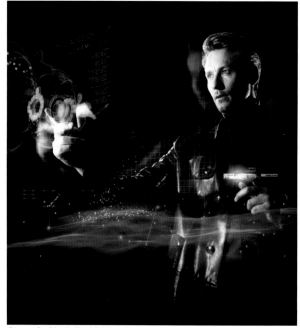

Comm. by Men's Health Magazine.

Comm. for House of Fraser store group (London).

Justin Metz

début **art** • Illustrators, Photographers and Fine Artists Agents. 30 Tottenham Street, London, W1T 4RJ. United Kingdom
Tel: 01144 20 7636 1064. Fax: 01144 20 7580 7017. **The Coningsby Gallery** • Tel: 01144 20 7636 7478

email: **info@debutart.com** • **www.debutart.com**

Comm. by Engage Magazine.

Comm. by Penthouse Magazine.

Comm. by Continuum Books.

Comm. by Men's Health Magazine.

The Red Dress

début **art** • Illustrators, Photographers and Fine Artists Agents. 30 Tottenham Street, London, W1T 4RJ. United Kingdom
Tel: 01144 20 7636 1064. Fax: 01144 20 7580 7017. **The Coningsby Gallery** • Tel: 01144 20 7636 7478

mail: **info@debutart.com** • **www.debutart.com**

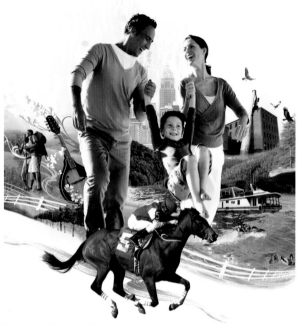

Comm. for Kentucky Tourism.

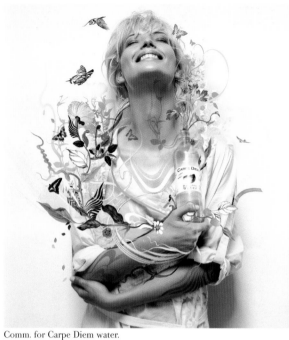

Comm. for Carpe Diem water.

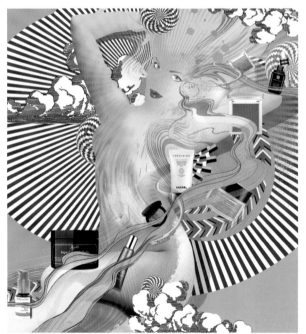

Comm. by The Wall Street Journal.

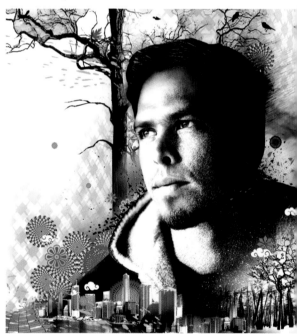

Comm. for Kyocera.

Sarah Howell
début **art** • Illustrators, Photographers and Fine Artists Agents. 30 Tottenham Street, London, W1T 4RJ. United Kingdom
Tel: 01144 20 7636 1064. Fax: 01144 20 7580 7017. **The Coningsby Gallery** • Tel: 01144 20 7636 7478

email: **info@debutart.com** • **www.debutart.com**

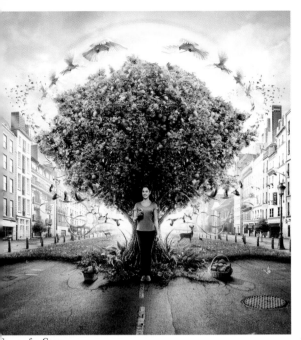

Comm. for Cappy.

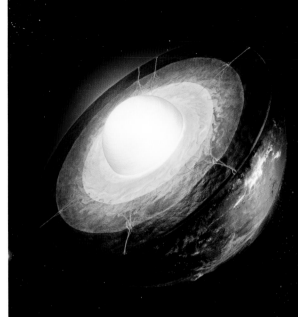

Comm. by BBC Focus Magazine.

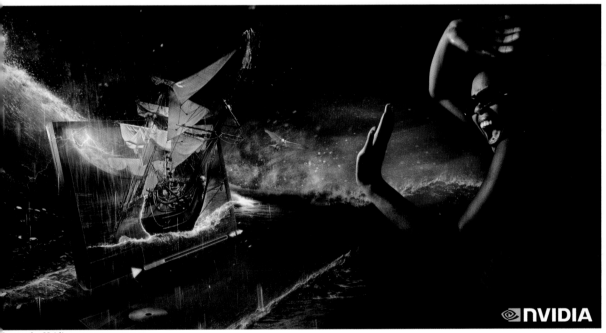

Comm. for Nvidia.

Ars Thanea

début **art** • Illustrators, Photographers and Fine Artists Agents. 30 Tottenham Street, London, W1T 4RJ. United Kingdom
Tel: 01144 20 7636 1064. Fax: 01144 20 7580 7017. **The Coningsby Gallery** • Tel: 01144 20 7636 7478

e-mail: **info@debutart.com** • **www.debutart.com**

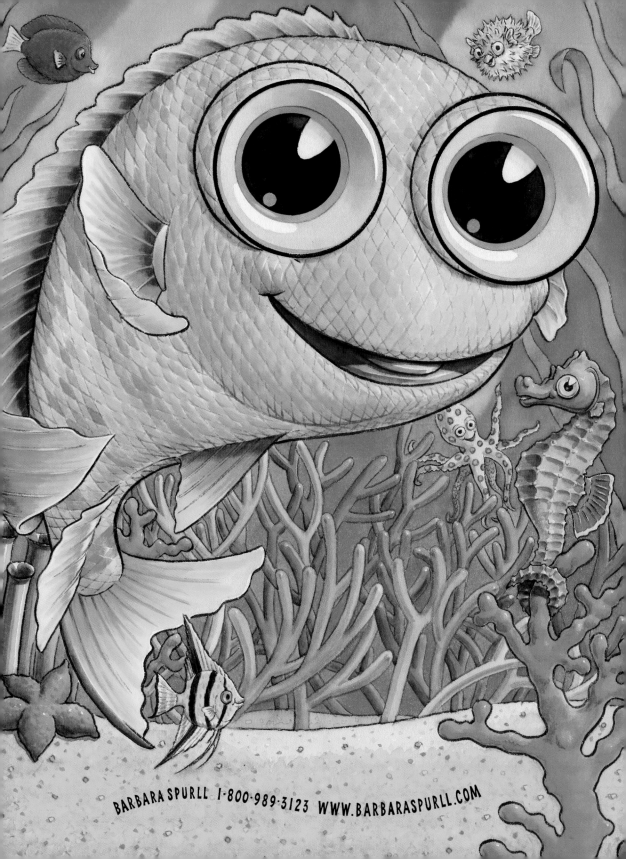

BARBARA SPURLL 1·800·989·3123 WWW.BARBARASPURLL.COM

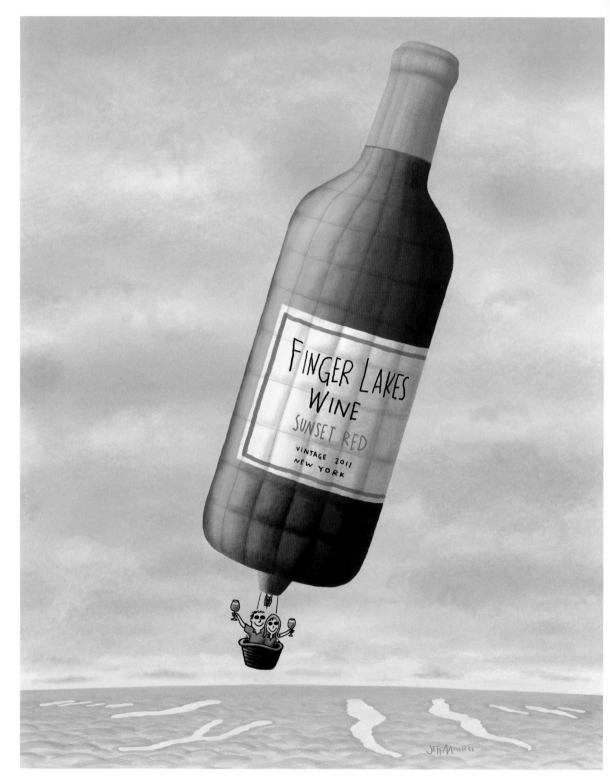

Jeff Moores

Jmoores1@rochester.rr.com jeffmoores.com

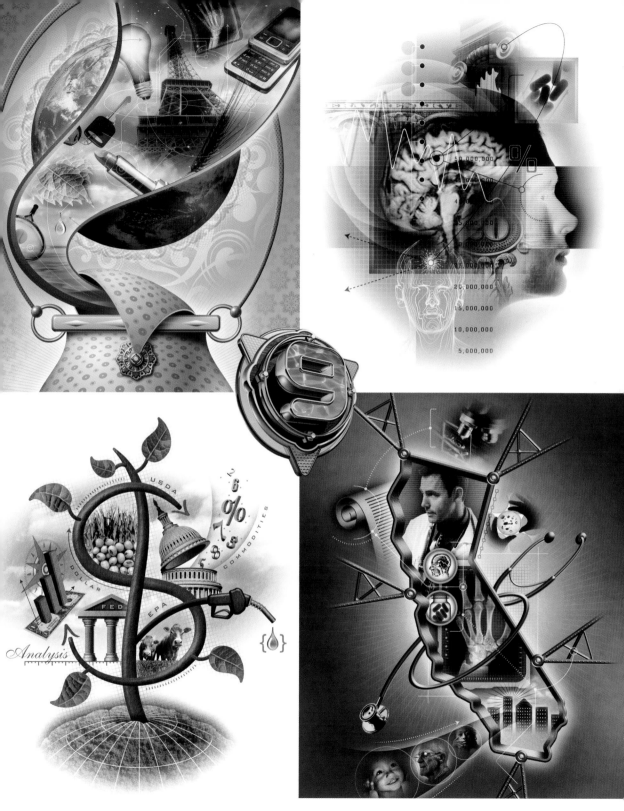

9 Surf Studios | *Tom White* | 212.866.8778 • tom@9surf.com • www.9surf.com

REACTOR ART + DESIGN

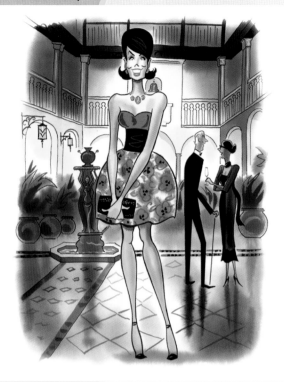

Maurice Vellekoop

Tracey Wood

R.O. Blechman

Alëna Skarina

PAUL ZWOLAK

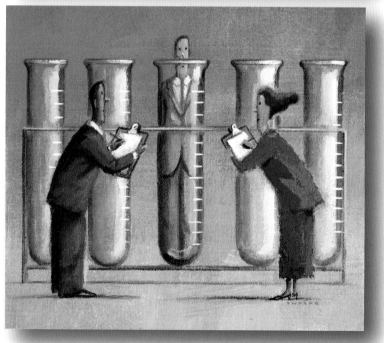

Marlena agency
609-252-9405 • www.marlenaagency.com

(PRE-SWEETENED)

ILLUSTRATION

SERVING
SUGGESTION

(917) 710-8010 ✳ CHIPWASS.COM

Wasco ✳

TIM BARRALL

illustration
lettering
digital enhancement

studio 212 243 9003 timbarrall.com email: info@timbarrall.com

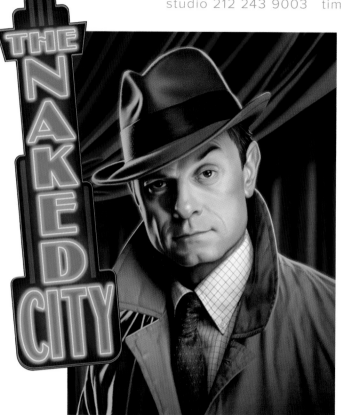

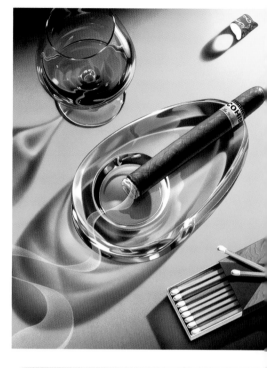

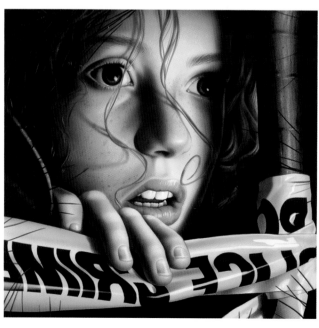

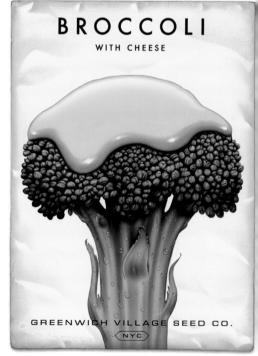

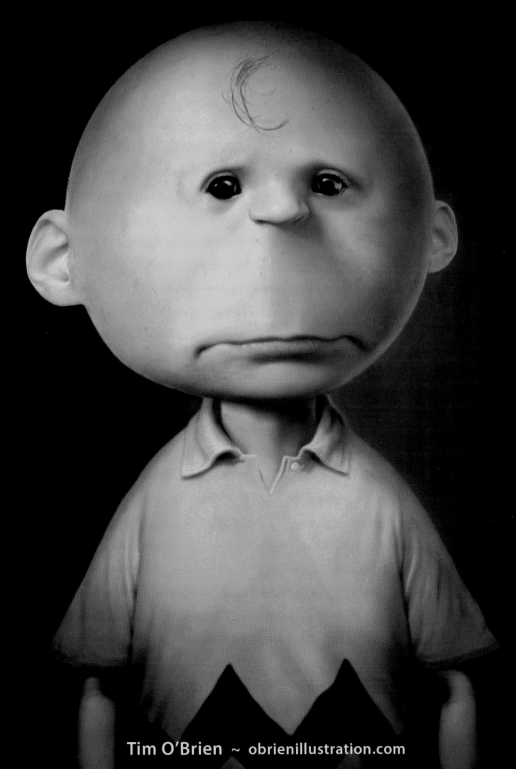

Tim O'Brien ~ obrienillustration.com

(718) 282-2821 ~ obrienillustration@me.com ~ Agent: Peter Lott ~ (212) 755-5737

LARRY JOST

REPRESENTED BY SUSAN AND CO. • 206 232 7873

WWW.SUSANANDCO.COM • WWW.LARRYJOSTILLUSTRATION.COM

the
Emperor
of
Paris

*a magical tale of a book,
a baker, and portrait painter*

'BUT NOT
ANYMORE'
I won't have
crazy
worries
not about LEAKS
or ANYTHING ELSE

Share
it's
you
day

To Commemorate the Marriage Of
PRINCE WILLIAM OF WALES & MISS CATHERINE MIDDLETON

29TH APRIL 2011

What if
No one
Proposes

i'm lovin' it

ALL OUR EGGS
ARE FREE RANGE

THAT'S WHAT MAKES McDONALD'S

MENDOLA
ARTISTS REPRESENTATIVES
WWW.MENDOLAART.COM
PH 212.986.5680 E info@mendolaart.com

milkytea
CGI Illustration Animation

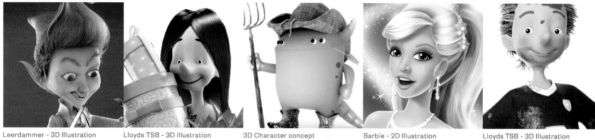

Leerdammer - 3D Illustration Lloyds TSB - 3D Illustration 3D Character concept Barbie - 2D Illustration Lloyds TSB - 3D Illustration

Character design and concept sketches

Suzie Pugh - 3D Children's book illustration

3D Character concept for AFC Asian Cup 2011

3D Children's book illustration

.loyds TSB - 3D illustration

CGI Car and photography composition

The **BLACK HORSE**

.loyds TSB - 3D illustration

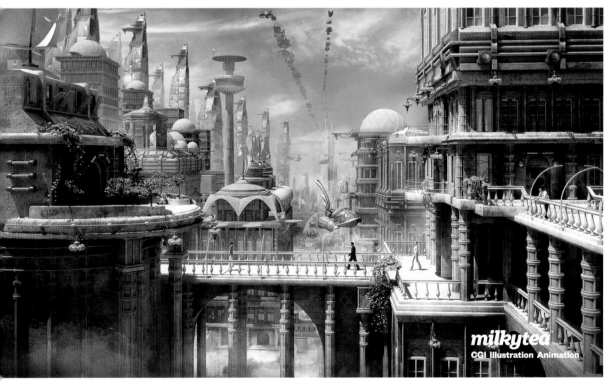

milkytea
CGI Illustration Animation

3D game environment concept

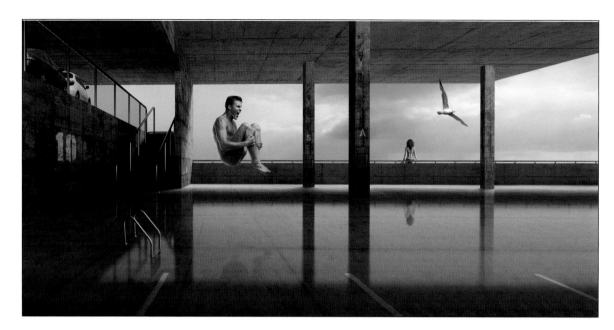

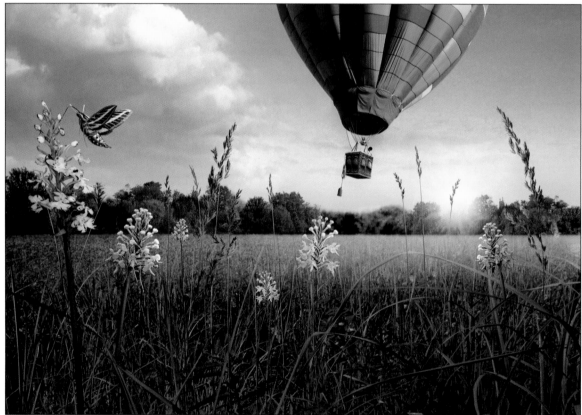

MENDOLA
ARTISTS REPRESENTATIVE

WWW.MENDOLAART.COM
212.986.5680 info@mendolaart.com

HUGH SYME

122

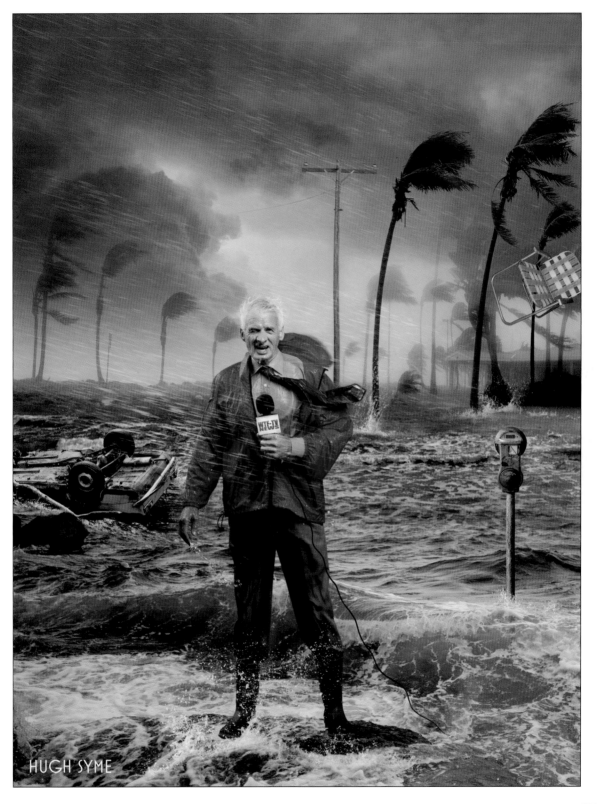

HUGH SYME

Swampland
Happy Happy Ecosystem!

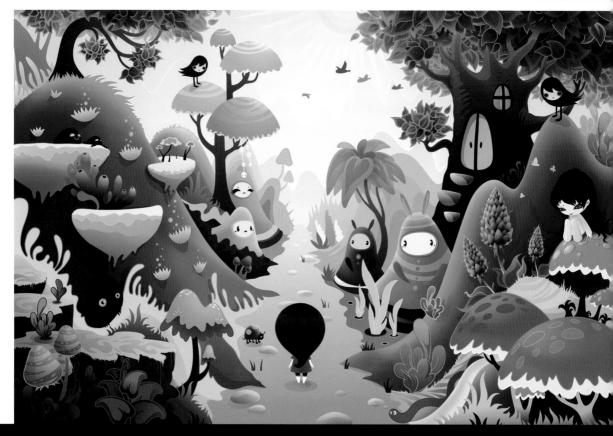

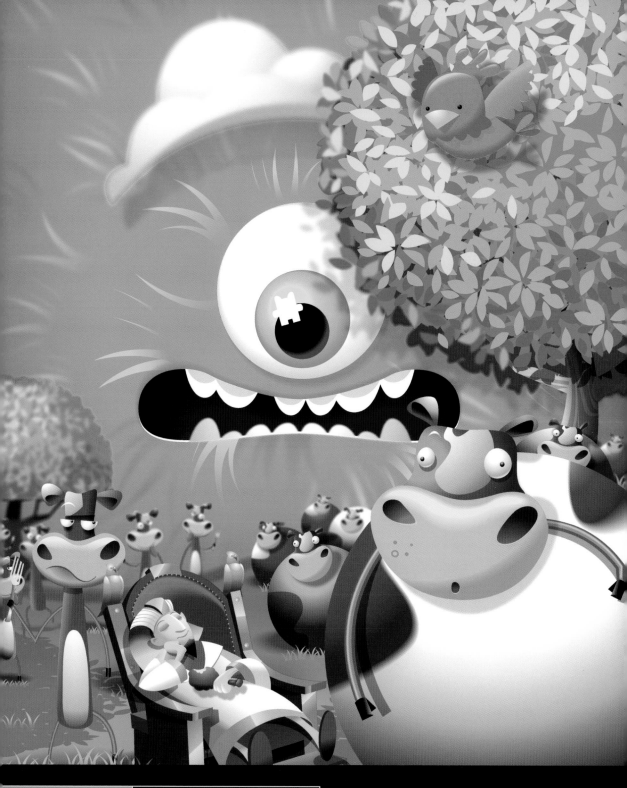

GOOD EARTH®

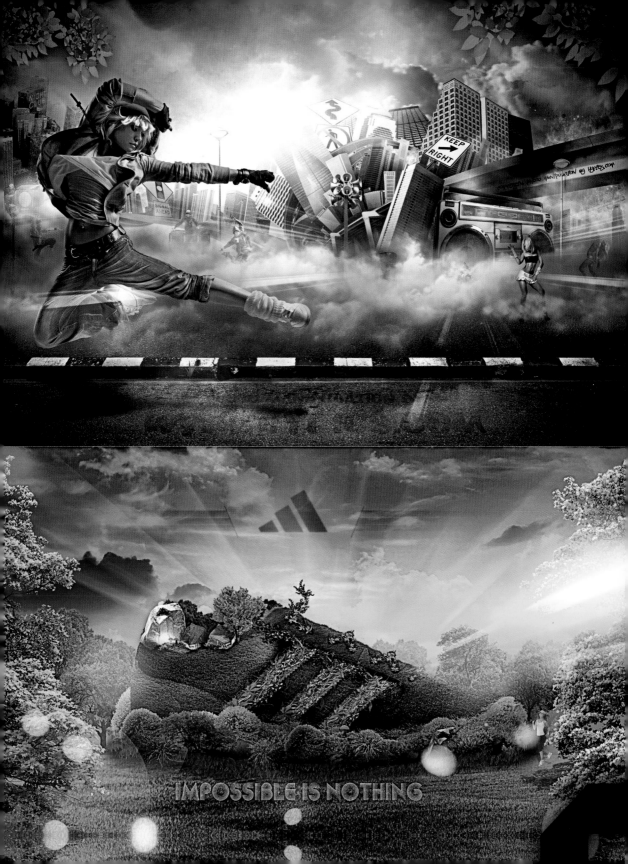

IMPOSSIBLE IS NOTHING

Carluccio's

BUONA PASQUA

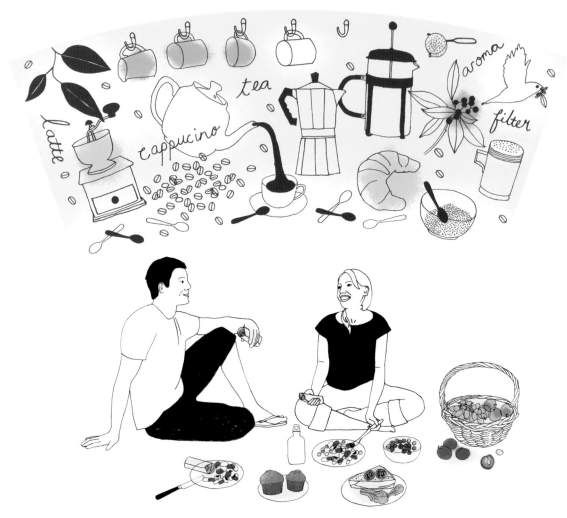

www.pariolicucina.com

PARIOLI
CUCINA
Gusto Fruttato
OLIO D'OLIVA
IDEALE PER INSALATE

GROWN IN ITALY

PRODOTTO D'ITALIA
PARIOLI

REAL ITALIAN FLAVOUR COMES FROM REAL ITALIAN INGREDIENTS
IMPORTED PARIOLI GROCERIES NOW AVAILABLE AT TESCO

A ROAMING NEW ENGLAND MYSTERY

GHOSTS FROM THE PAST

GLEN EBISCH

MENDOLA

Gwenola Carrere

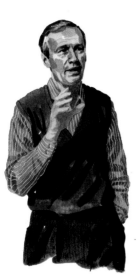

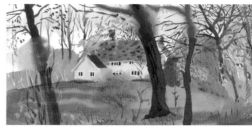

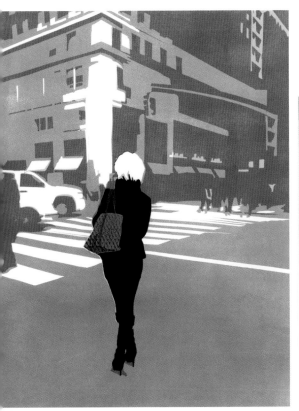
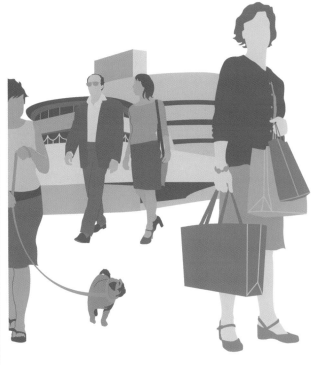
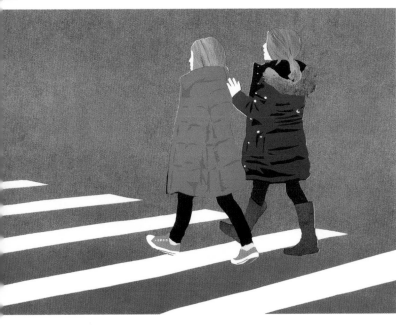

ELEVATOR OPERATOR -
MUSIC VIDEO FOR JIM BIANCO

CAROLINE ATTIA ANIMATION & ILLUSTRATION

THIOMUCASE - LA PLAYA TE ESPERA
INTERNET ANIMATION & ILLUSTRATIONS FOR HC-BNC

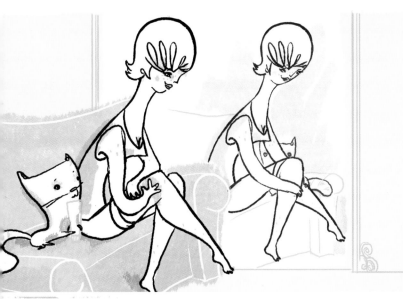

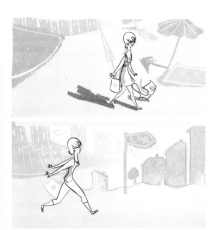

MAAD ADVOCATE - ILLUSTRATED ANIMATION

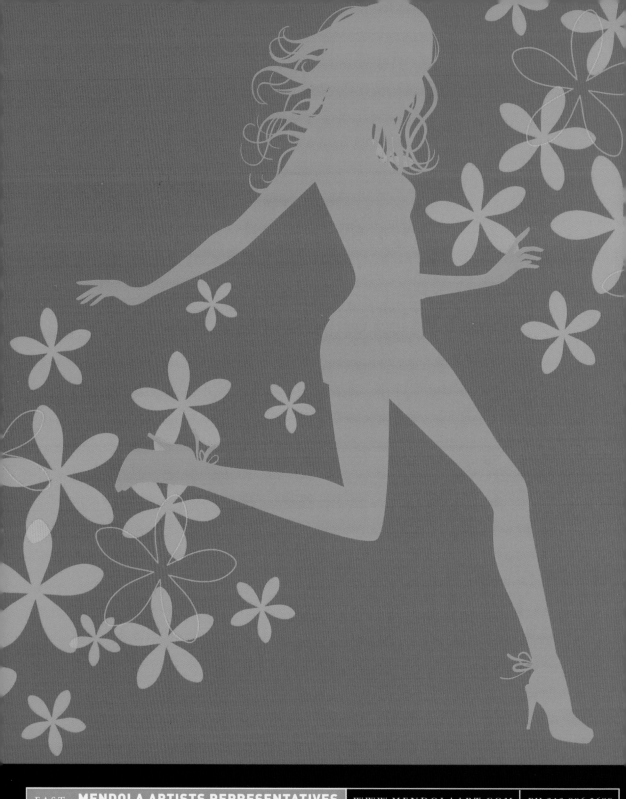

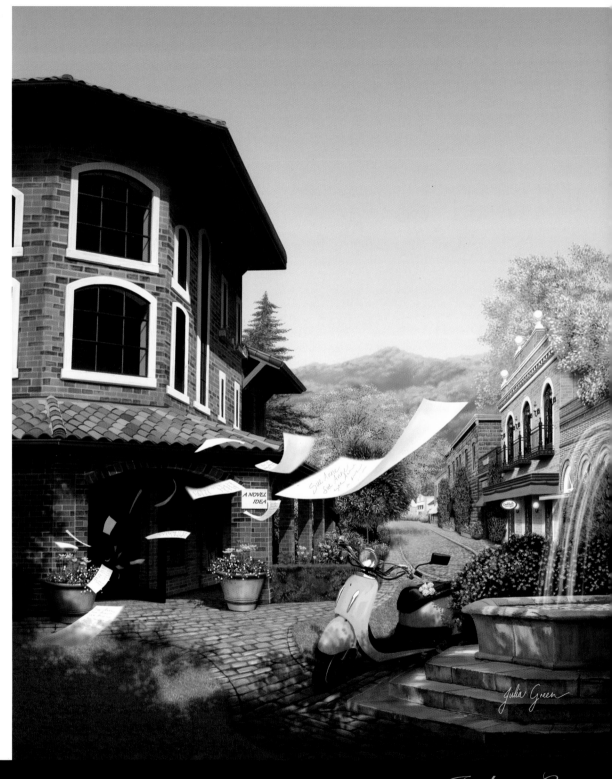

Julia Green

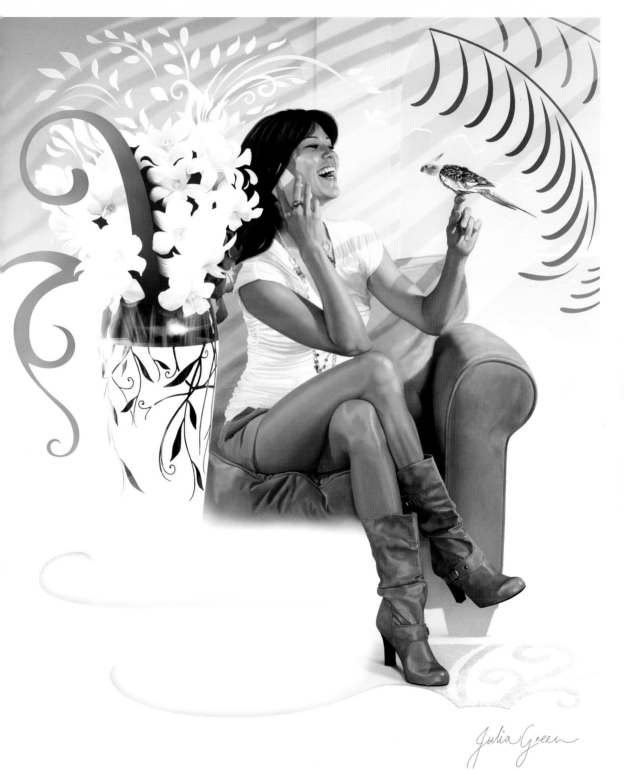

Julia Green

abc

WIPEOUT
IN THE ZONE

WACK Jeffwack.com
wackart@pacbell.net

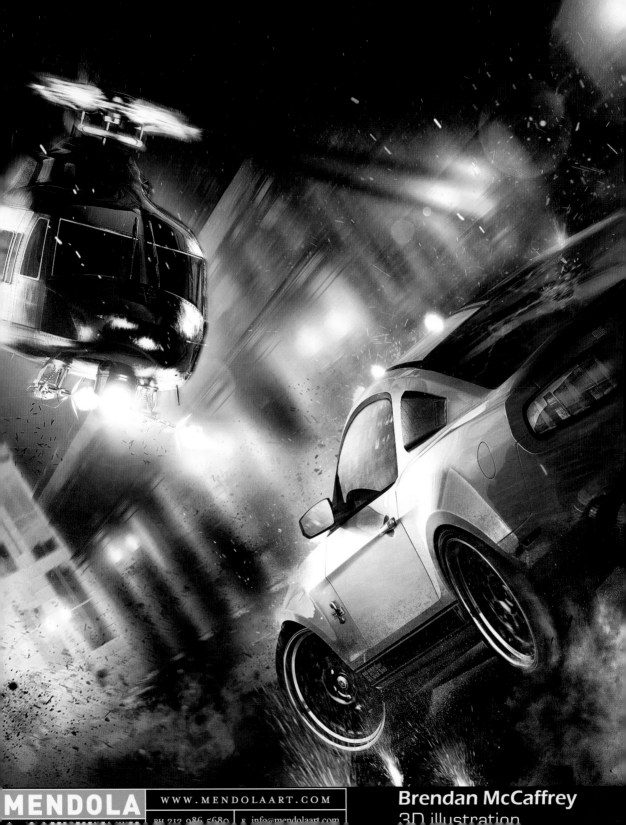

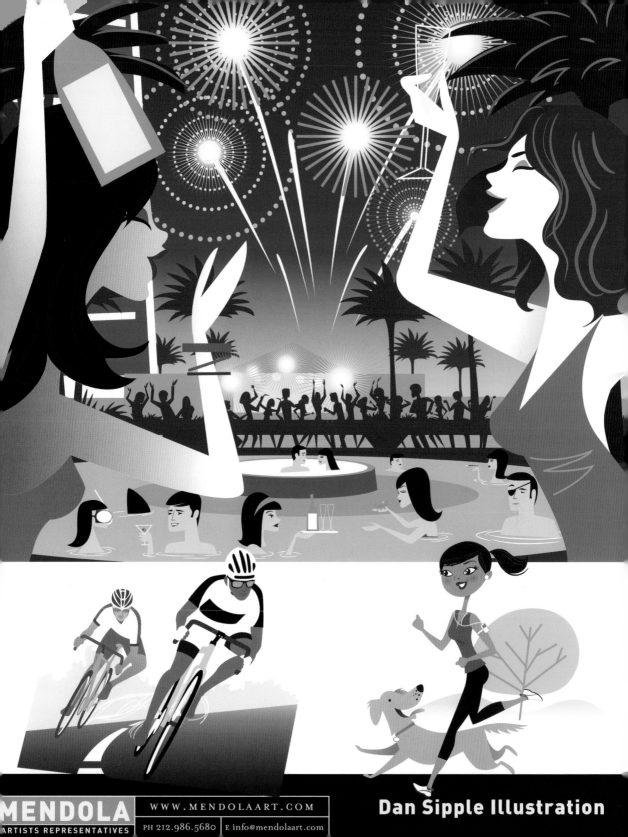

CARTOON ILLUSTRATION
CHARACTER DESIGN
CGI ILLUSTRATION
ANIMATION
www.billledger.com

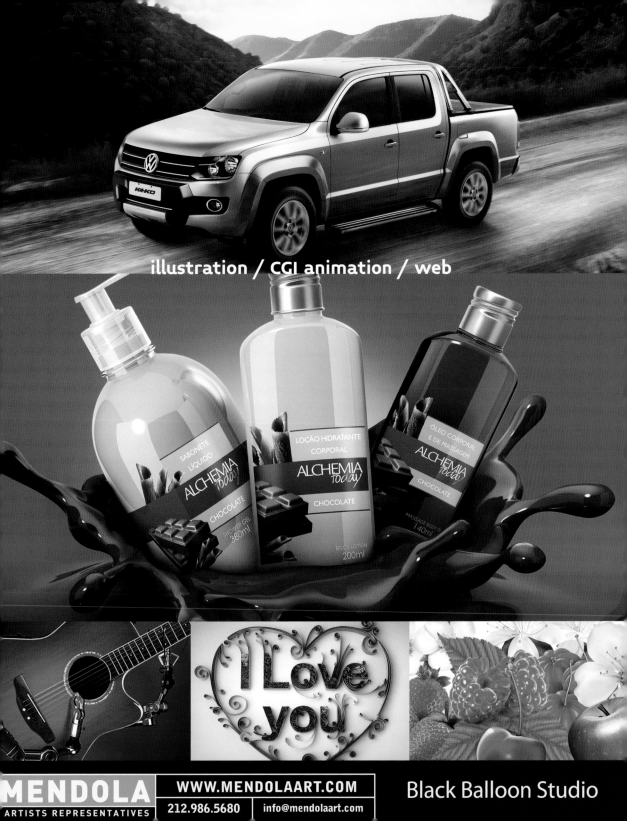

illustration / CGI animation / web

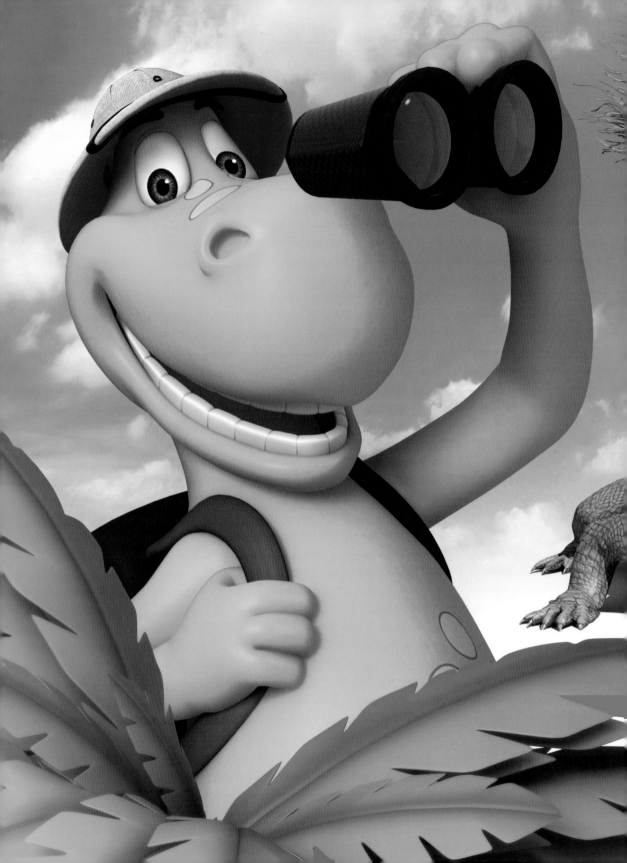

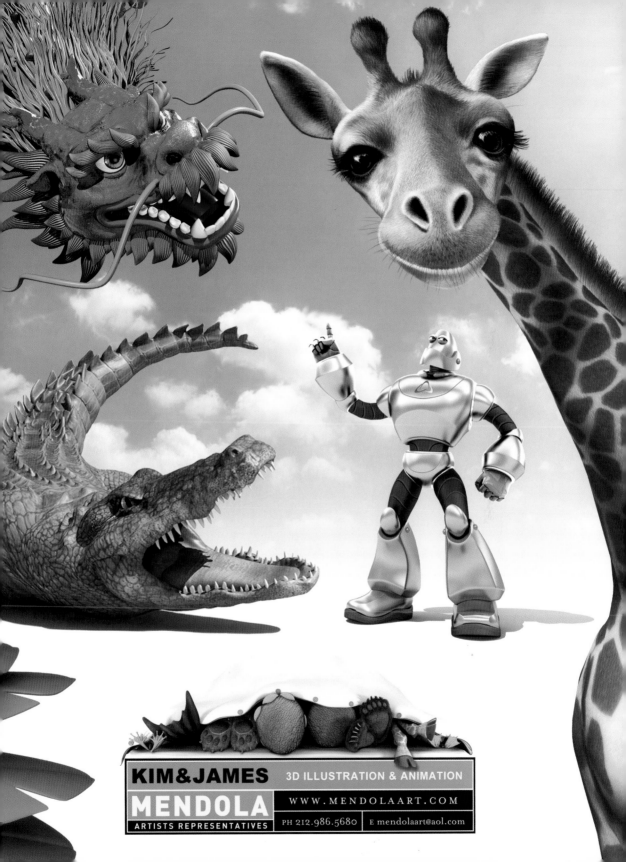

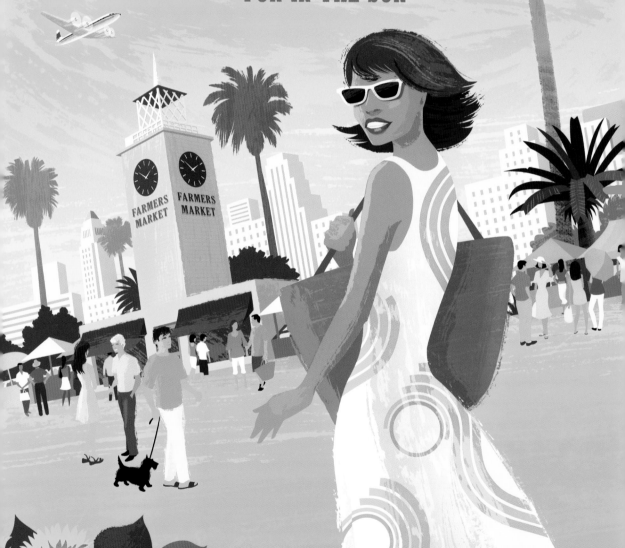

LOS ANGELES

FUN IN THE SUN

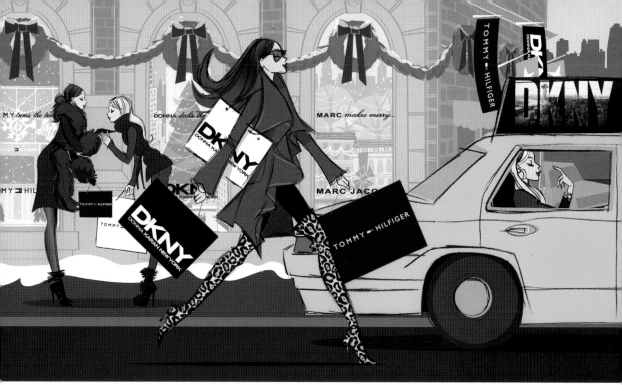

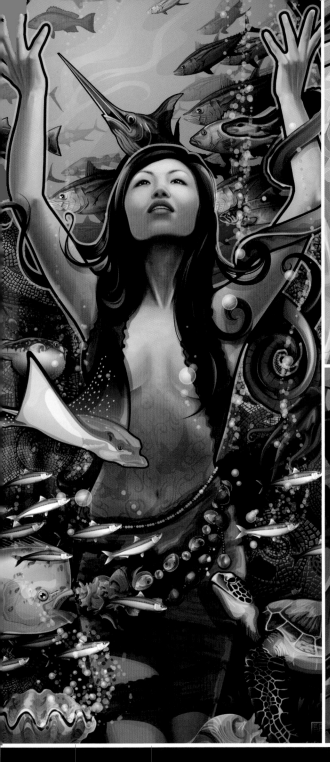

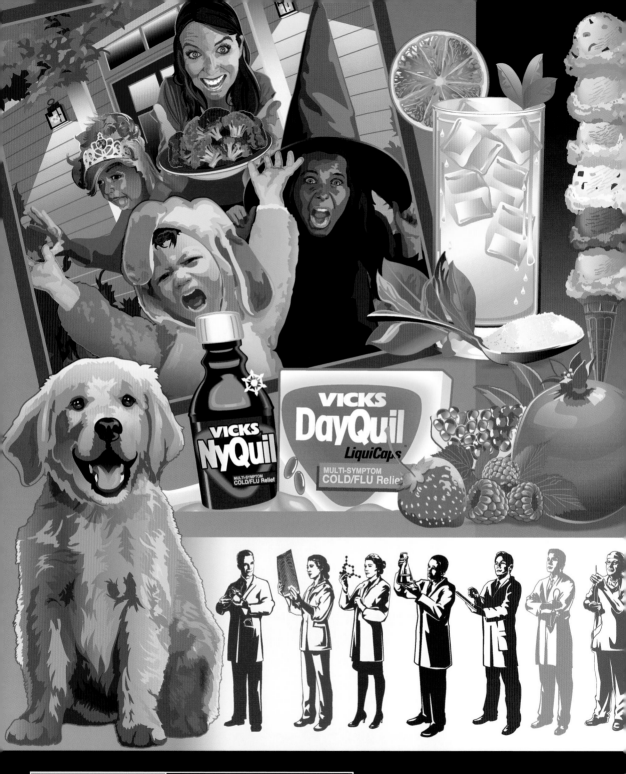

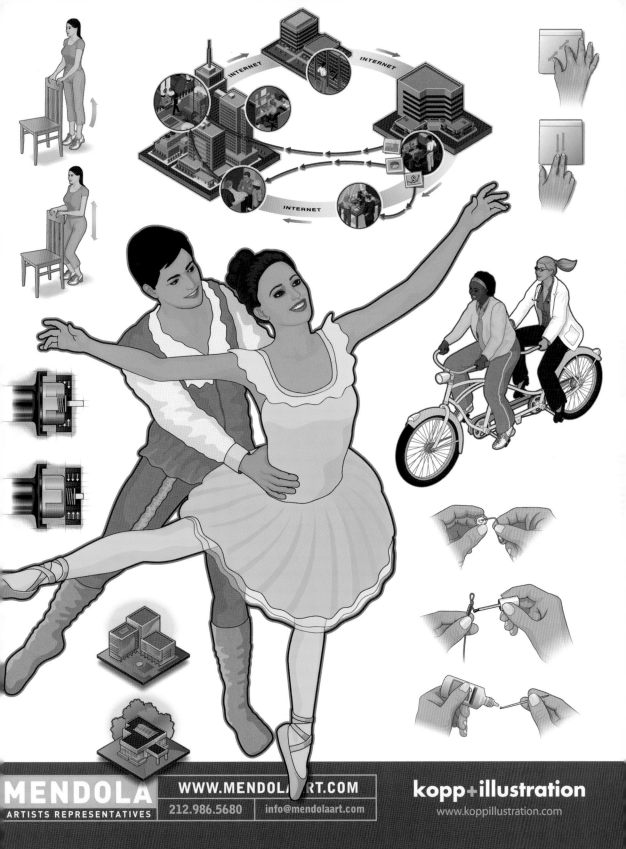

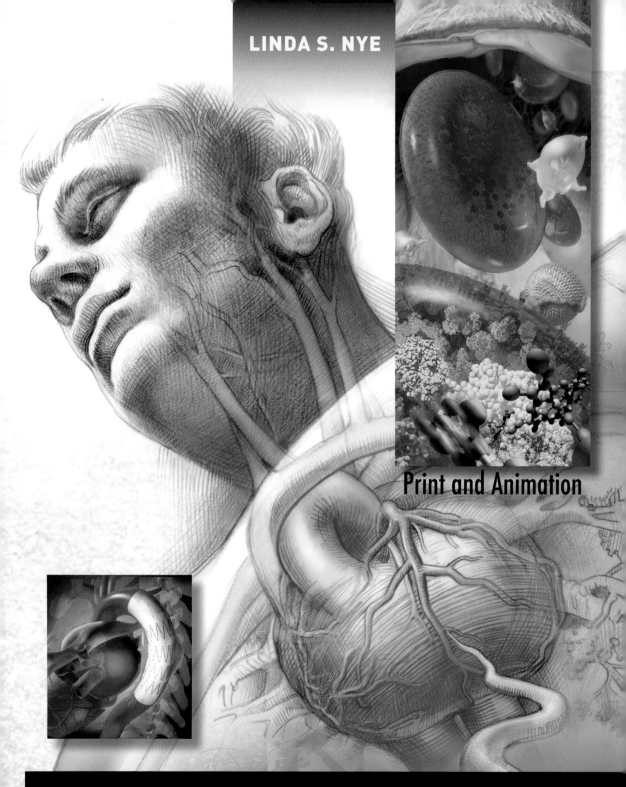

LINDA S. NYE

Print and Animation

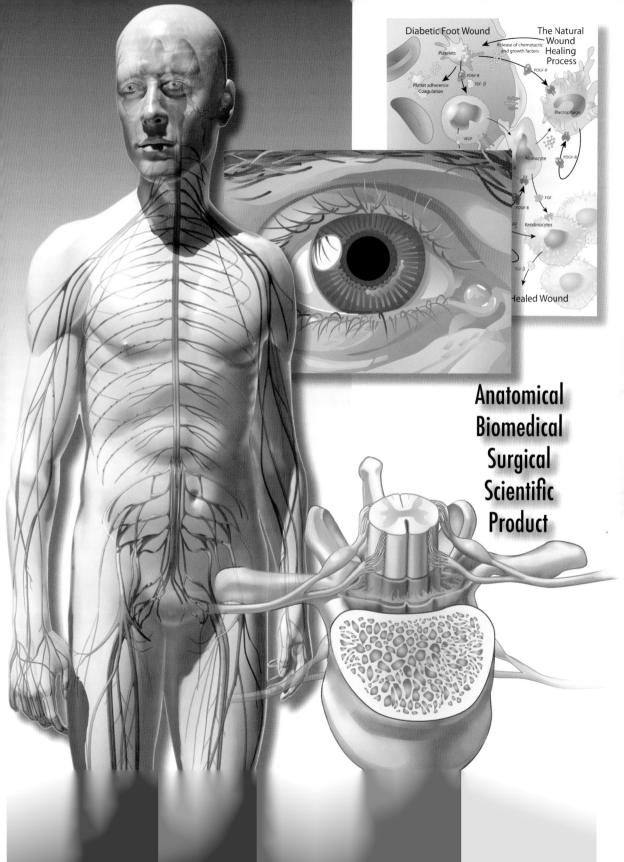

Diabetic Foot Wound

The Natural Wound Healing Process

Release of chemotactic and growth factors

Platelets

PDGF-B

TGF-β

Platlet adherence
Coagulation

PDGF-B

Macrophage

VEGF

Monocyte

PDGF-B

PDGF-B

FGF

Keratinocytes

TGF-β

Healed Wound

Anatomical
Biomedical
Surgical
Scientific
Product

IMPERIAL SERIES
SAMUEL ADAMS®

DOUBLE BOCK

9.3% ALC./VOL.

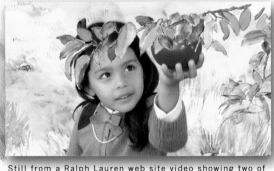

Still from a Ralph Lauren web site video showing two of
the approximatly 240 watercolors used

SAM WARD
samwardart.com

MIRACLE STUDIOS

WEBISODES • MANGA • ONLINE GAMES • COMIC BOOKS • CHARACTER DESIGN • CONCEPT ART
www.miraclestudios.com

JALAPEÑO

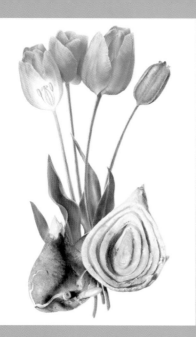

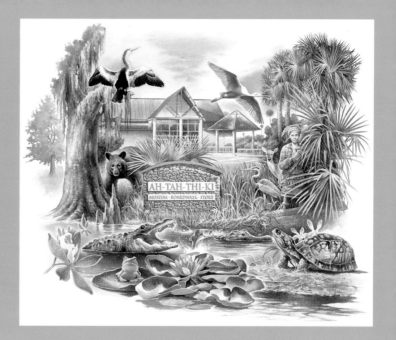

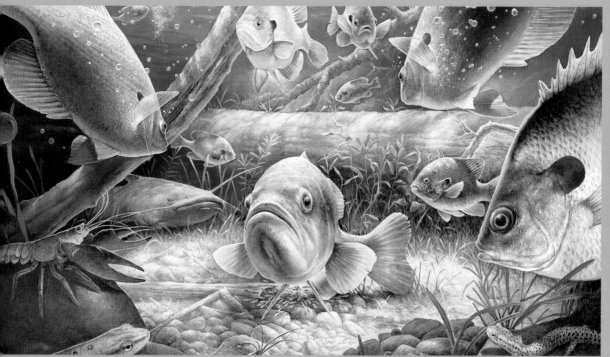

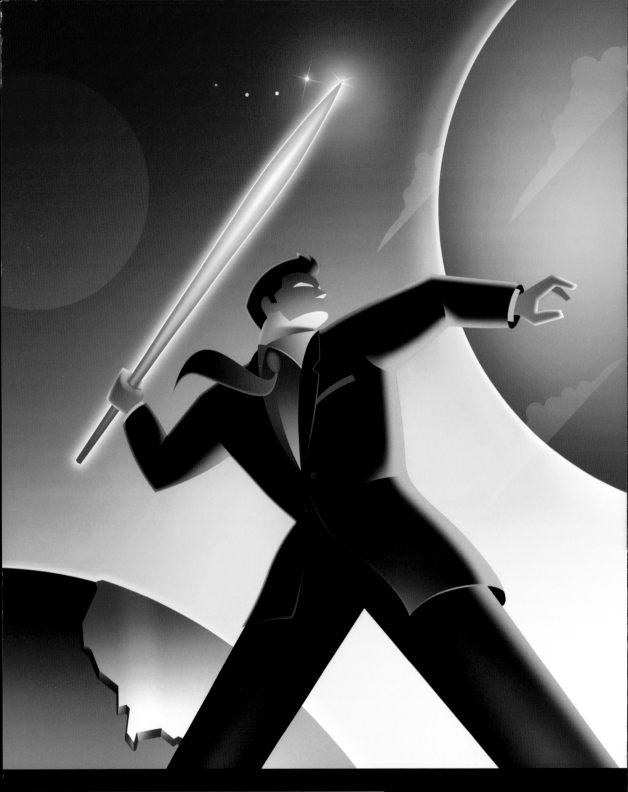

picturegrill.com

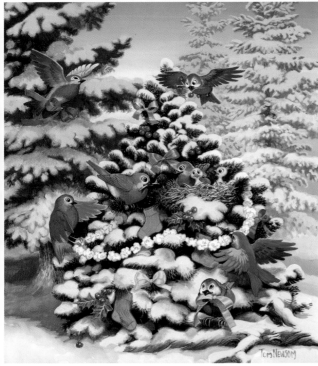

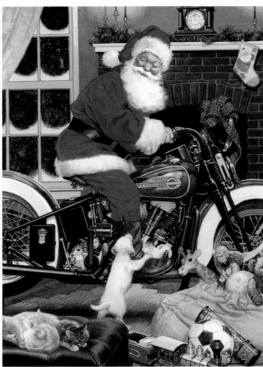

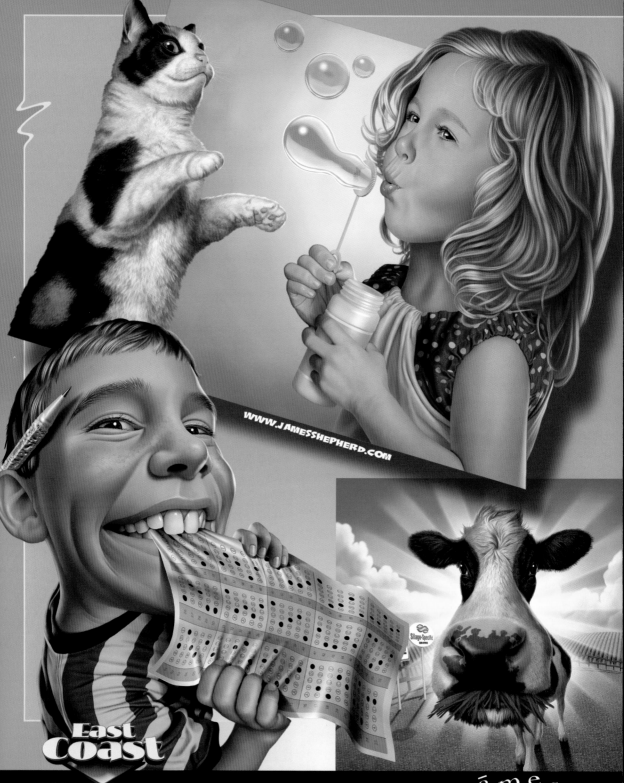

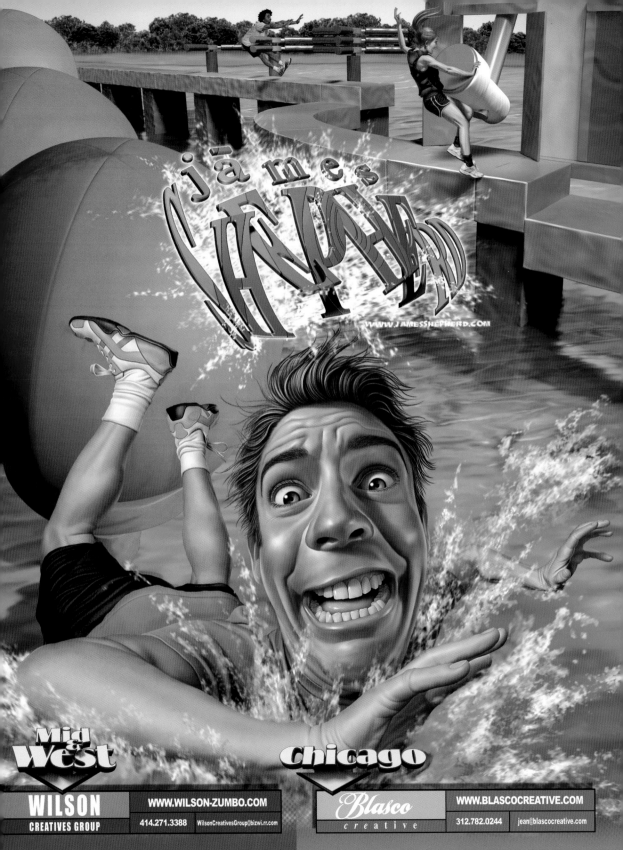

CARLA BAUER WOODCUTS CARLABAUER@EARTHLINK.NET 212 807 830

PATRICK STEFANSKI
3D Design & Illustration

hello@patrickstefanski.com
(201)855-6022

see entire portfolio at **garypierazzi.com**

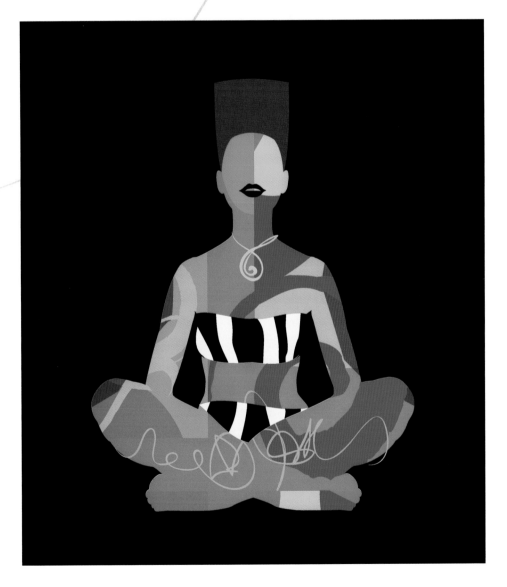

see entire portfolio at **garypierazzi.com**

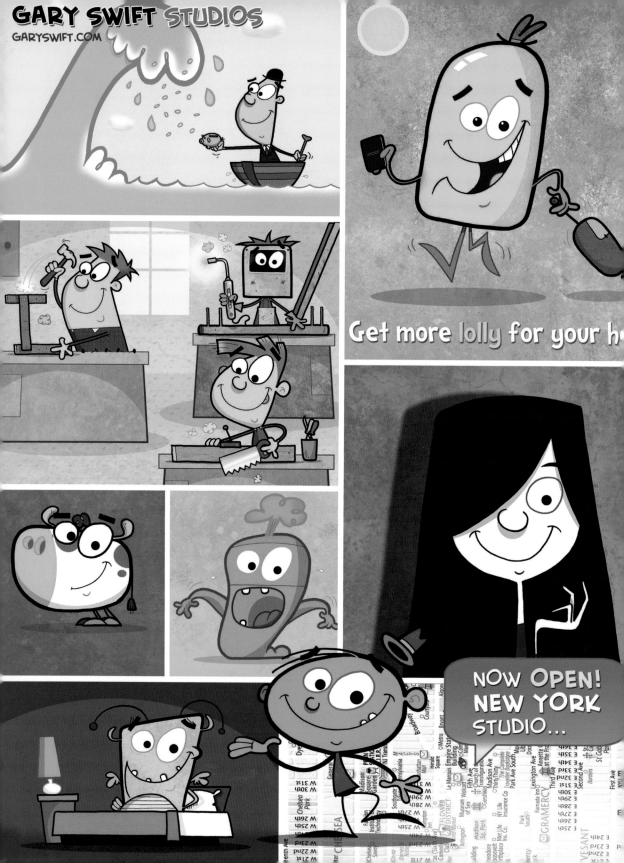

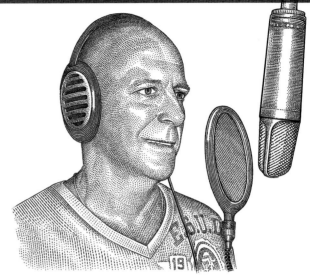

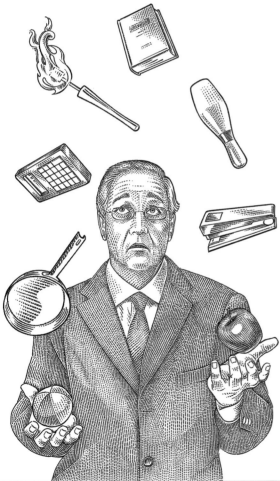

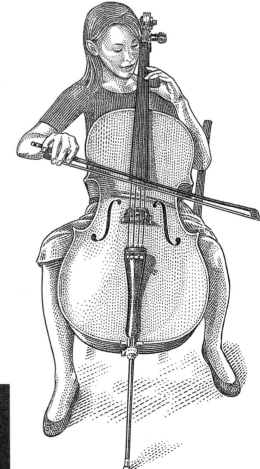

WWW.SPROULS.COM
KEVIN@SPROULS.COM
PH. 609.965.4795

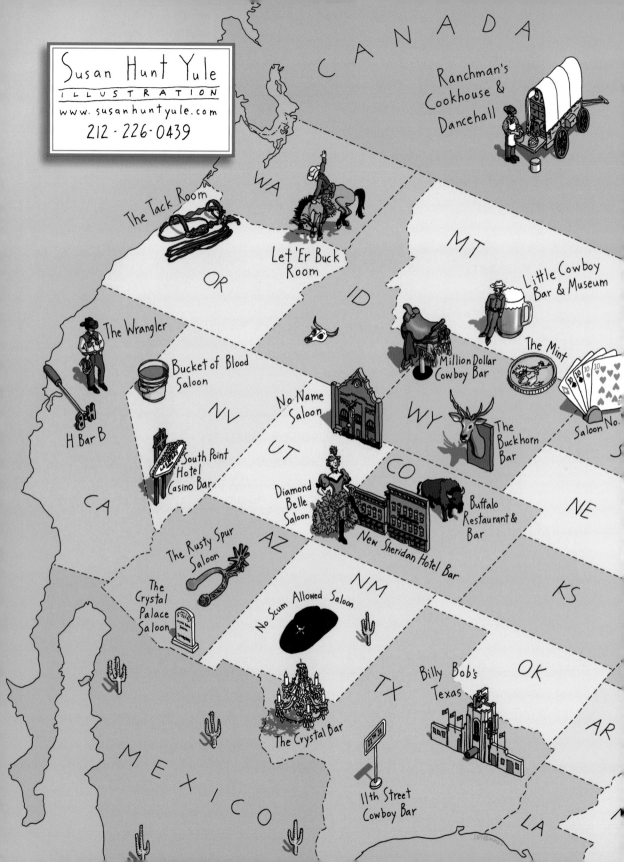

tricia crambleT

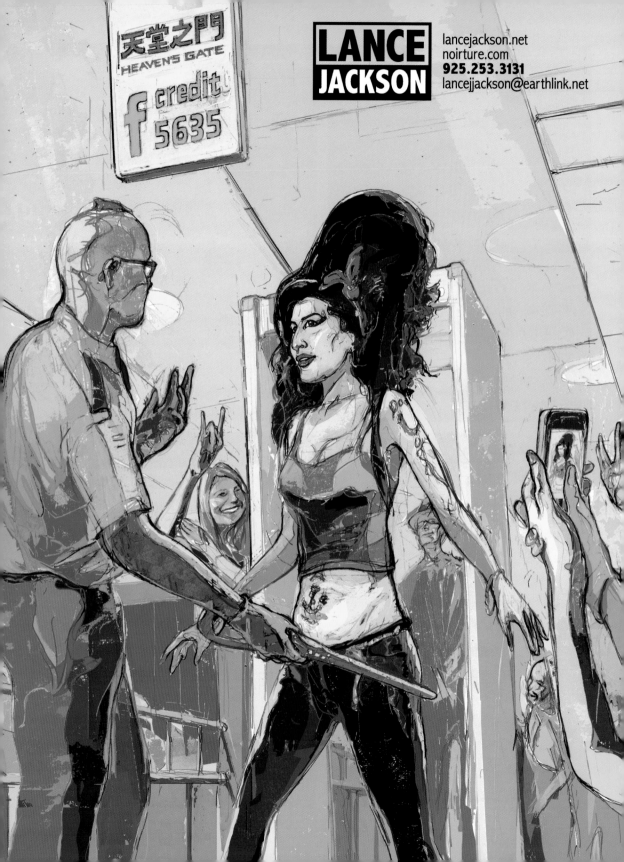

joe saputo technical illustration joesaputo.com (541)746-9886

RICHARD
SOLOMON™
ARTISTS REPRESENTATIVE

James Bennett
Scott Brundage
CF Payne
Jason Seiler

Kent Barton
Chris Gall
David Johnson
Bill Sanderson
Douglas Smith
Mark Summers

Tim Bower
Eric Drooker
Murray Kimber

Niklas Asker
Dongyun Lee
Goñi Montes
Andrew R. Wright

Paul Cox
Yan Nascimbene

Sterling Hundley
Gary Kelley
Edward Kinsella III
Octavia Monaco

Raoul & Davide
Rudy Gutierrez
Mark T. Smith

John Hersey
John Mattos
Guy Stauber
Chris Whetzel
Ted Wright

John Collier
Thomas Ehretsmann
Jon Foster
Tyler Jacobson
Gregory Manchess
Chase Stone

www.richardsolomon.com
richard@richardsolomon.com

212 223 9545 · 917 841 1333
110 E 30th St, Ste. 501
New York, NY 10016

Photography by Robert Gendler

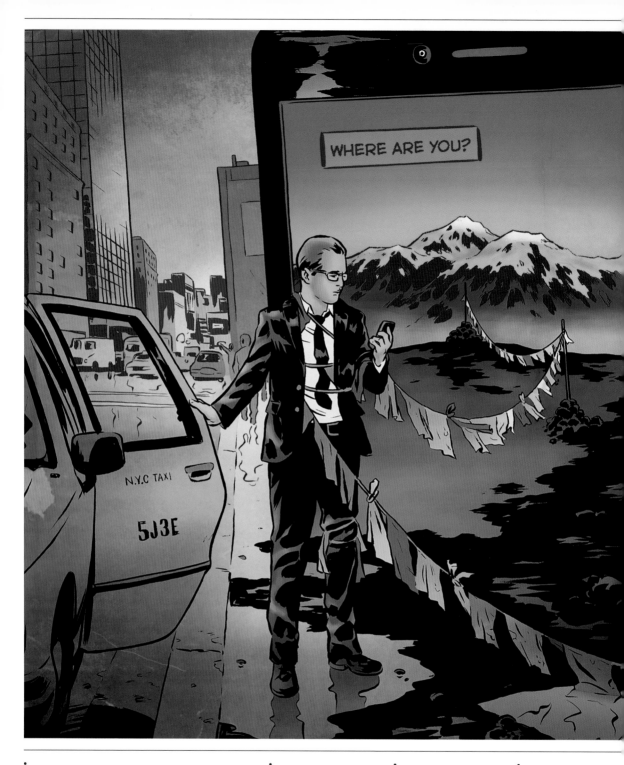

NIKLAS
ASKER

RICHARD
SOLOMON™
ARTISTS REPRESENTATIVE

www.richardsolomon.com
richard@richardsolomon.com

212 223 9545 · 917 841 133
110 E 30th St, Ste. 501
New York, NY 10016

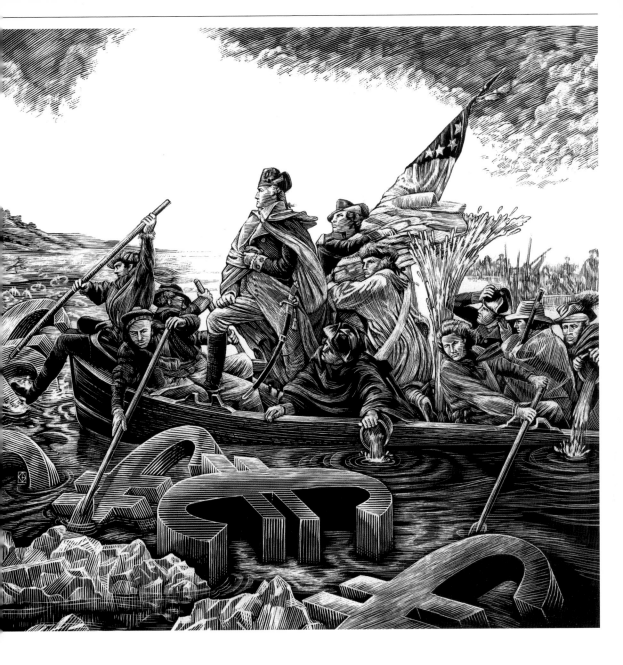

KENT
BARTON

 RICHARD
SOLOMON™
ARTISTS REPRESENTATIVE

www.richardsolomon.com
richard@richardsolomon.com

212 223 9545 · 917 841 1333
110 E 30th St, Ste. 501
New York, NY 10016

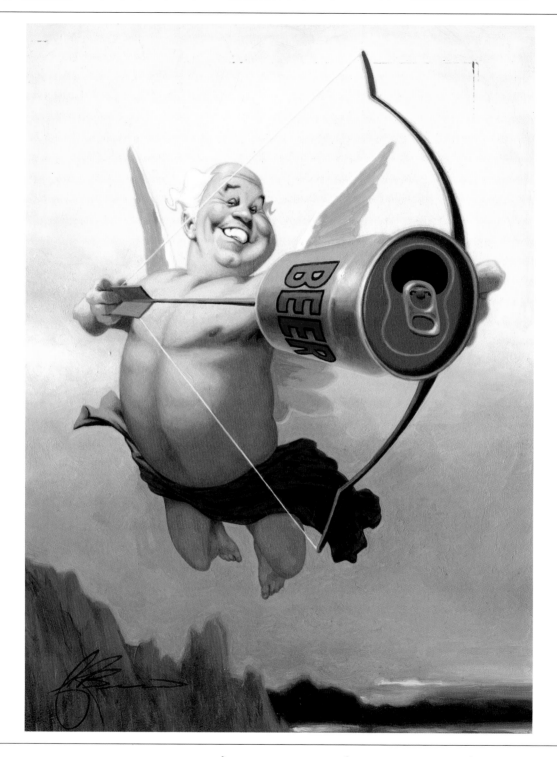

JAMES
BENNETT

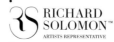
RICHARD
SOLOMON™
ARTISTS REPRESENTATIVE

www.richardsolomon.com
richard@richardsolomon.com

212 223 9545 · 917 841 133
110 E 30th St, Ste. 501
New York, NY 10016

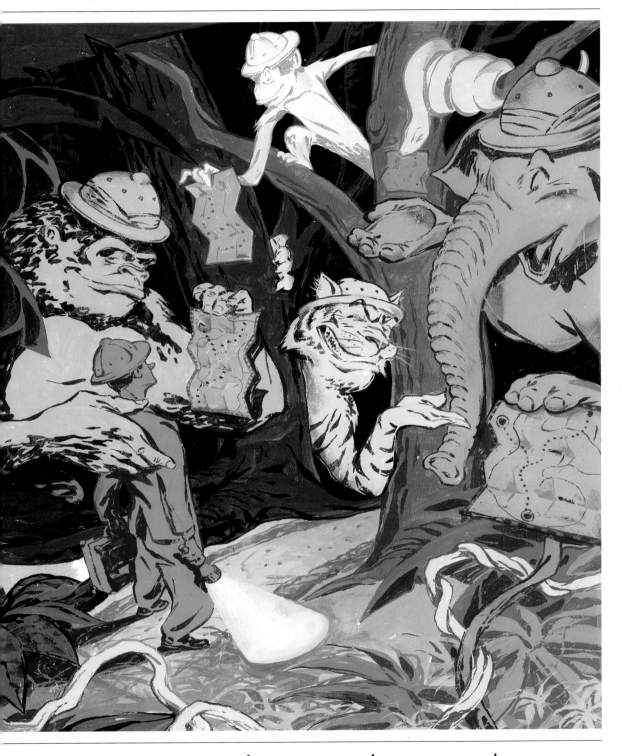

RICHARD
SOLOMON™
ARTISTS REPRESENTATIVE

www.richardsolomon.com
richard@richardsolomon.com

212 223 9545 · 917 841 1333
110 E 30th St, Ste. 501
New York, NY 10016

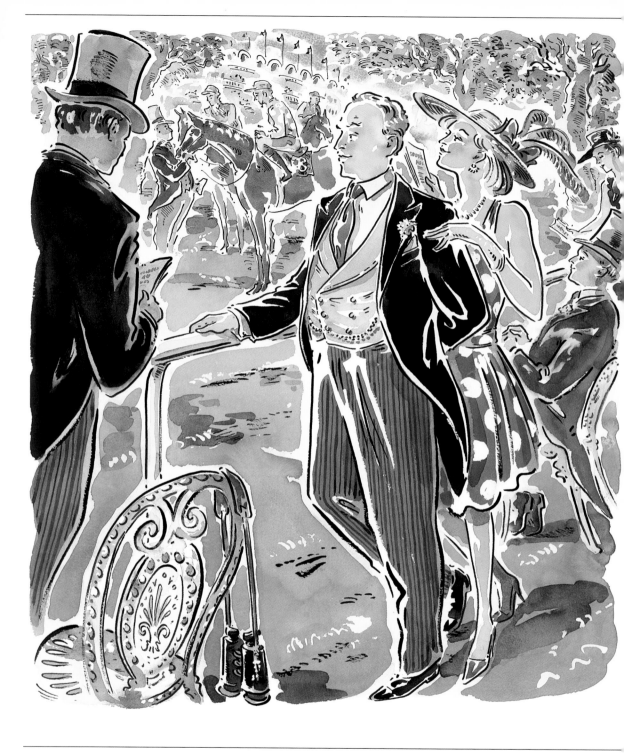

196

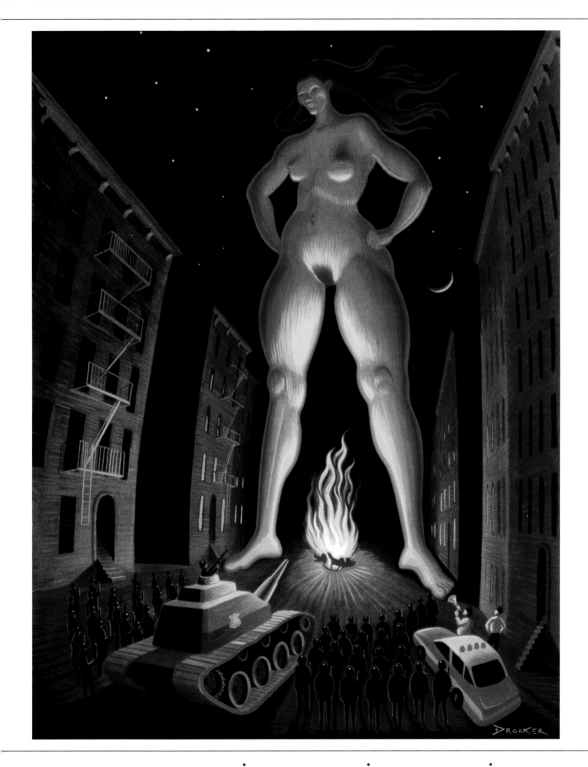

ERIC
DROOKER

RICHARD
SOLOMON™
ARTISTS REPRESENTATIVE

www.richardsolomon.com
richard@richardsolomon.com

212 223 9545 · 917 841 1333
110 E 30th St, Ste. 501
New York, NY 10016

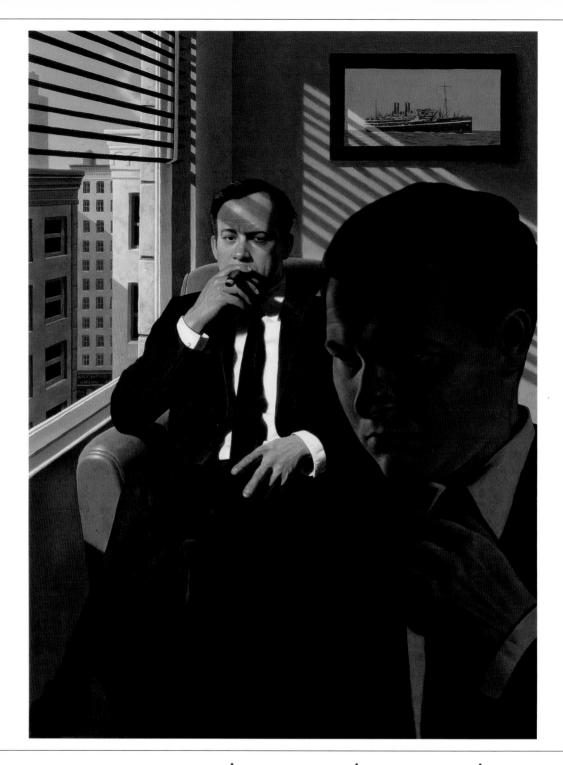

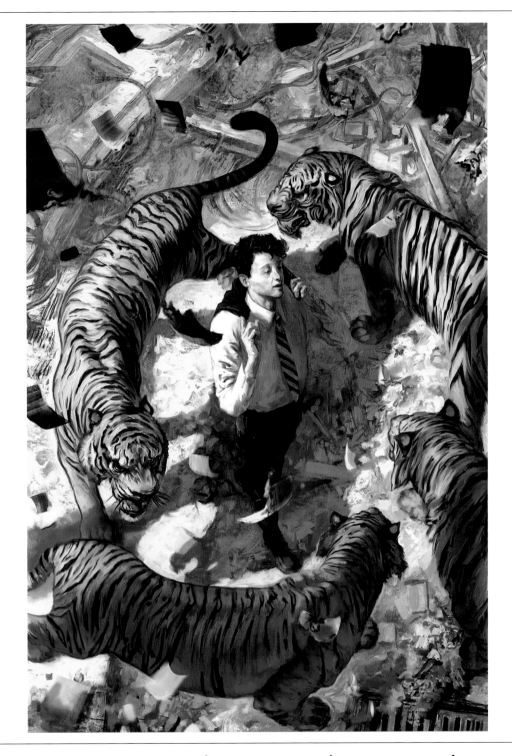

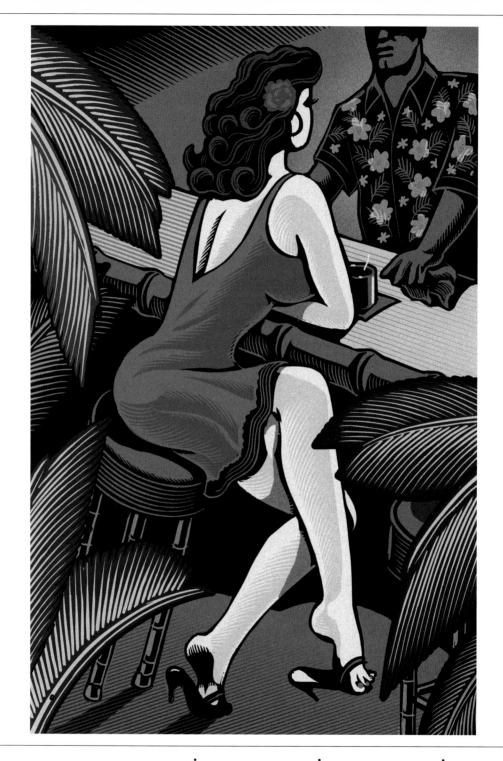

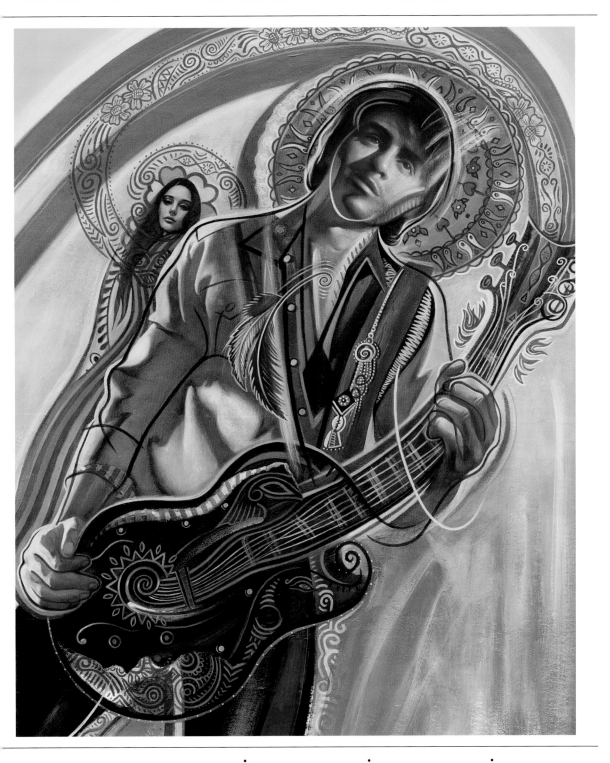

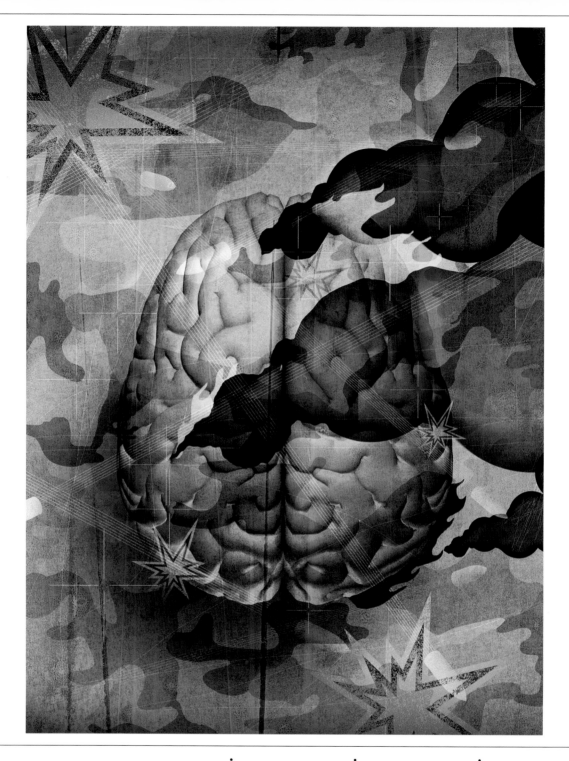

**JOHN
HERSEY**

 RICHARD
SOLOMON™
ARTISTS REPRESENTATIVE

www.richardsolomon.com
richard@richardsolomon.com

212 223 9545 · 917 841 13"
110 E 30th St, Ste. 501
New York, NY 10016

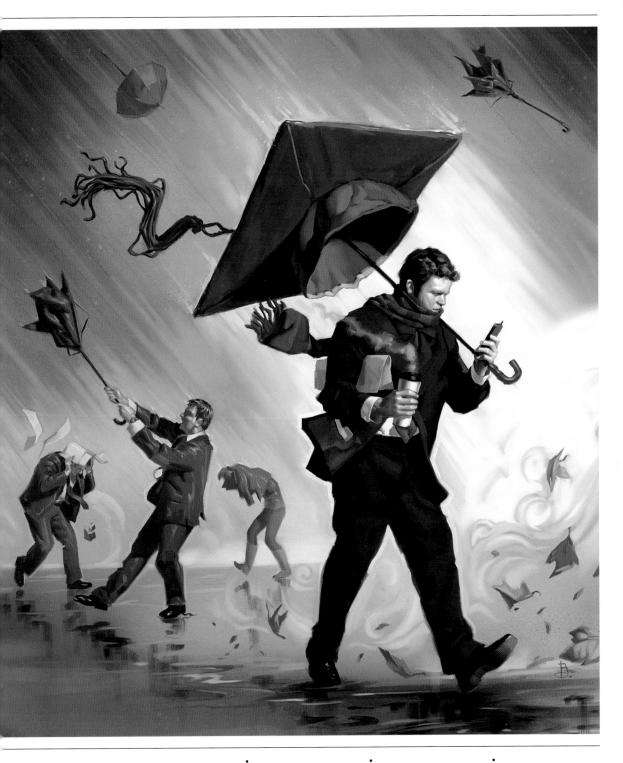

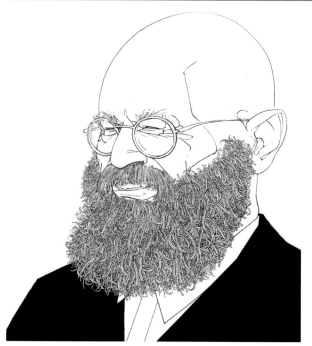
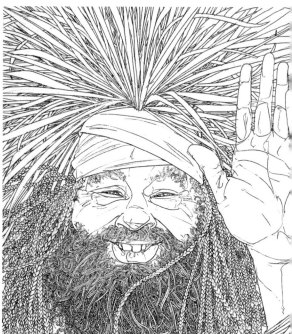
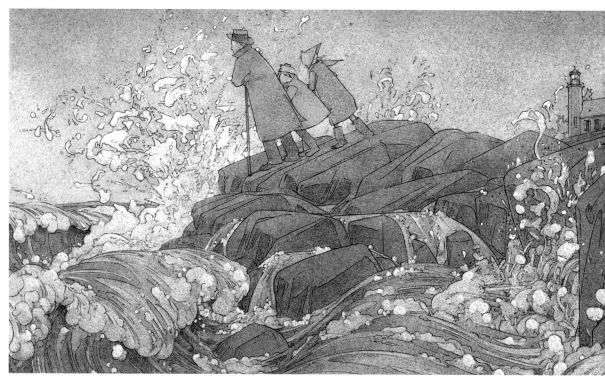

**DAVID
JOHNSON**

**RICHARD
SOLOMON**™
ARTISTS REPRESENTATIVE

www.richardsolomon.com
richard@richardsolomon.com

212 223 9545 · 917 841 133
110 E 30th St, Ste. 501
New York, NY 10016

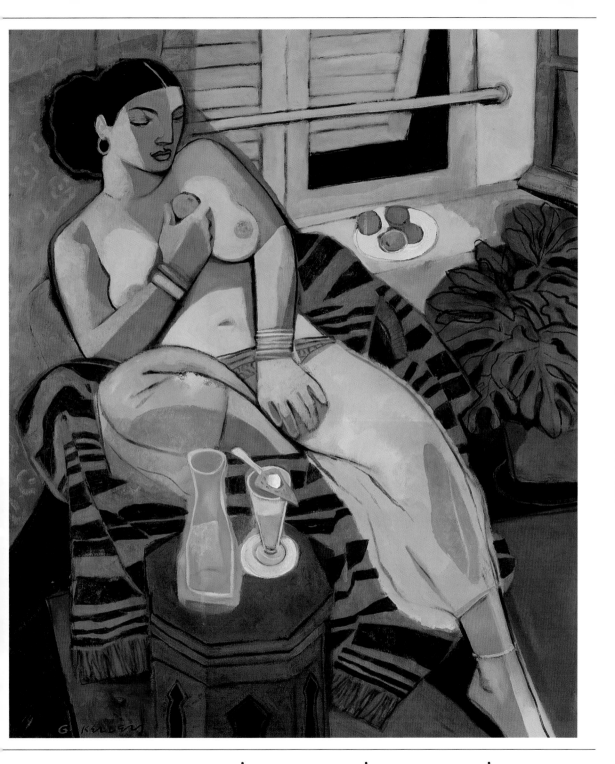

RICHARD
SOLOMON™
ARTISTS REPRESENTATIVE

www.richardsolomon.com
richard@richardsolomon.com

212 223 9545 · 917 841 1333
110 E 30th St, Ste. 501
New York, NY 10016

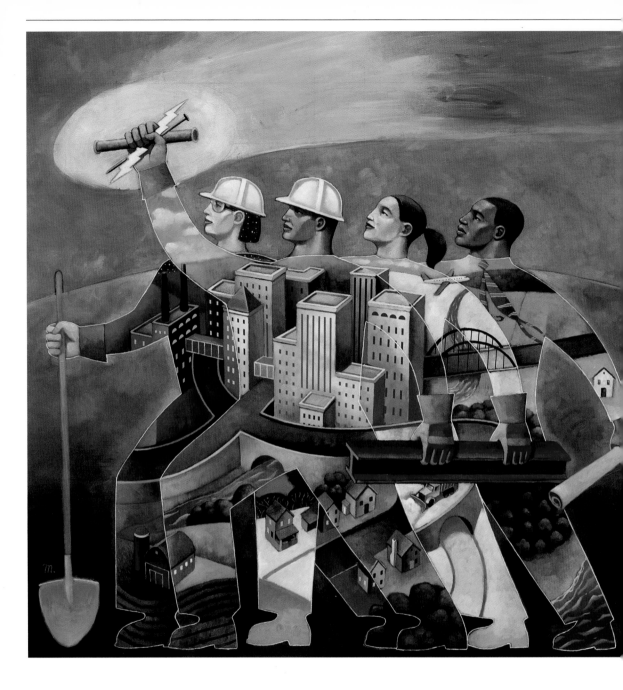

**MURRAY
KIMBER**

 RICHARD
SOLOMON™
ARTISTS REPRESENTATIVE

www.richardsolomon.com
richard@richardsolomon.com

212 223 9545 · 917 841 13
110 E 30th St, Ste. 501
New York, NY 10016

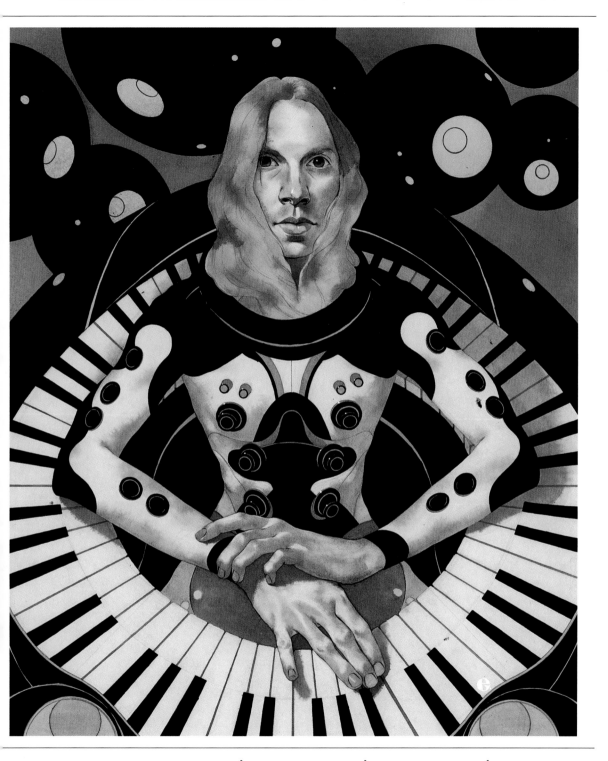

HOWARD
KINSELLA III

RICHARD SOLOMON™
ARTISTS REPRESENTATIVE

www.richardsolomon.com
richard@richardsolomon.com

212 223 9545 · 917 841 1333
110 E 30th St, Ste. 501
New York, NY 10016

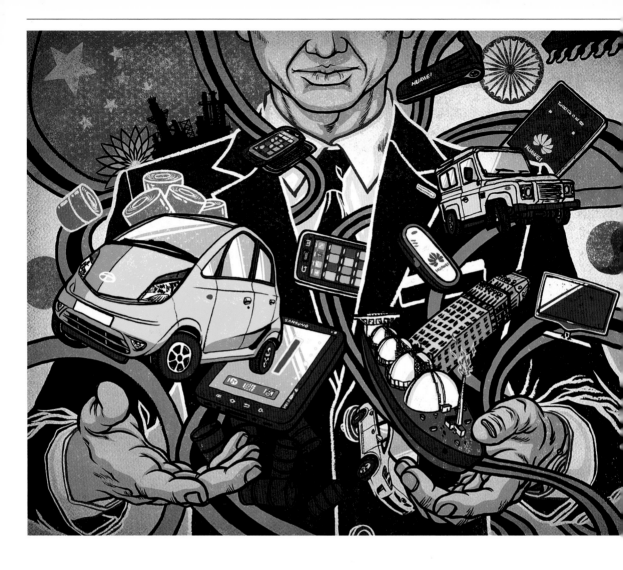

**DONGYUN
LEE**

RICHARD
SOLOMON™
ARTISTS REPRESENTATIVE

www.richardsolomon.com
richard@richardsolomon.com

212 223 9545 · 917 841 13
110 E 30th St, Ste. 501
New York, NY 10016

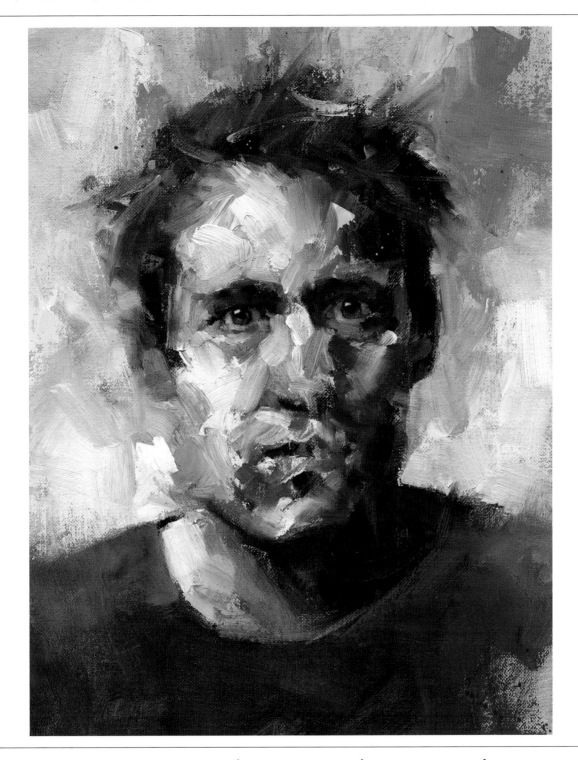

REGORY
ANCHESS

RICHARD
SOLOMON™
ARTISTS REPRESENTATIVE

www.richardsolomon.com
richard@richardsolomon.com

212 223 9545 · 917 841 1333
110 E 30th St, Ste. 501
New York, NY 10016

209

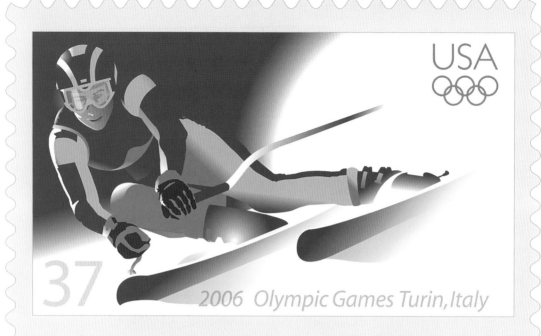

USA

37 2006 Olympic Games Turin, Italy

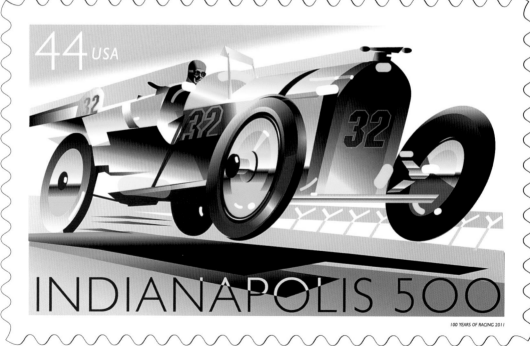

44 USA

INDIANAPOLIS 500

100 YEARS OF RACING 2011

JOHN
MATTOS

 RICHARD
SOLOMON™
ARTISTS REPRESENTATIVE

www.richardsolomon.com
richard@richardsolomon.com

212 223 9545 · 917 841 13
110 E 30th St, Ste. 501
New York, NY 10016

210

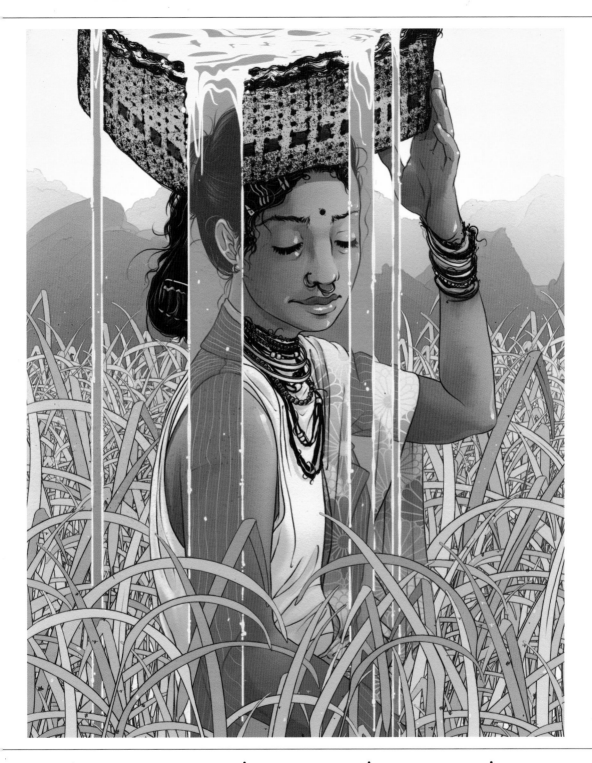

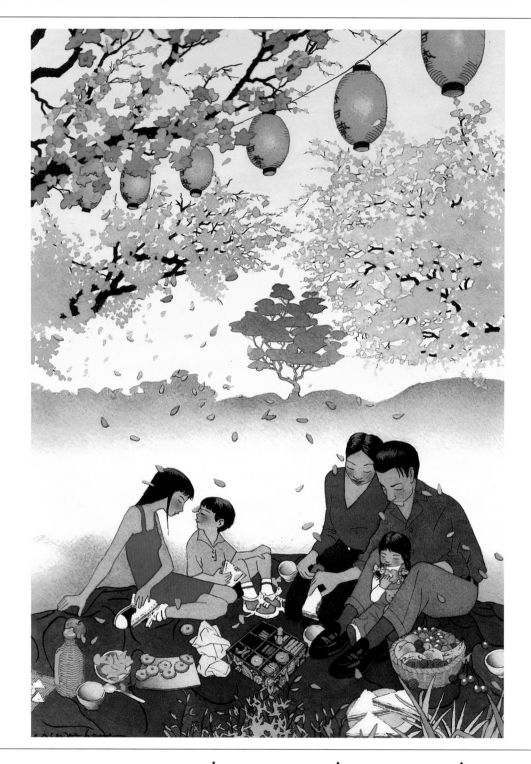

YAN
NASCIMBENE

RICHARD SOLOMON™
ARTISTS REPRESENTATIVE

www.richardsolomon.com
richard@richardsolomon.com

212 223 9545 · 917 841 133
110 E 30th St, Ste. 501
New York, NY 10016

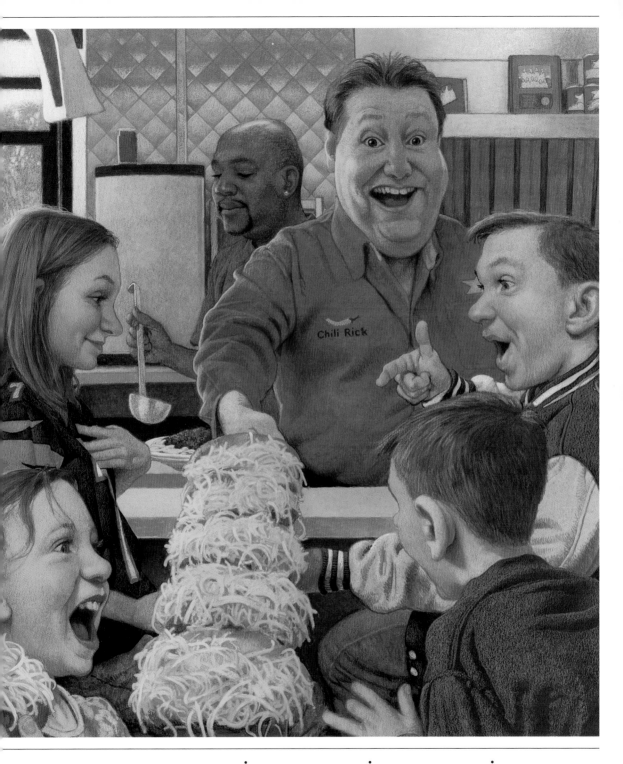

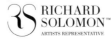

RICHARD
SOLOMON™
ARTISTS REPRESENTATIVE

www.richardsolomon.com
richard@richardsolomon.com

212 223 9545 · 917 841 1333
110 E 30th St, Ste. 501
New York, NY 10016

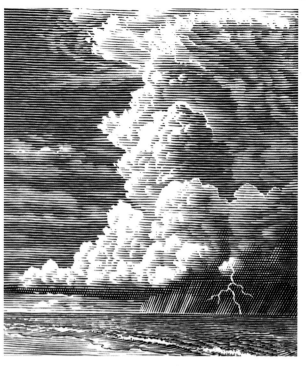
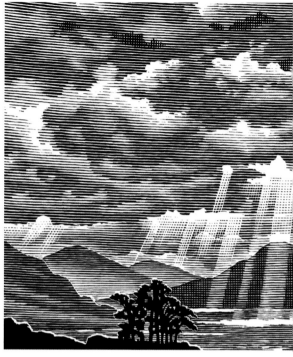

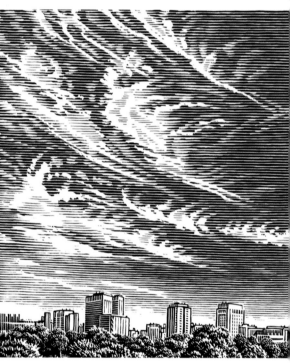

BILL
SANDERSON

RICHARD
SOLOMON™
ARTISTS REPRESENTATIVE

www.richardsolomon.com
richard@richardsolomon.com

212 223 9545 · 917 841 133
110 E 30th St, Ste. 501
New York, NY 10016

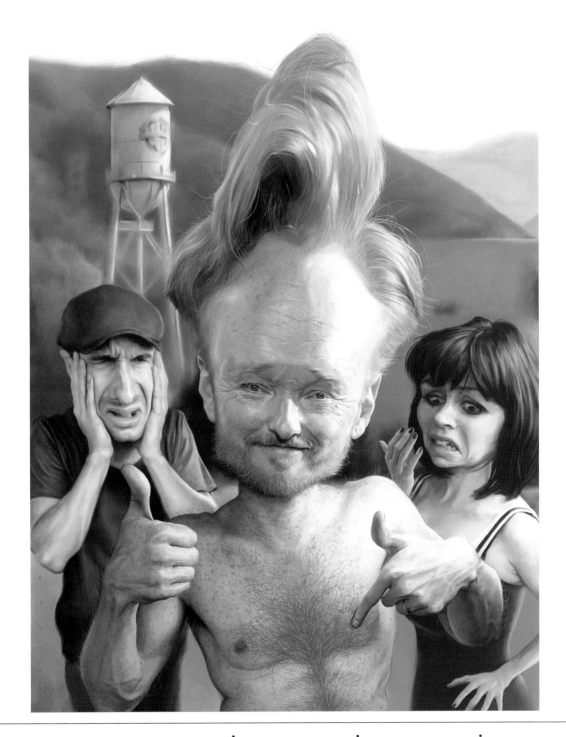

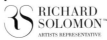 RICHARD
SOLOMON™
ARTISTS REPRESENTATIVE

www.richardsolomon.com
richard@richardsolomon.com

212 223 9545 · 917 841 1333
110 E 30th St, Ste. 501
New York, NY 10016

DOUGLAS SMITH

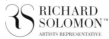 RICHARD SOLOMON™
ARTISTS REPRESENTATIVE

www.richardsolomon.com
richard@richardsolomon.com

212 223 9545 · 917 841 13
110 E 30th St, Ste. 501
New York, NY 10016

BEIJING, CHINA · 2008

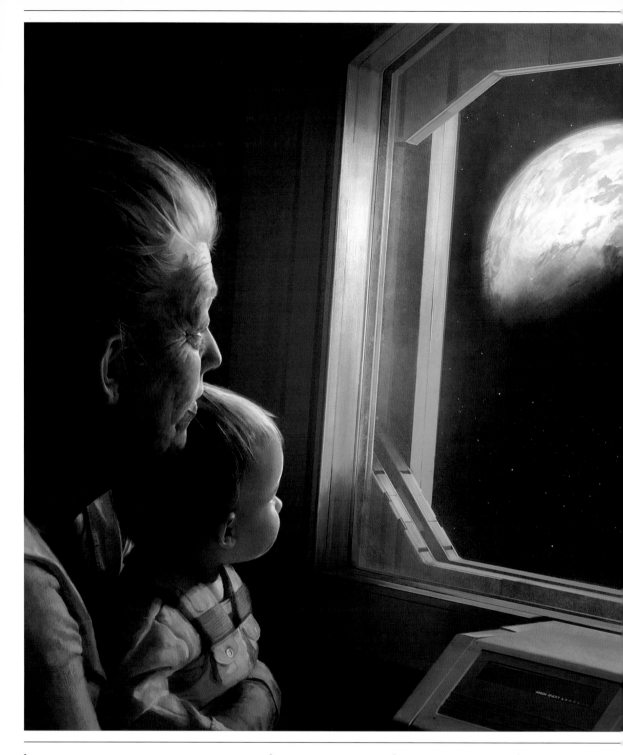

CHASE
STONE

 RICHARD
SOLOMON™
ARTISTS REPRESENTATIVE

www.richardsolomon.com
richard@richardsolomon.com

212 223 9545 · 917 841 133
110 E 30th St, Ste. 501
New York, NY 10016

RICHARD
SOLOMON™
ARTISTS REPRESENTATIVE

www.richardsolomon.com
richard@richardsolomon.com

212 223 9545 · 917 841 1333
110 E 30th St, Ste. 501
New York, NY 10016

CHRIS WHETZEL

 RICHARD SOLOMON™
ARTISTS REPRESENTATIVE

www.richardsolomon.com
richard@richardsolomon.com

212 223 9545 · 917 841 13
110 E 30th St, Ste. 501
New York, NY 10016

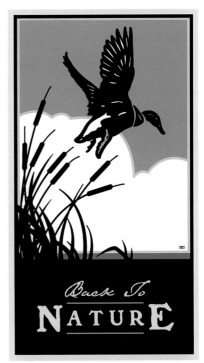

Back To
NATURE

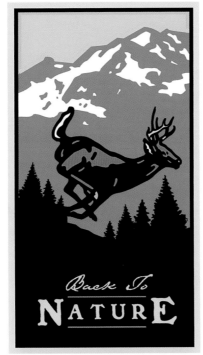

Back To
NATURE

Back To
NATURE

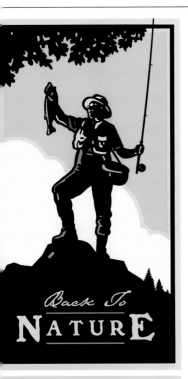

Back To
NATURE

Back To
NATURE

Back To
NATURE

RICHARD
SOLOMON™
ARTISTS REPRESENTATIVE

www.richardsolomon.com
richard@richardsolomon.com

212 223 9545 · 917 841 1333
110 E 30th St, Ste. 501
New York, NY 10016

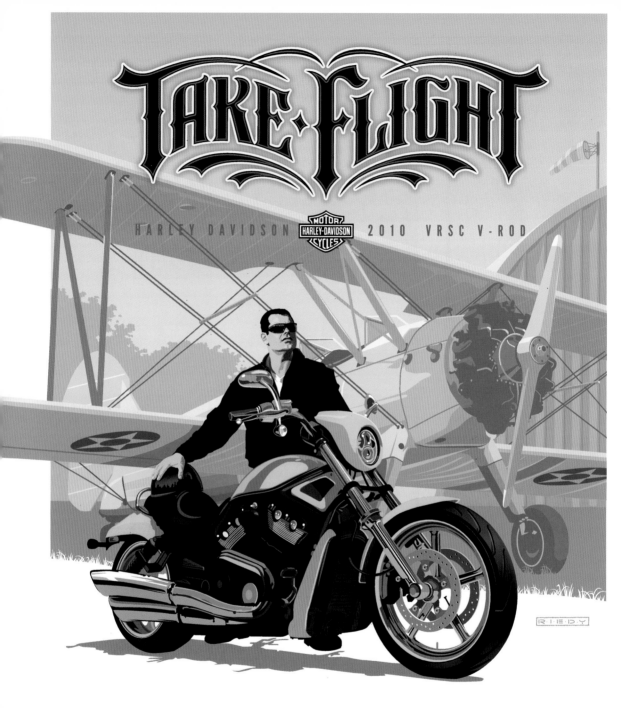

TAKE·FLIGHT

HARLEY DAVIDSON 2010 VRSC V-ROD

RIEDY

PENELOPE DULLAGHAN

REPRESENTED BY SCOTT HULL ASSOCIATES

(937) 433-8383 // SCOTT @ SCOTTHULL.COM

SCOTTHULL.COM // PENELOPEDULLAGHAN.COM

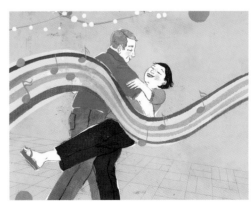

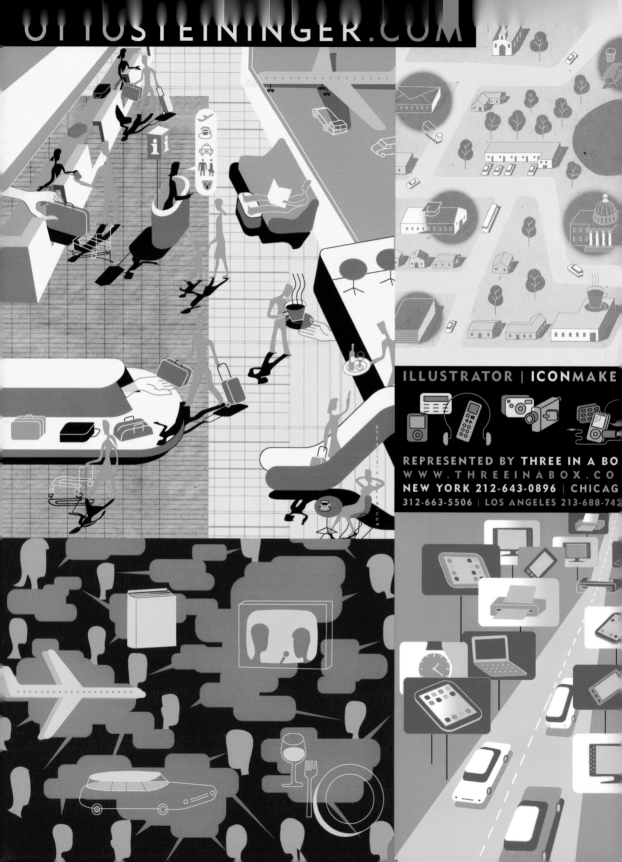

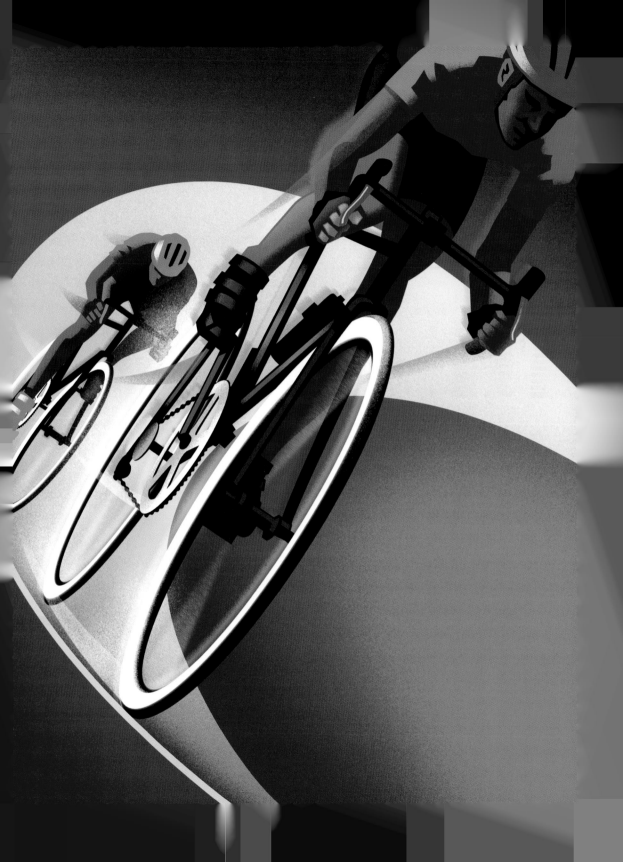

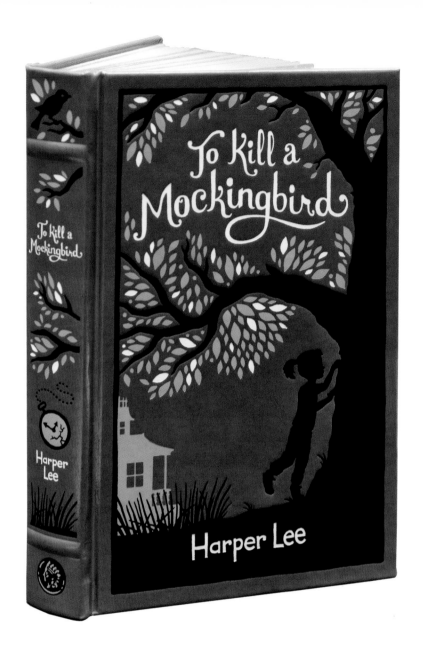

HUGH D'ANDRADE www.hughillustration.com 415.513.3444

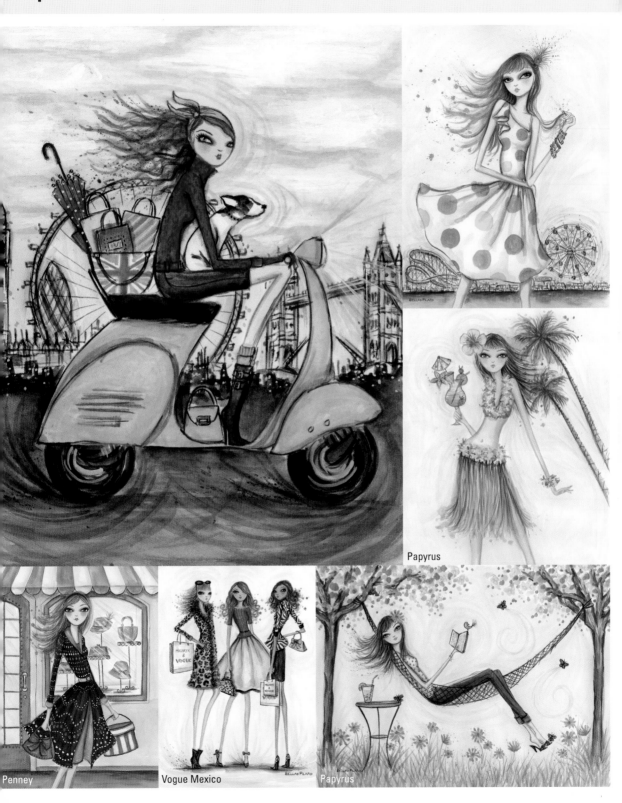

Papyrus

Penney

Vogue Mexico

Papyrus

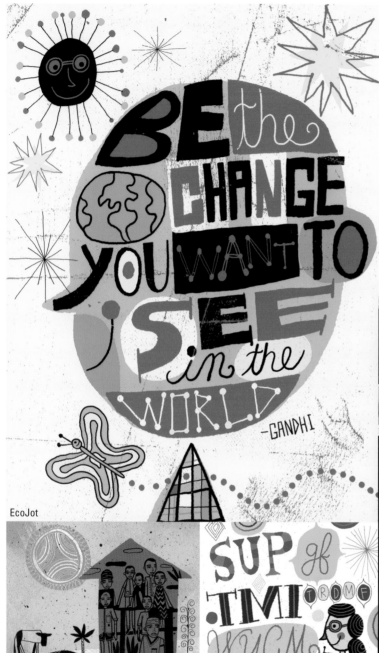

EcoJot

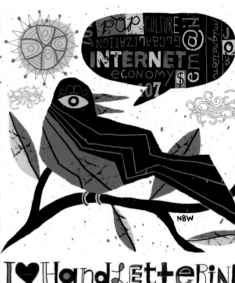

I ♥ HandLettering

Backstoffer W

SPECIALS
of the month

30-Minute MEALS

5-ingredient skillet suppers

BEACH HOUSE Party

SHELLFISH Spectacular

Everyc

Pennsylvania Gazette

Today's Parent

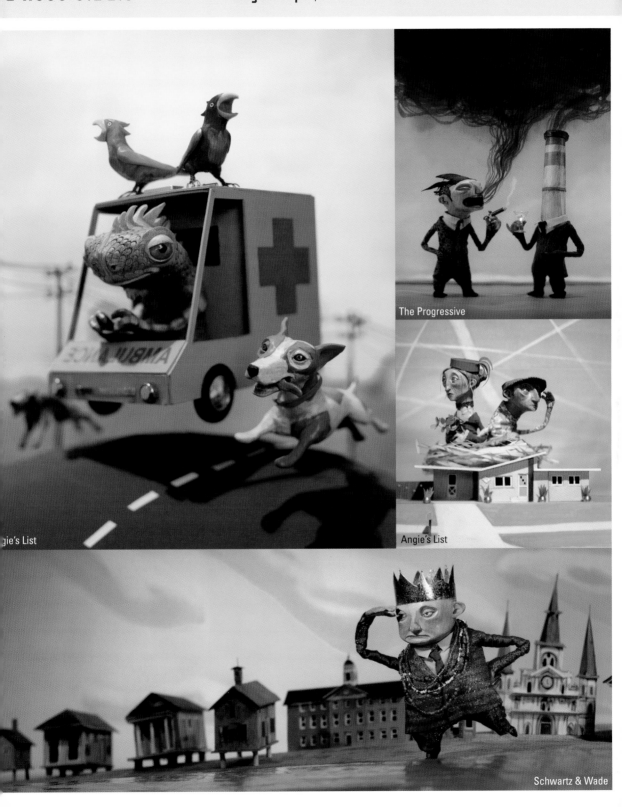

The Progressive

Angie's List

Angie's List

Schwartz & Wade

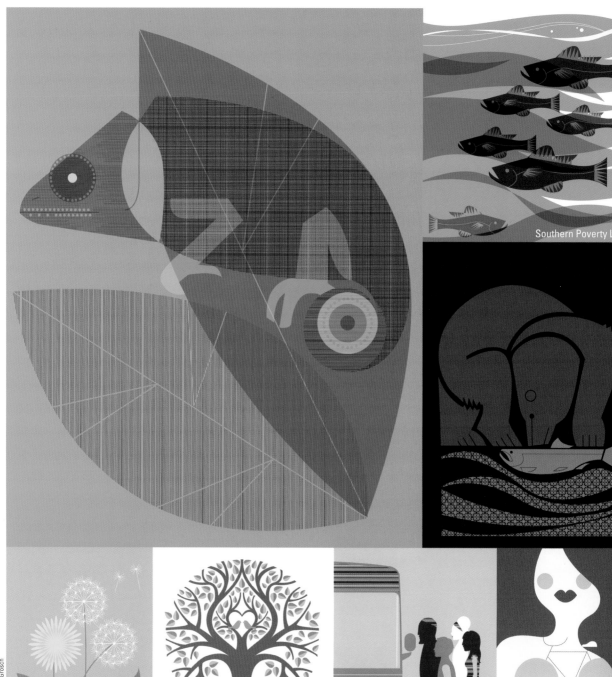

Southern Poverty L

Tiny Prints

Next American City

Poster Cabaret

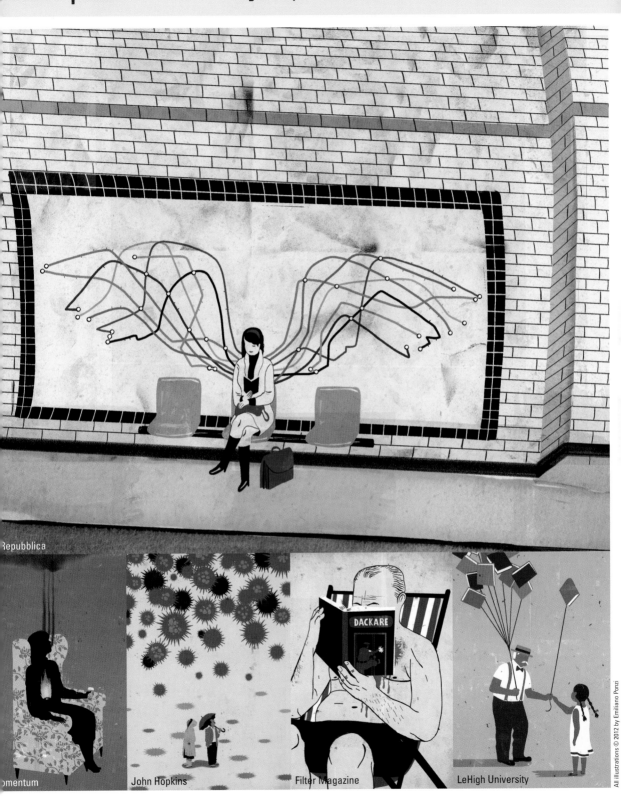

Republica

momentum John Hopkins Filter Magazine LeHigh University

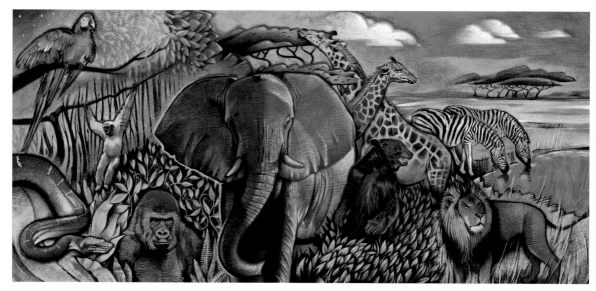

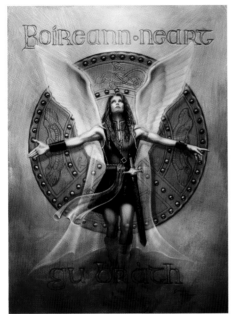
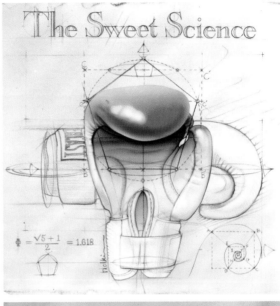
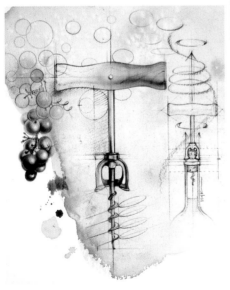

helenravenhillrepresents

tel 816.333.0744 web ravenhill.net

dougbowles

dougbowles.net

BOB KAYGANICH

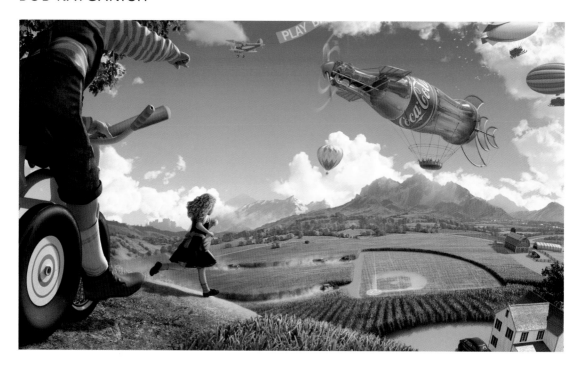

MARK COLLINS

215.232.6666 www.illustrationOnLine.com DEBORAH WOLFE LTD

215.232.6666 www.illustrationOnLine.com DEBORAH WOLFE LTD

RALPH VOLTZ

DAN MCGEEHAN

215.232.6666 www.illustrationOnLine.com DEBORAH WOLFE LTD

AMY CARTWRIGHT

NANCY HARRISON

WATERMARK

GREG COPELAND

ROSS JONES

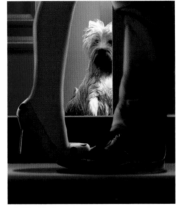

AMY WUMMER

RICHARD CARBAJAL

TED HAMMOND

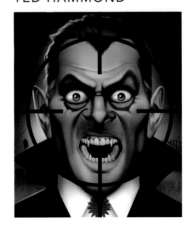

CINDY REVELL

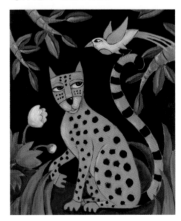

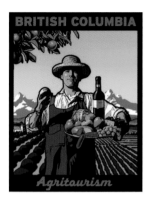

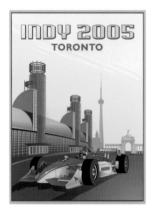

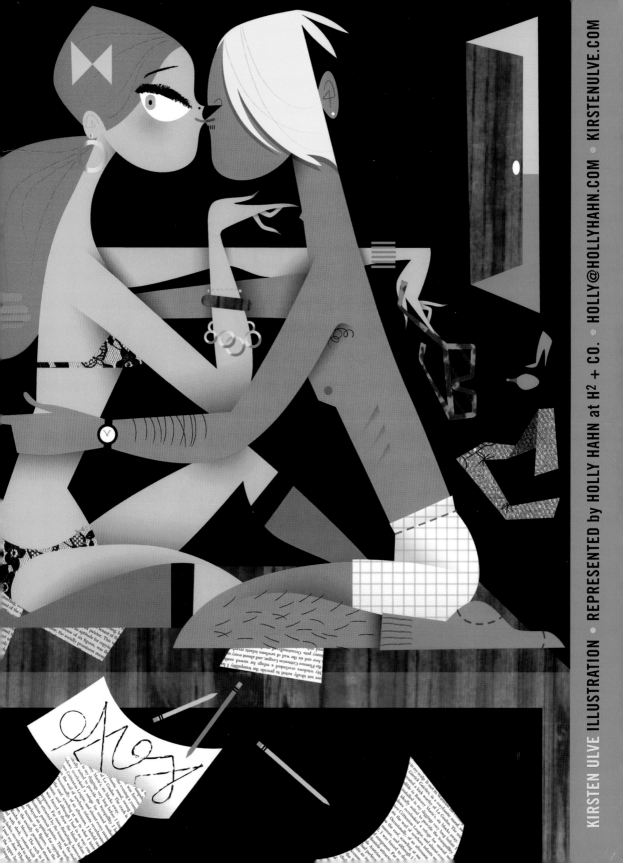

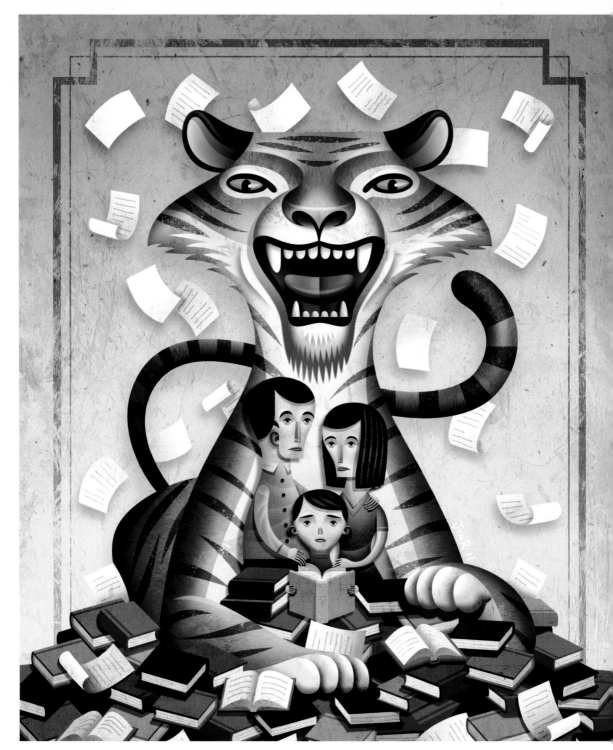

JON REINFURT

+ GERALD AND CULLEN RAP
+ 212 889 3337
+ WWW.RAPPART.COM
+ INFO@RAPPART.COM

Gerald & Cullen Rapp

212-889-3337
info@rappart.com
www.rappart.com

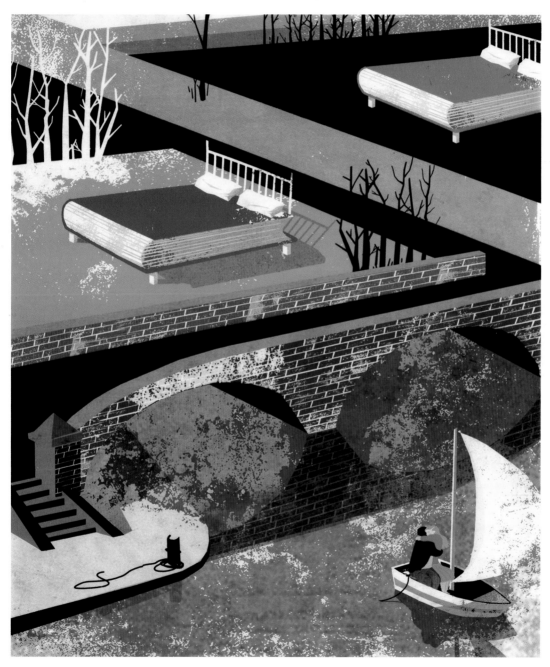

EVA VÁZQUEZ evavazquezdibujos.com

YUTA ONODA
www.yutaonoda.com

Gerald & Cullen Rapp | 212.899.3337
info@rappart.com | www.rappart.com

BETWEEN TWO ENDS

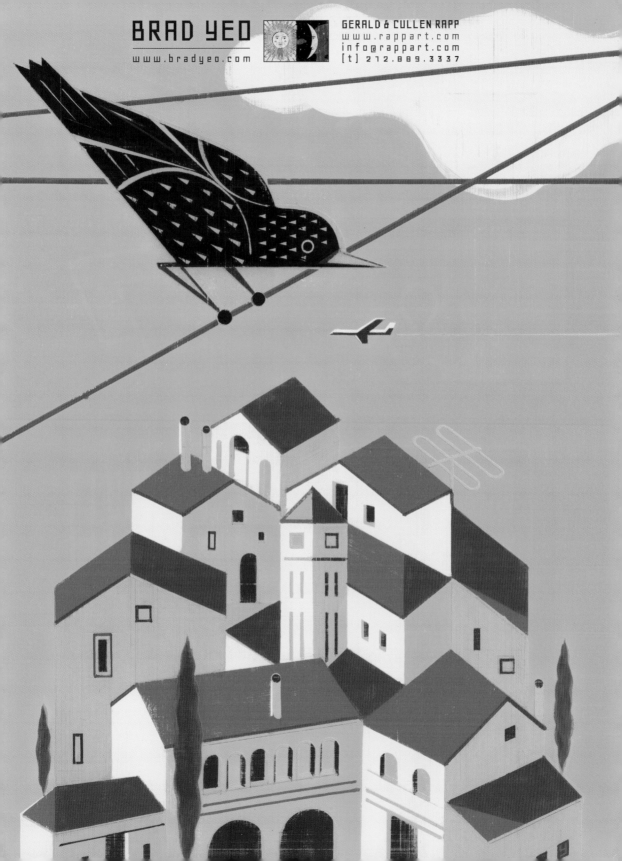

anders wenngren • gerald & cullen rapp • 212 889-3337 • info@rappart.com • www.rappart.com

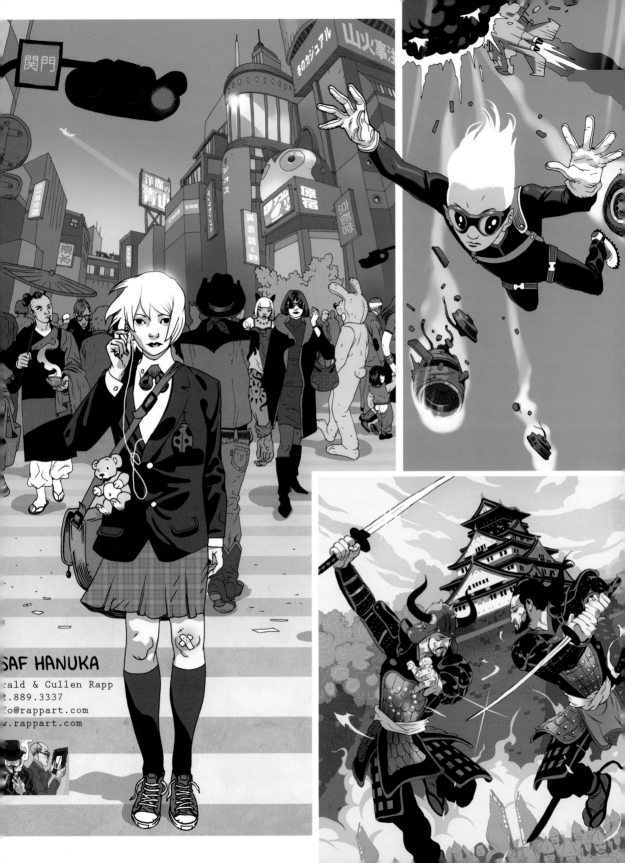

SAF HANUKA
...ald & Cullen Rapp
...2.889.3337
...fo@rappart.com
...w.rappart.com

H A N K O S U N A

REPRESENTED BY GERALD & CULLEN RAPP

212.889.3337

INFO@RAPPART.COM

WWW.RAPPART.COM

WWW.HANKOSUNA.COM

Daniel Hertzberg Illustration

Represented by Gerald & Cullen Rapp

(212) 889-3337 | info@rappart.com | www.rappart.com

www.danielhertzberg.com

A TRADITION 2000 YEARS OLD.

THE RIKISHI ONCE DREW PRINCESS TO HIS BOUTS.

TO PLEASE THE SHINTO GODS AND PURIFY ONESELF BEFORE THEM.

NOW THREATENED BY SCANDALS...

...AND TURNED INTO A SPECTACLE.

IT NEEDS A HERO TO SAVE IT

BEFORE IT IS TOO LATE

Raúl Allén

ILLUSTRATIO

www.raulallen.co

Gerald &
Cullen Rapp
INFO@RAPPART.CO
212 889 3337
www.rappart.com

ELIZABETH TRAYNOR

Gerald & Cullen Rapp
212 889 3337
info@rappart.com
www.rappart.com
www.elizabethtraynor.com

Scratchboard

UBS/SwissBank

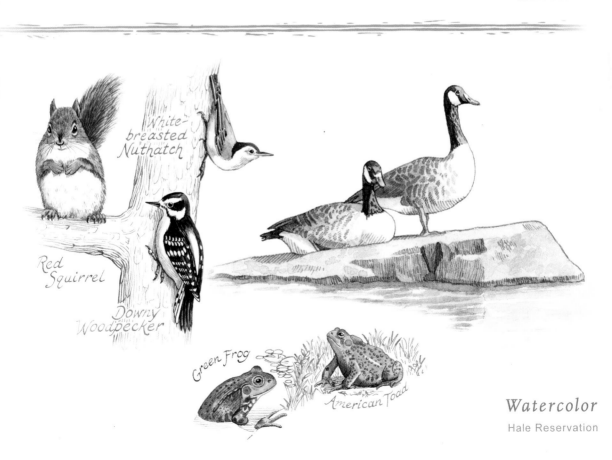

White-breasted Nuthatch

Red Squirrel

Downy Woodpecker

Green Frog

American Toad

Watercolor

Hale Reservation

David M. Brinley

Gerald & Cullen Rapp
212.889.3337
info@rappart.com
www.rappart.com
www.davidbrinley.com

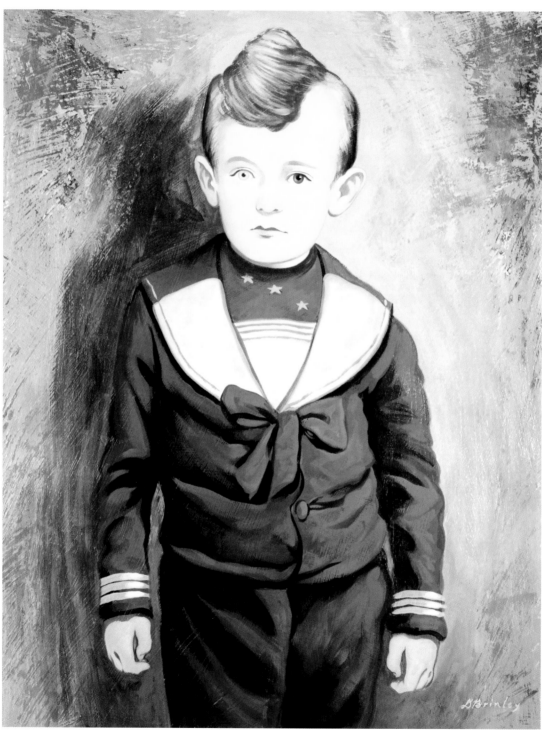

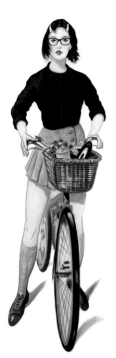

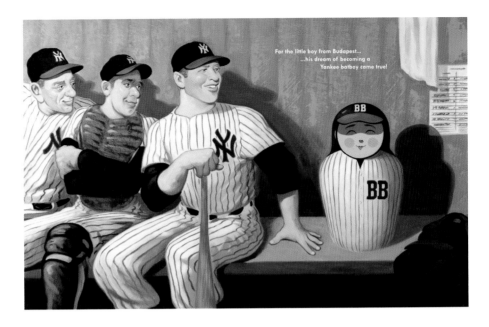

For the little boy from Budapest...
...his dream of becoming a
Yankee batboy came true!

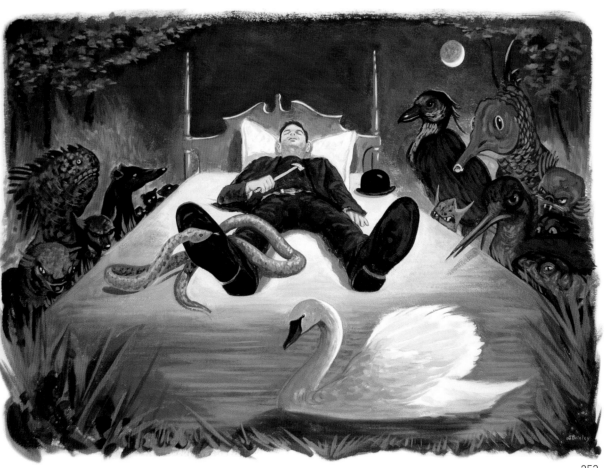

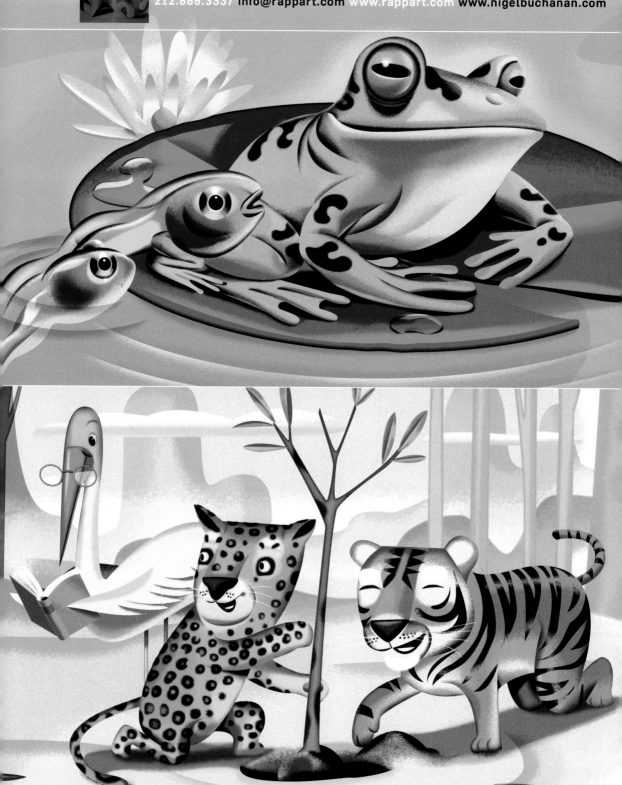

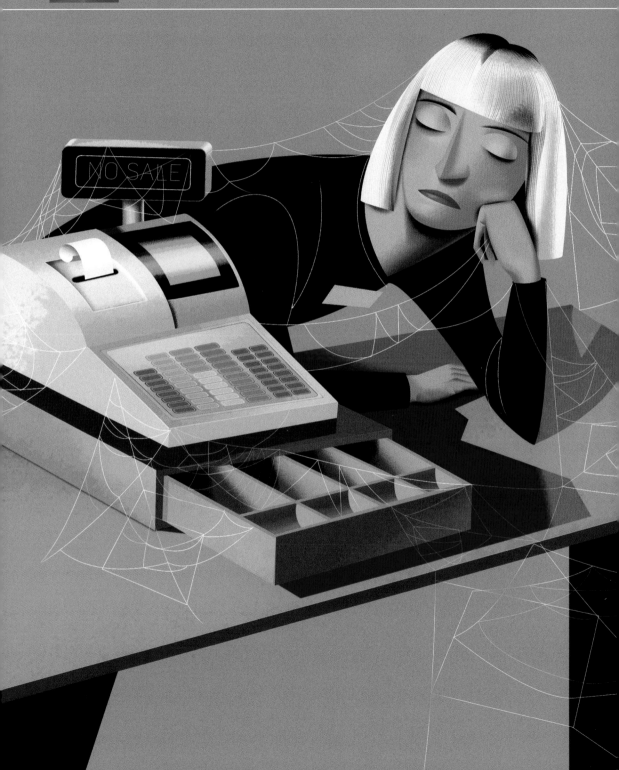

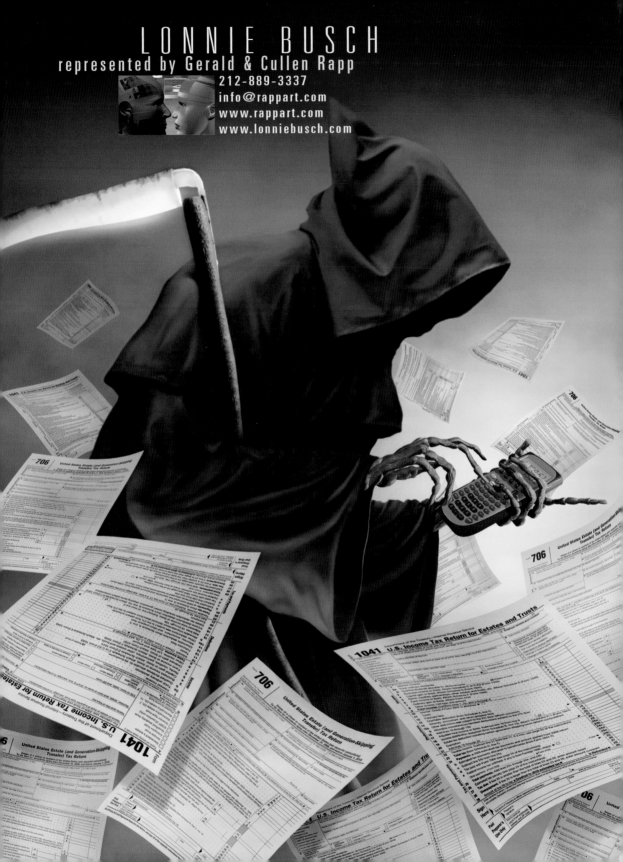

LONNIE BUSCH

represented by Gerald & Cullen Rapp

212-889-3337
info@rappart.com
www.rappart.com
www.lonniebusch.com

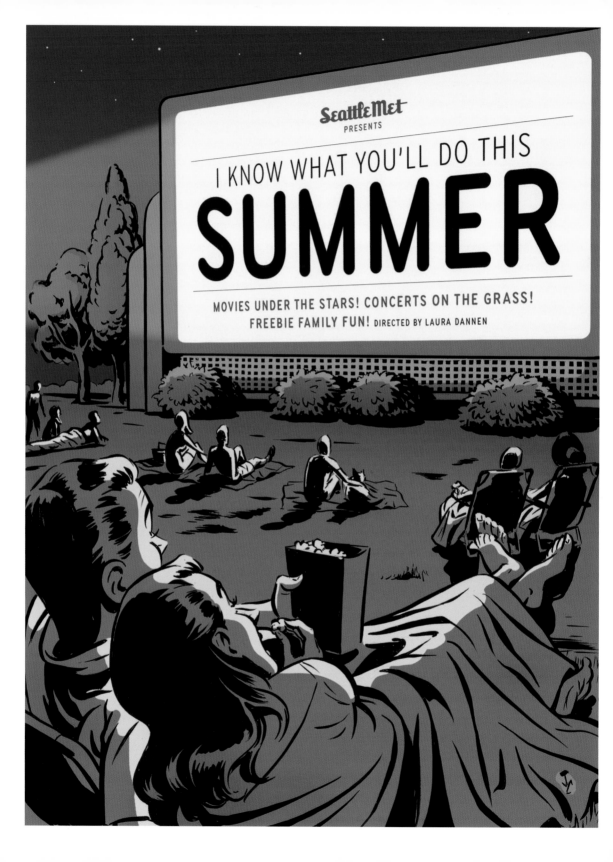

Jonathan Carlson

Gerald & Cullen Rapp
212-889-3337
www.rappart.com
info@rappart.com

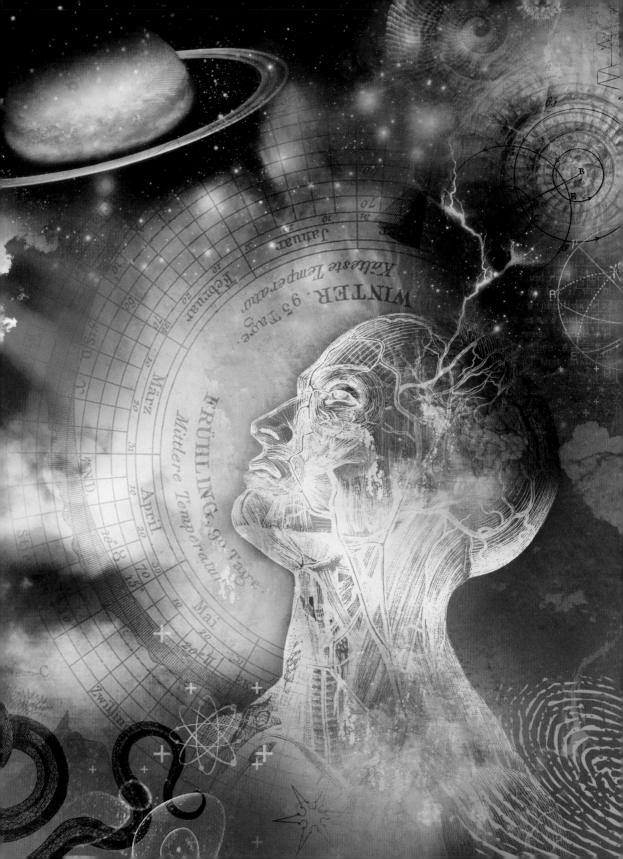

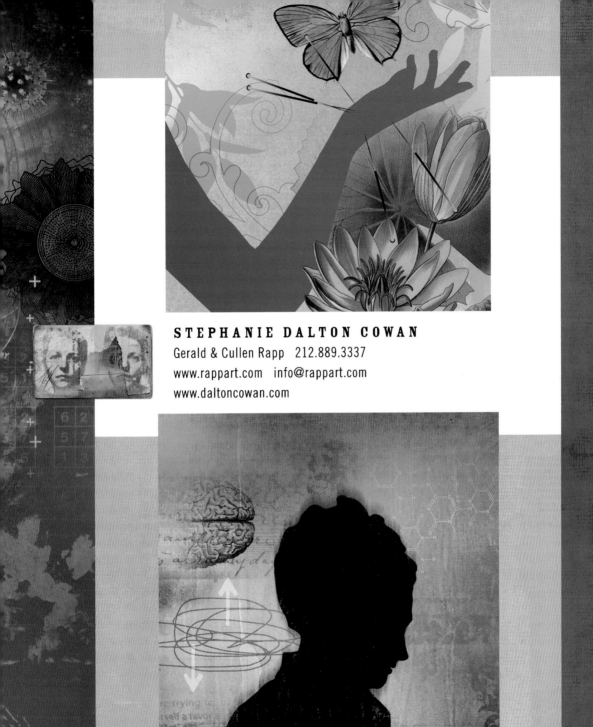

STEPHANIE DALTON COWAN

Gerald & Cullen Rapp 212.889.3337

www.rappart.com info@rappart.com

www.daltoncowan.com

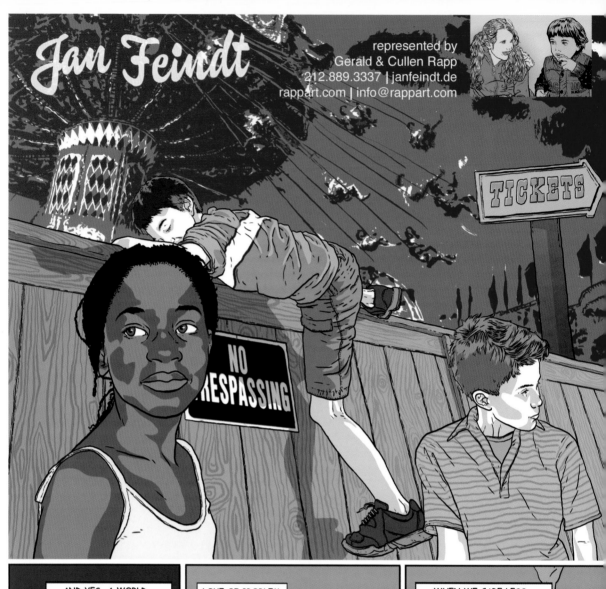

Jan Feindt

represented by
Gerald & Cullen Rapp
212.889.3337 | janfeindt.de
rappart.com | info@rappart.com

TICKETS

NO TRESPASSING

...AND YES, A WORLD, WHOSE DAMAGE CAN BE HEALED BY CARING SKILL.

LOVE OF PROBLEM SOLVING...

...AND A FUTURE...

...WHEN WE CARE LESS ABOUT BLAME, OR DOGMAS, OR RECRIMINATIONS...

...AND MORE ABOUT...

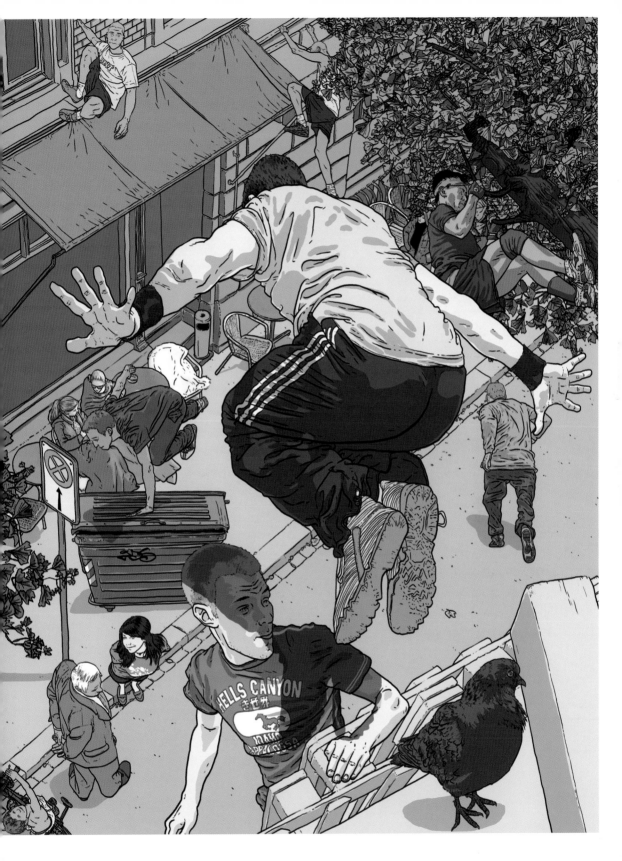

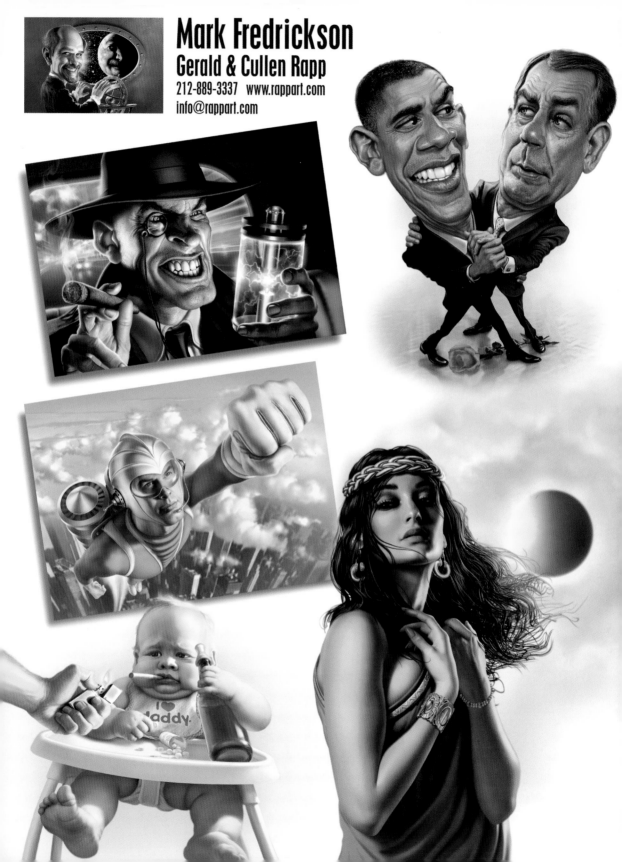

Mark Fredrickson
Gerald & Cullen Rapp
212-889-3337 www.rappart.com
info@rappart.com

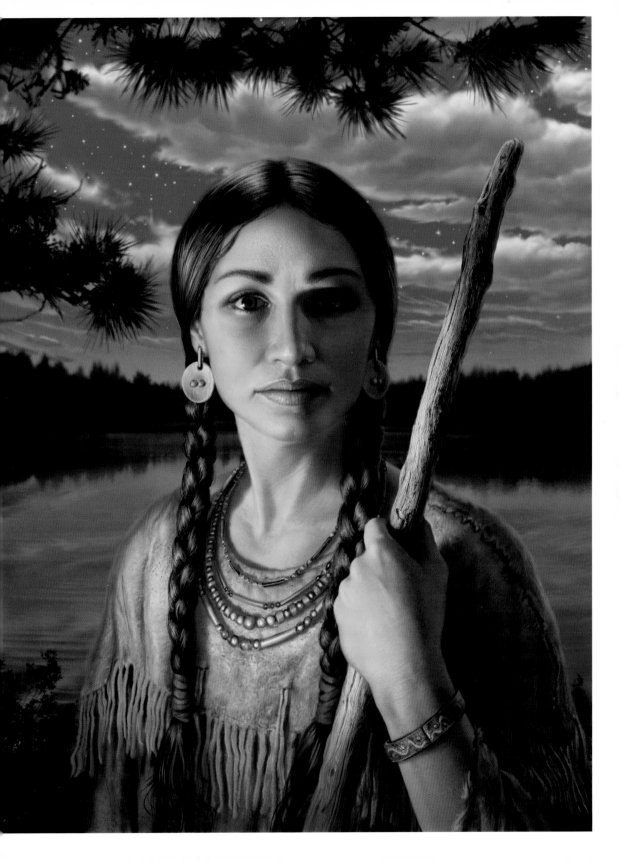

Laszlo Kubinyi

Gerald & Cullen Rapp
212 889 3337
info@rappart.com
www.rappart.com

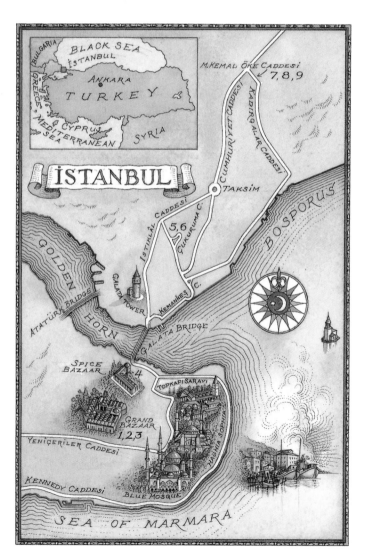

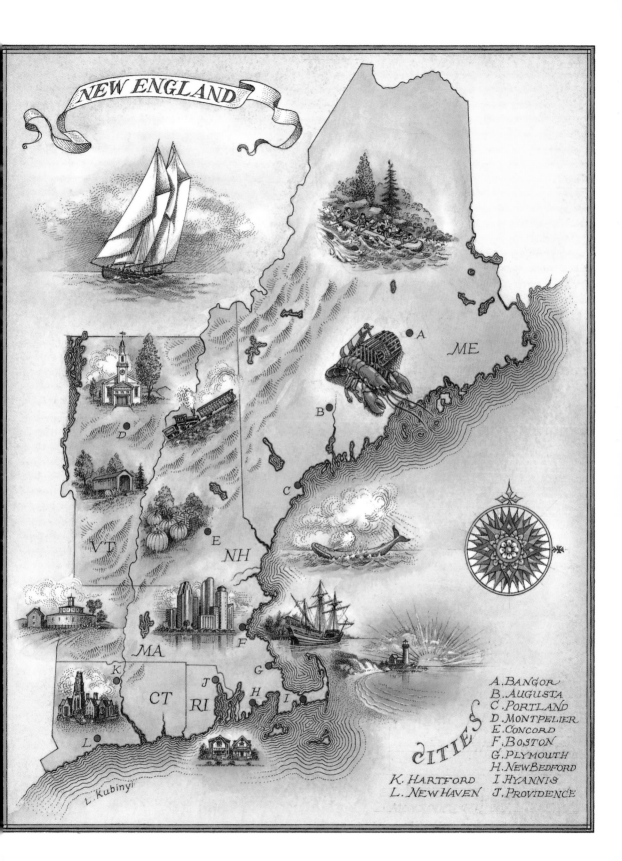

NEW ENGLAND

A

ME

B

C

D

VT

E

NH

MA

F

G

H I

K

CT RI

J

L. Kubinyi

L

CITIES

A. BANGOR
B. AUGUSTA
C. PORTLAND
D. MONTPELIER
E. CONCORD
F. BOSTON
G. PLYMOUTH
H. NEW BEDFORD
K. HARTFORD I. HYANNIS
L. NEW HAVEN J. PROVIDENCE

Sean McCabe

GERALD & CULLEN RAPP
212.889 3337 / info@rappart.com
www.rappart.com / www.wider-than-pictures.com

 # Richard Mia

www.richardmia.com | Gerald & Cullen Rapp | 212-889-3337 | info@rappart.com | www.rappart.com

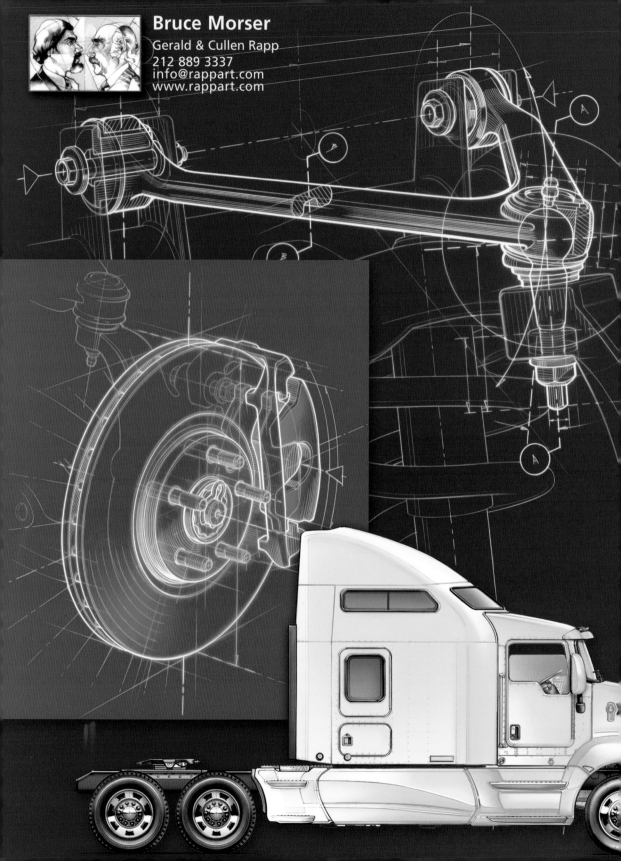

Bruce Morser
Gerald & Cullen Rapp
212 889 3337
info@rappart.com
www.rappart.com

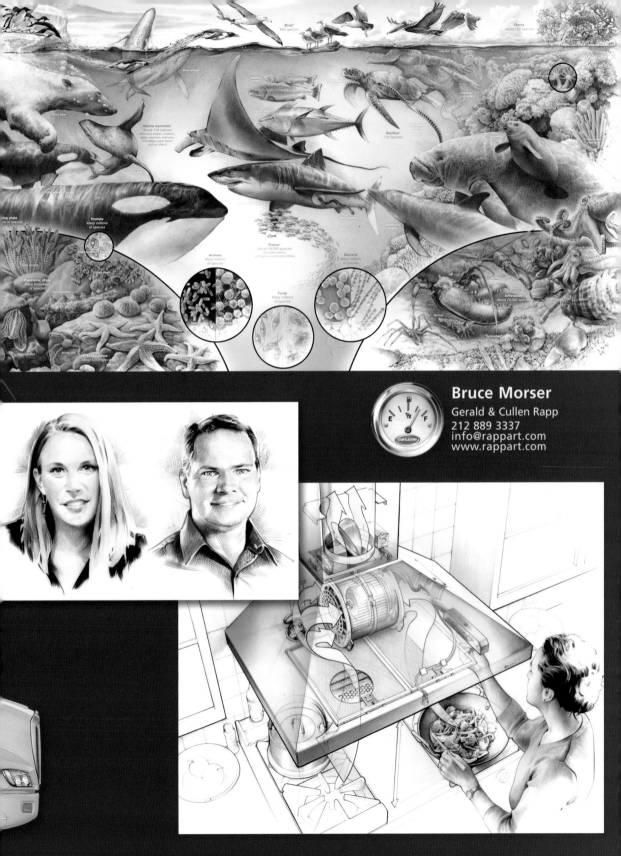

Bruce Morser

Gerald & Cullen Rapp
212 889 3337
info@rappart.com
www.rappart.com

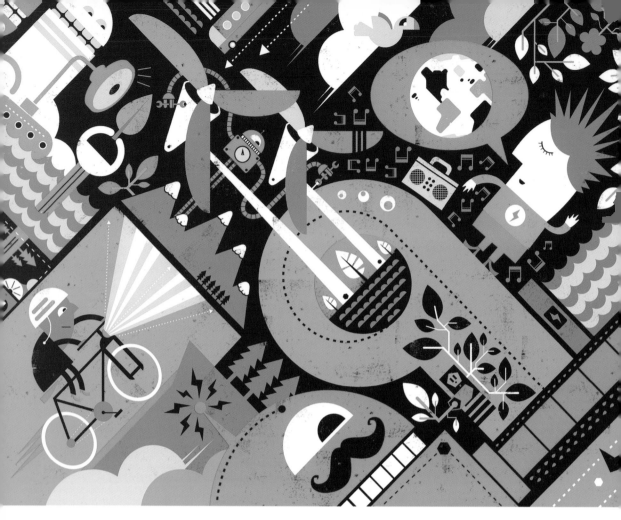

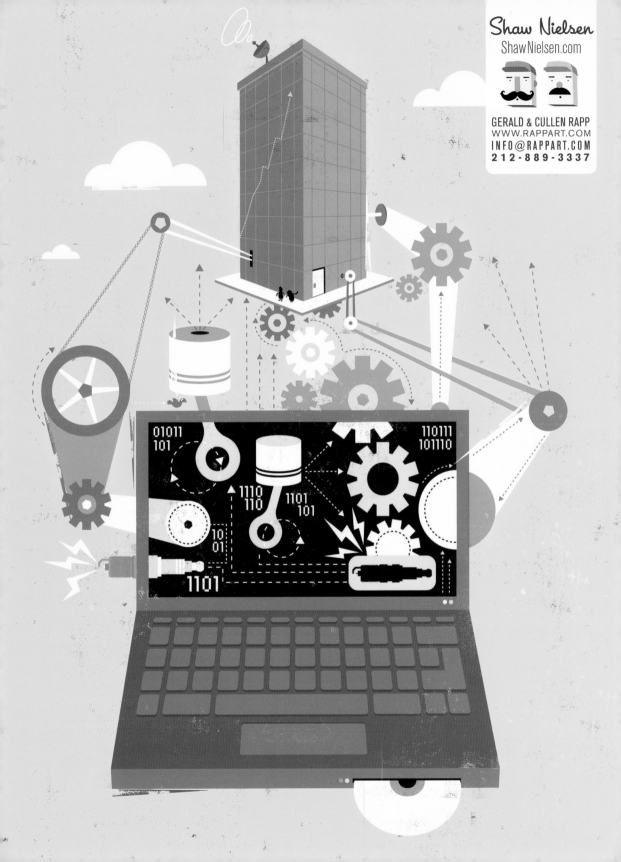

Dan Page

www.danpage.net

Gearld & Cullen Rapp
212-889-3337
info@rappart.com
www.rappart.com

 Marc Rosenthal REPRESENTED BY GERALD & CULLEN RAPP
212-889-3337 • INFO@RAPPART.COM
WWW.RAPPART.COM • WWW.MARC-ROSENTHAL.COM

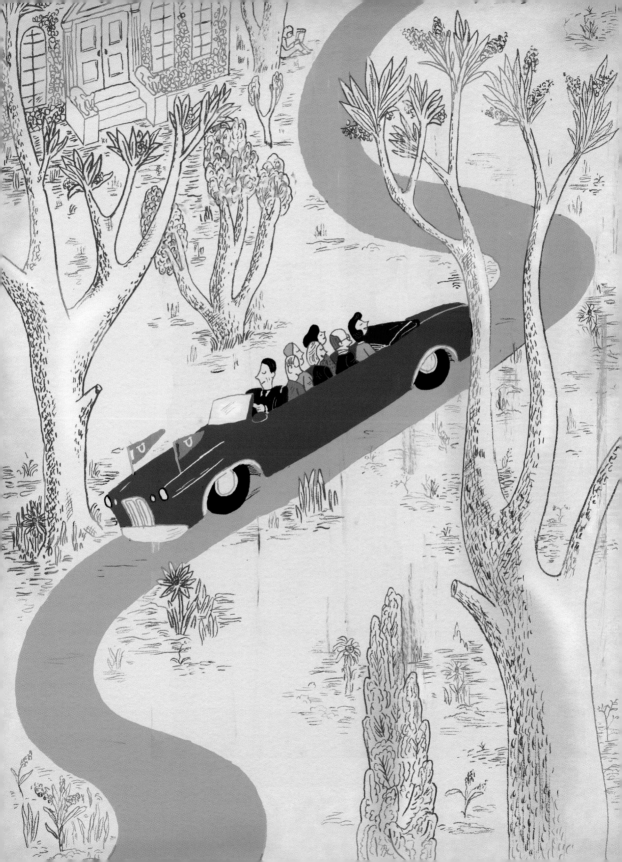

JEFFREY SMITH

Gerald & Cullen Rapp 212-889-3337 info@rappart.com www.rappart.com

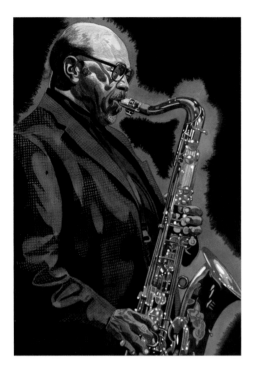

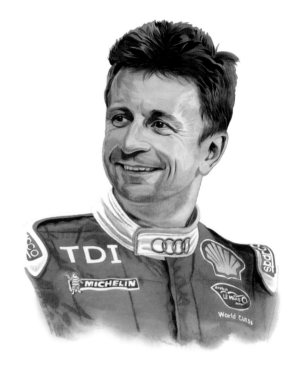

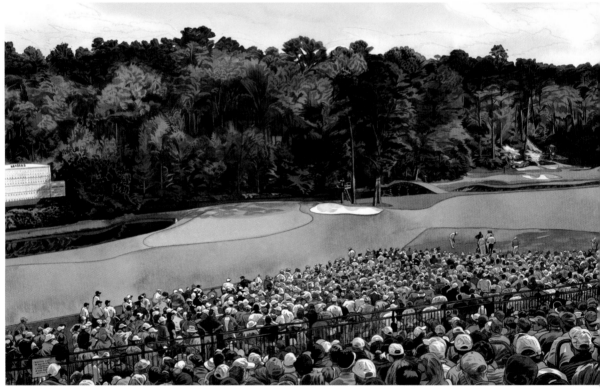

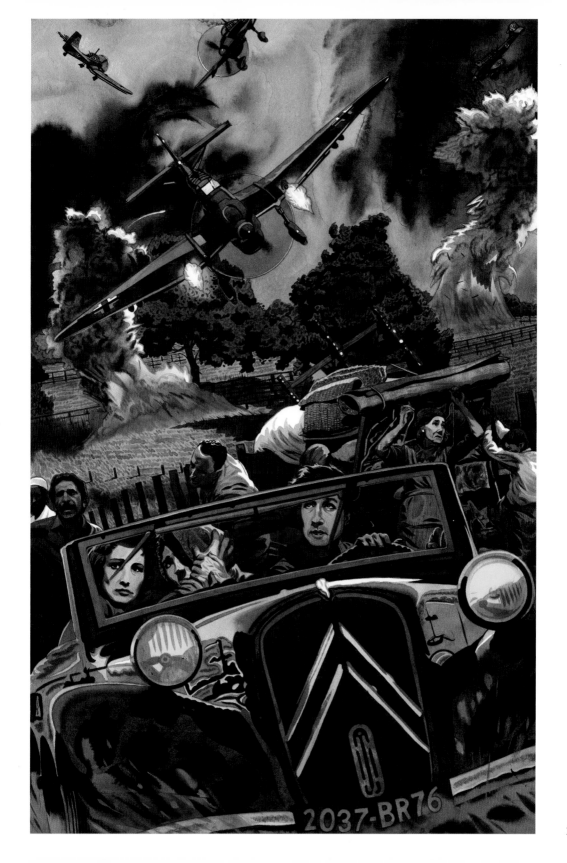

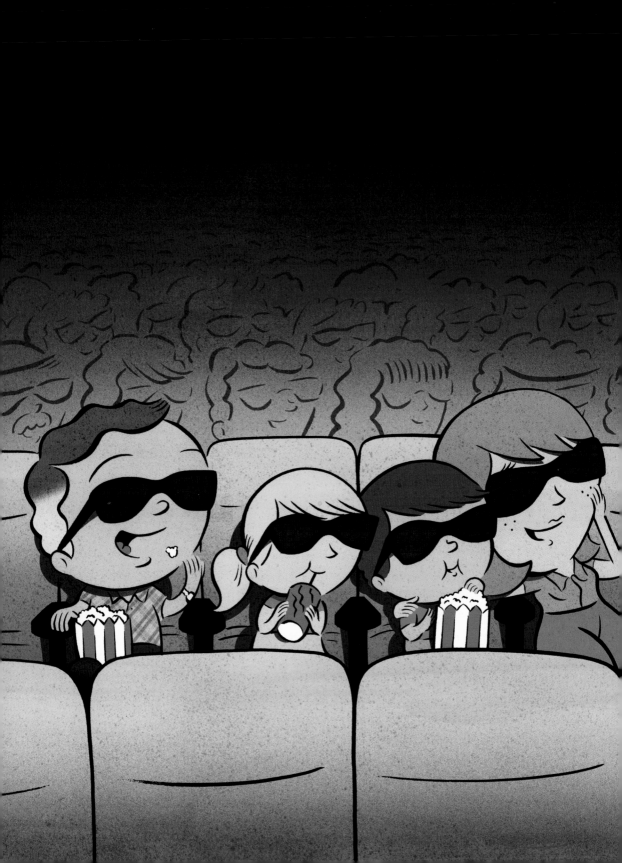

RYAN SNOOK
Represented by Gerald & Cullen Rapp
212-889-3337
info@rappart.com
www.rappart.com

ryansnook.com
twitter.com/ryansnook

 represented by gerald & cullen rapp www.rappart.com 212 889 3337 info@rappart.com

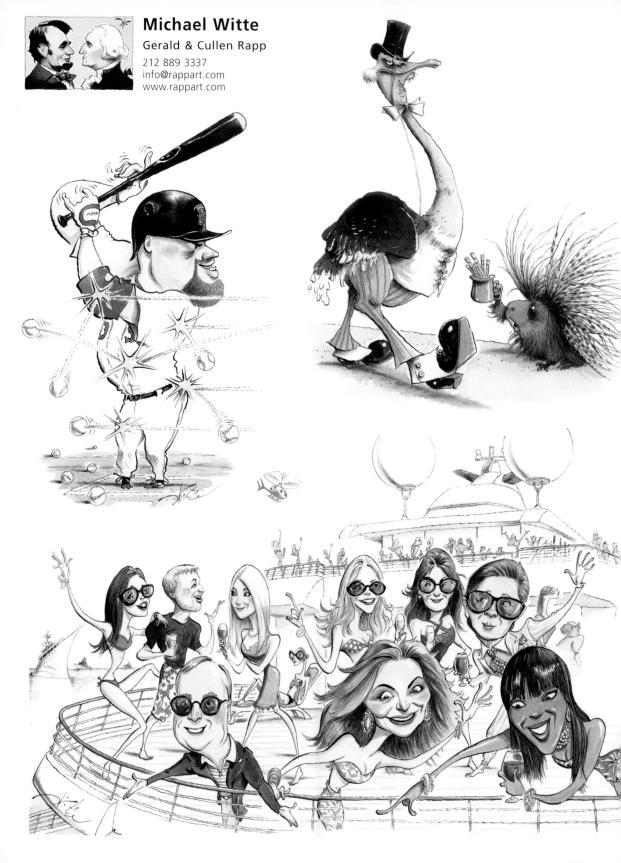

Michael Witte

Gerald & Cullen Rapp

212 889 3337
info@rappart.com
www.rappart.com

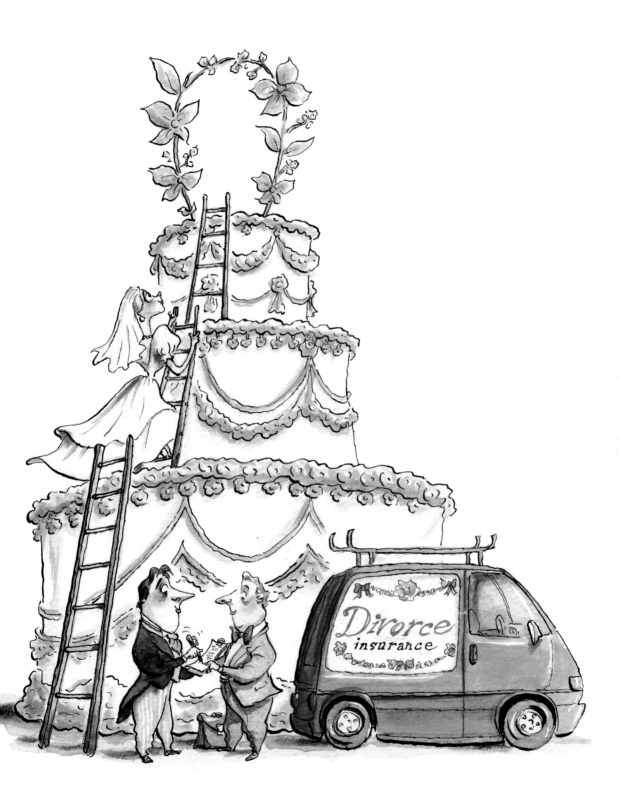

Noah Woods

Gerald & Cullen Rapp
212-889-3337

www.noahwoods.com
info@rappart.com
www.rappart.com

JAMES O'BRIEN

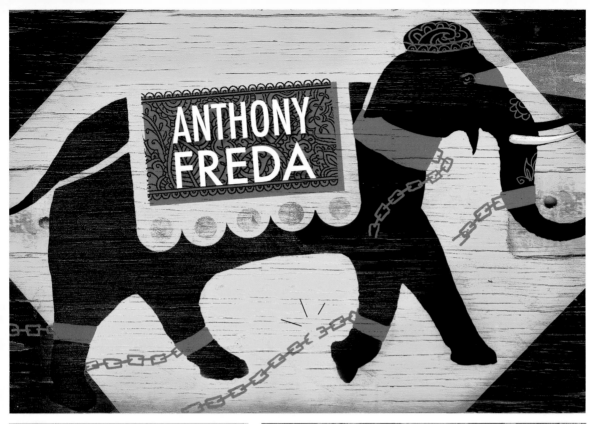

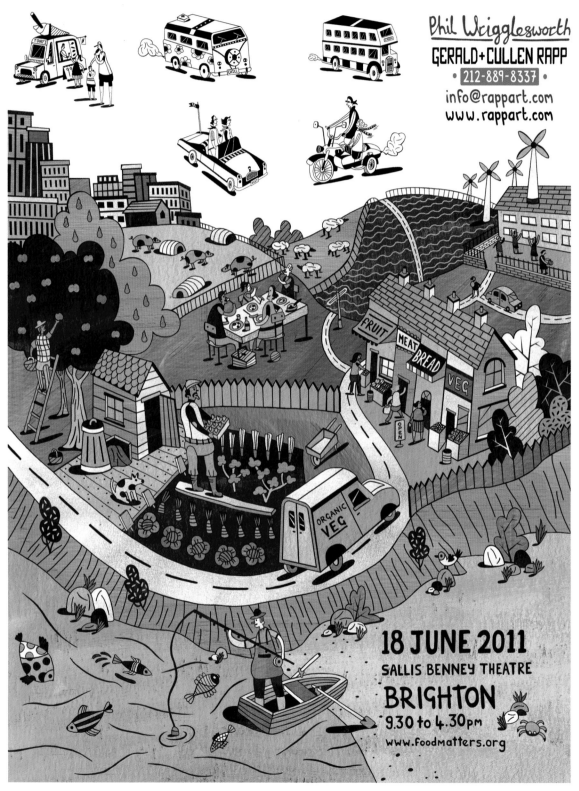

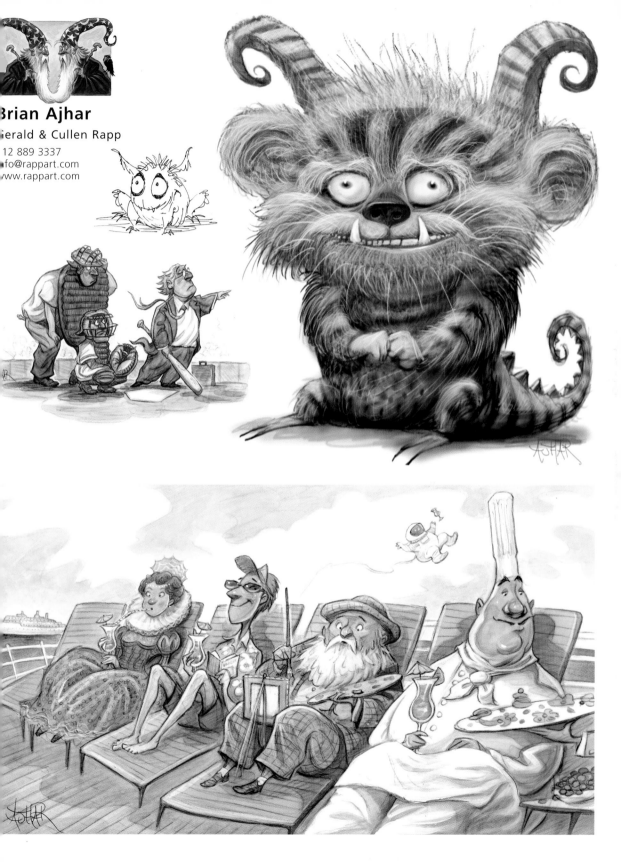

Brian Ajhar

Gerald & Cullen Rapp

12 889 3337
fo@rappart.com
ww.rappart.com

RAFAEL RICOY WWW.RAFAELRICOY.COM

GERALD & CULLEN RAPP 212-889-3337

INFO@RAPPART.COM WWW.RAPPART.COM

James Steinberg

Gerald & Cullen Rapp | 212-889-3337 | info@rappart.com
www.james-steinberg.com | www.rappart.com

SCOTTY REIFSNYDER

Gerald & Cullen Rapp

212.889.3337

www.rappart.com

info@rappart.com

HAMLET
ACT:5
SCENE:1

DECLINED

ZIT AWAY

WORLD'S BEST BOSS

CARA PETRUS

REPRESENTED BY GERALD & CULLEN RAPP

WWW.RAPPART.COM INFO@RAPPART.COM 212.889.3337

JOHN S. DYKES
·ILLUSTRATION·

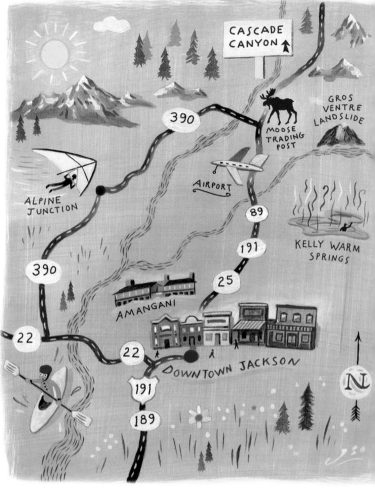

The **Sandwich Issue**

"It's all about the story. It's all about the product. The product drives the story rather than a sales idea driving the product." — Michael Besancon, SENIOR GLOBAL VICE-PRESIDENT OF PROCUREMENT, DISTRIBUTION AND COMMUNICATIONS, Whole Foods Markets. (pls. see p.30)

represented by
Gerald & Cullen Rapp
212.889.3337
info@rappart.com
www.rappart.com

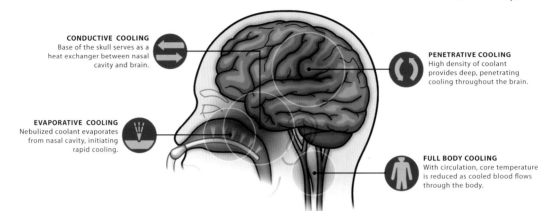

CONDUCTIVE COOLING
Base of the skull serves as a heat exchanger between nasal cavity and brain.

PENETRATIVE COOLING
High density of coolant provides deep, penetrating cooling throughout the brain.

EVAPORATIVE COOLING
Nebulized coolant evaporates from nasal cavity, initiating rapid cooling.

FULL BODY COOLING
With circulation, core temperature is reduced as cooled blood flows through the body.

client: **D-Link**

client: **Physio-Contro**

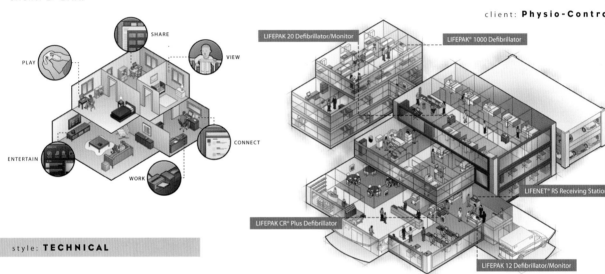

SHARE

VIEW

PLAY

CONNECT

ENTERTAIN

WORK

LIFEPAK 20 Defibrillator/Monitor

LIFEPAK® 1000 Defibrillator

LIFENET® RS Receiving Station

LIFEPAK CR® Plus Defibrillator

LIFEPAK 12 Defibrillator/Monitor

style: **TECHNICAL**

client: **Mountain Hardwear**

OutDry Technology

Competitor's Technology

TOP**DOG**™
ILLUSTRATION

www.**topdogillustration**.com

call **TROY DOOLITTLE** toll-free at **800-826-4592**

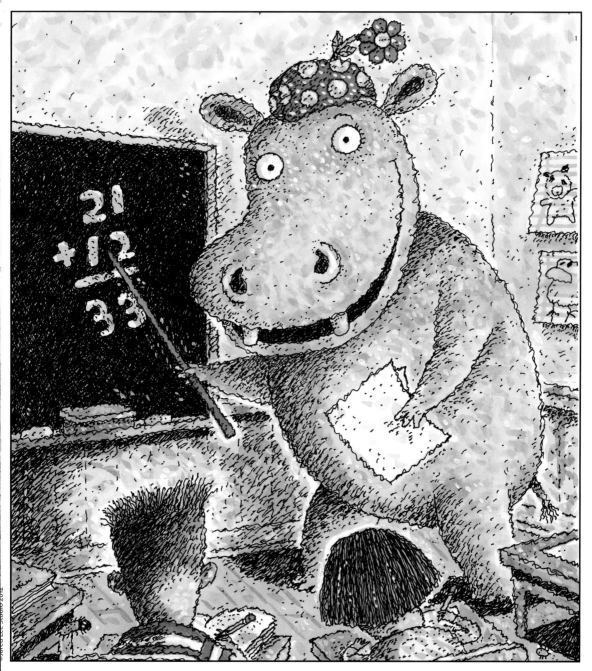

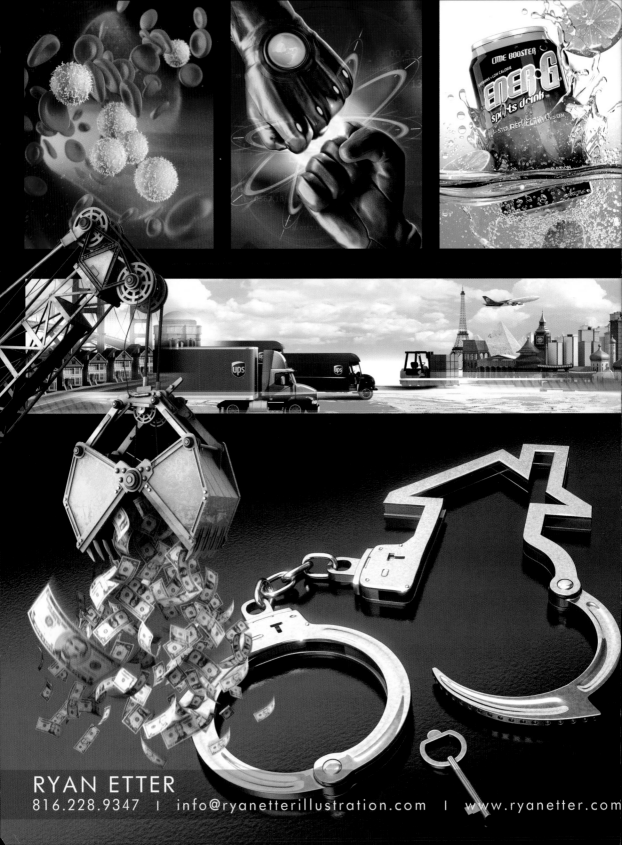

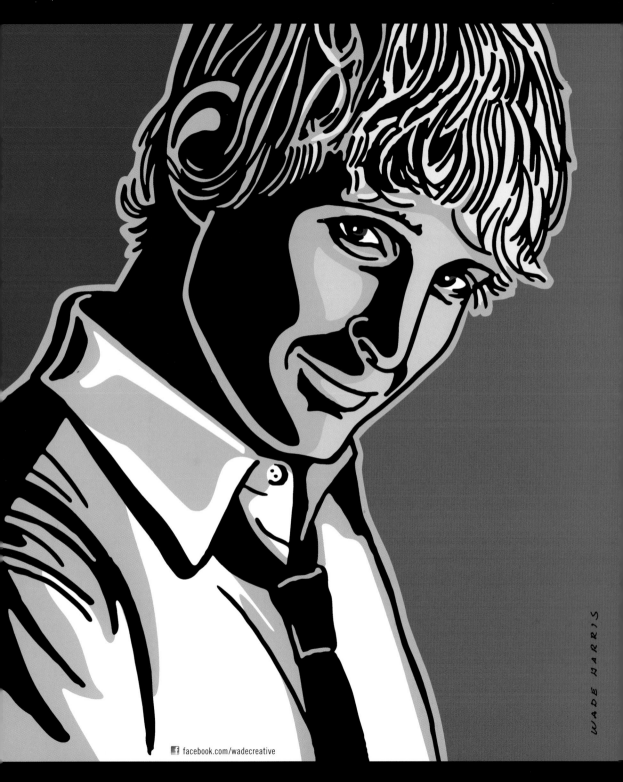

WADE HARRIS

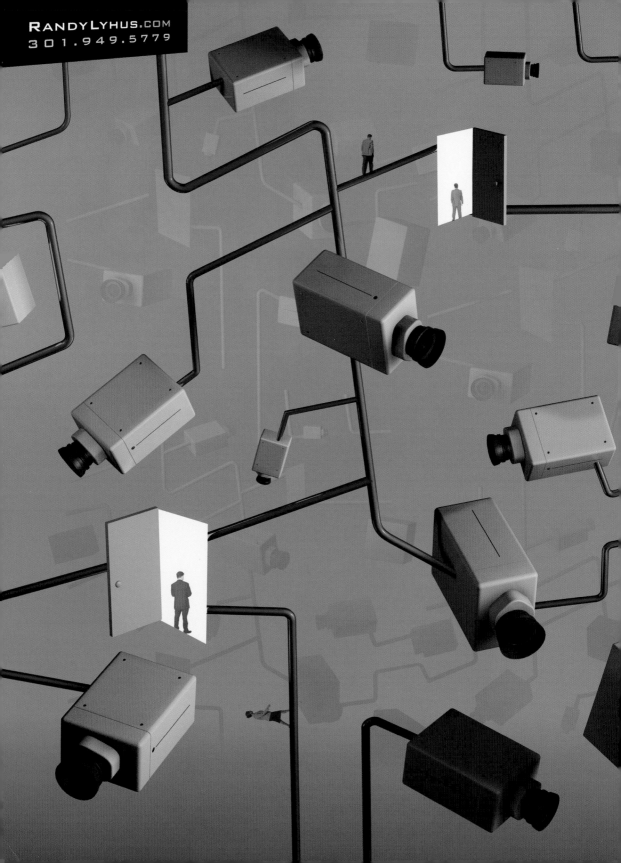

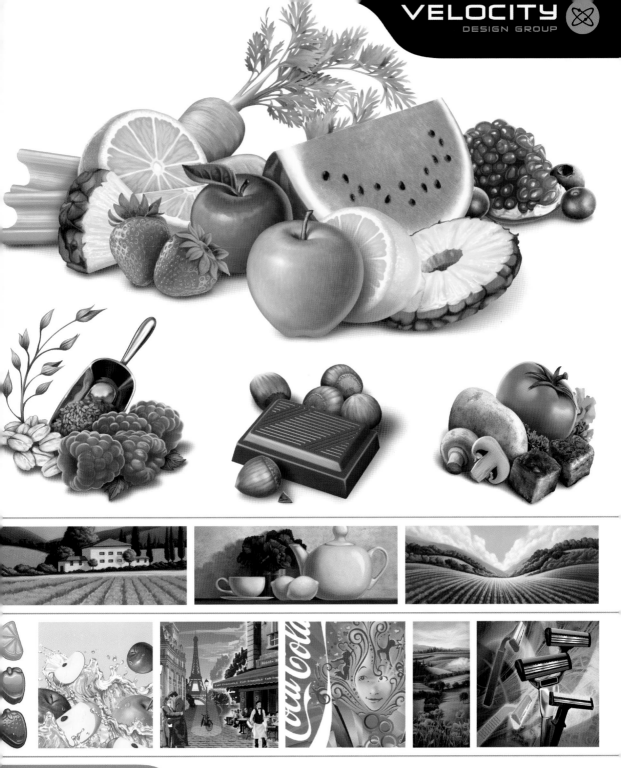

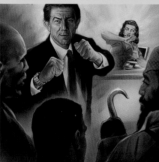
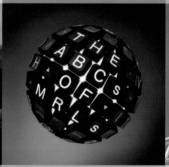

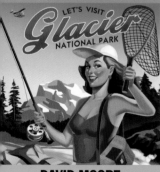

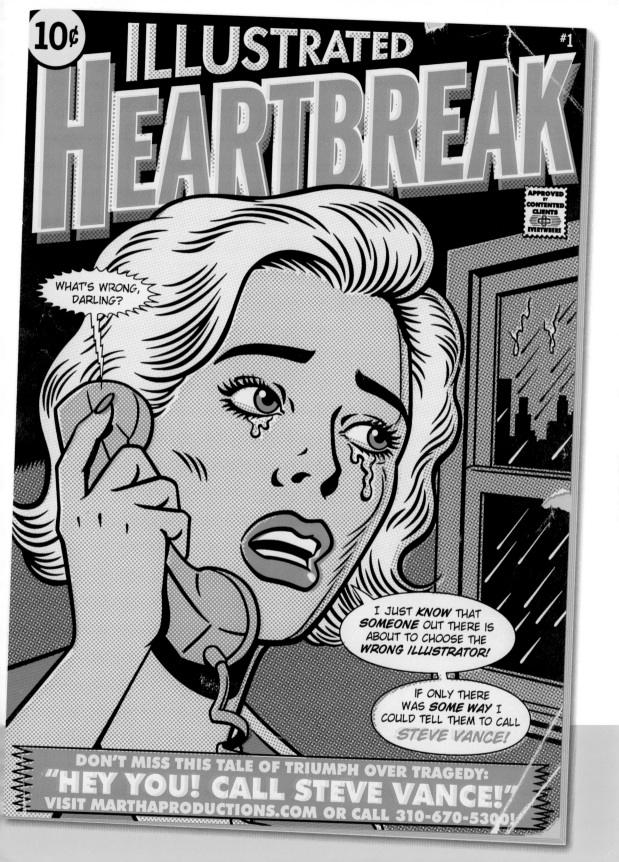

DAVID MOORE /RETROREPS.COM 310 670-5300

Denise Hilton Campbell

SALZMAN
international

415.285.8267 salzint.com 212.997.0115

Debbie Tilley

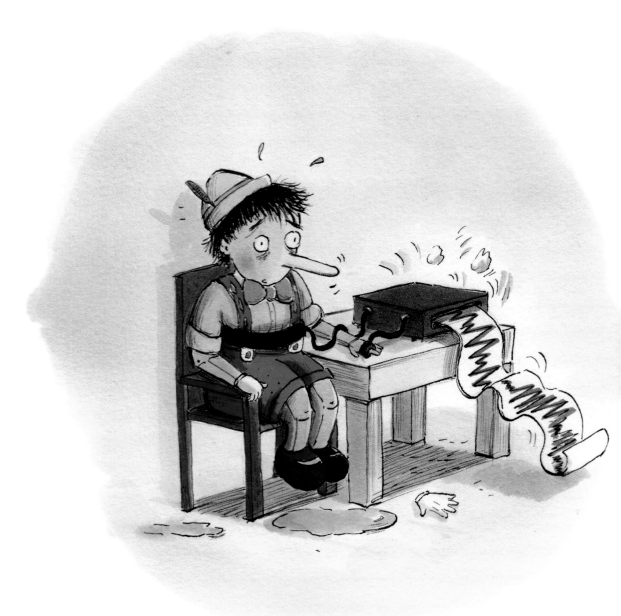

SALZMAN

international

415.285.8267 salzint.com DebbieTilley.com facebook.com/SalzmanInternational 212.997.0115

Mark Smith

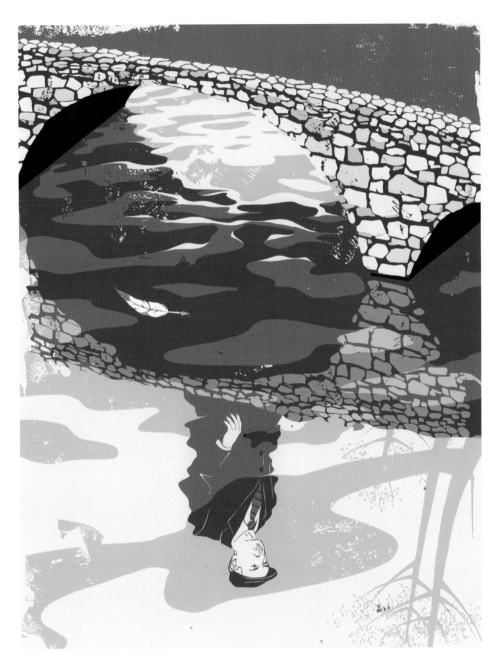

SALZMAN

international

415.285.8267 salzint.com facebook.com/SalzmanInternational 212.997.0115

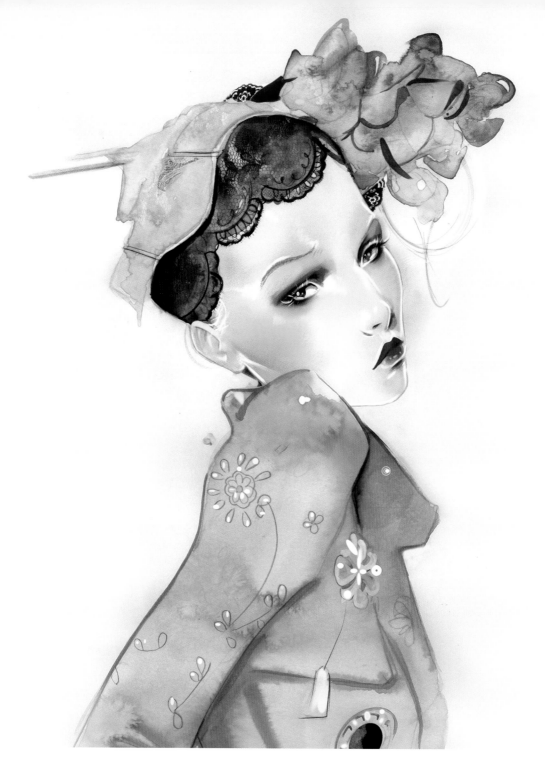

Illustration

Agents

Stacey Endress Victoria Pearce

Juliette Lott Mike Cowley

illustrationweb.com 23 Ohio Street

973.763.1712 Maplewood

howdy@illustrationweb.com NJ 07040

Montana Forbes
Christian David Moore

◄ Nuno DaCosta

Miss Led
Sarah Beetson

illustrationweb.com howdy@illustrationweb.com 973.763.1712 *Illustration*

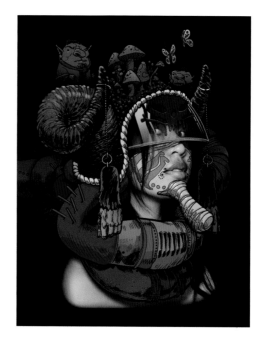

BoomArtwork
Pete Pachoumis

Paul Holland
Alex Fuentes

Gail Armstrong ▶

 illustrationweb.com howdy@illustrationweb.com 973.763.1712

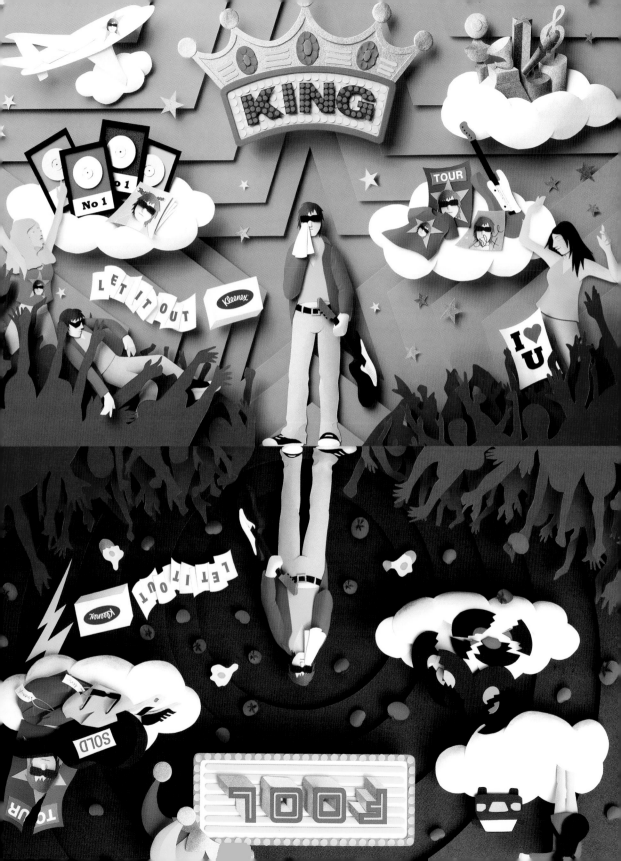

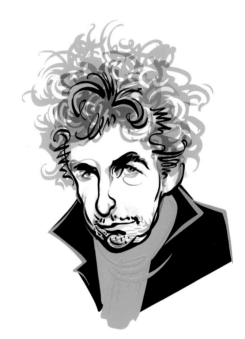

Rosie Sanders Philip Bannister
Richard Phipps Kathryn Rathke

◀ Syd Brak

illustrationweb.com howdy@illustrationweb.com 973.763.1712 *Illustration*

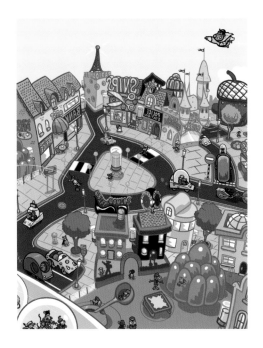
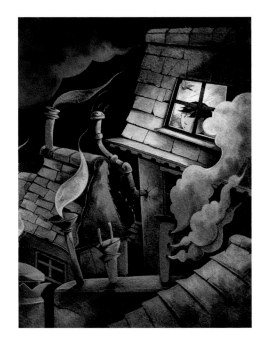

Bill Greenhead

Mark Oliver

T.S Spookytooth

Alexandra Ball

Fernando Juarez ▶

 illustrationweb.com **howdy@illustrationweb.com** **973.763.1712**

KLICK
REIMAGINE

 IGNITE

iMOTIV
JUICE

illustrationweb.com howdy@illustrationweb.com 973.763.1712

Illustration

MUNROCAMPAGNA.COM
E. steve@munrocampagna.com P. 312.335.8925
630 N State St #2109 Chicago, IL 60654

Mike Right

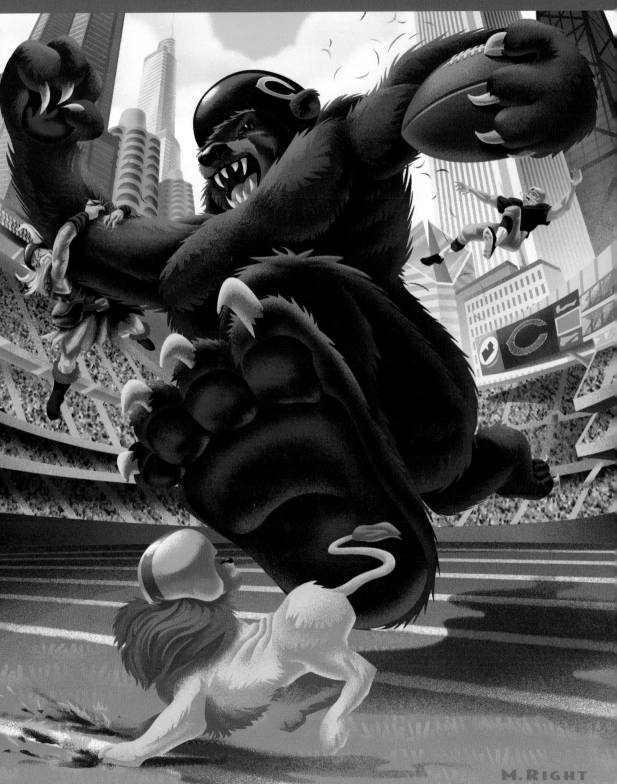

David Preiss

MUNRO
CAMPAGNA

ARTIST
REPRESENTATIVES

MUNROCAMPAGNA.COM
E. steve@munrocampagna.com P. 312.335.8925
630 N State St #2109 Chicago, IL 60654

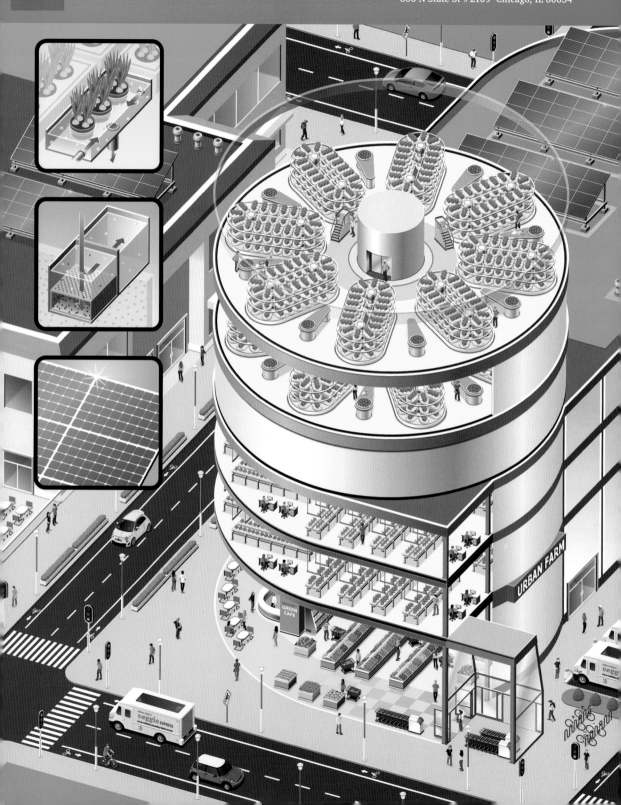

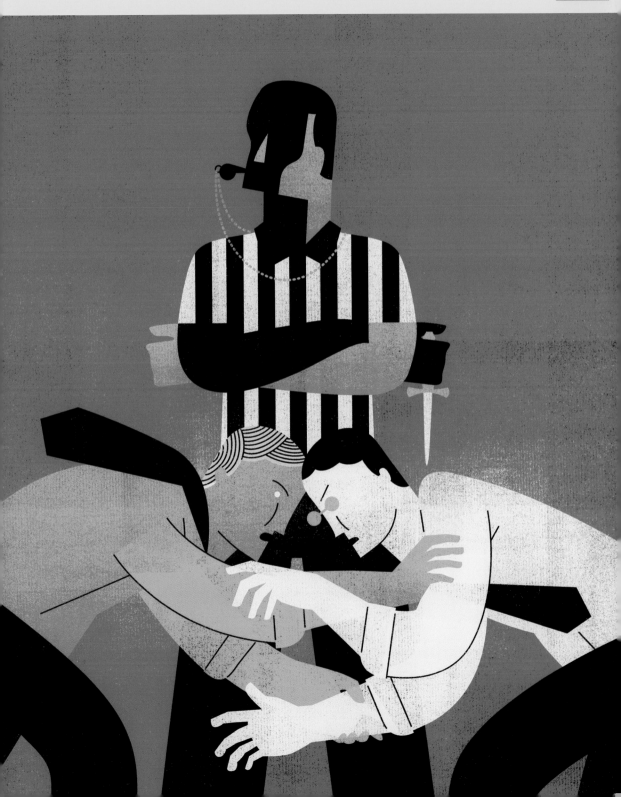

MUNRO
CAMPAGNA

ARTIST
REPRESENTATIVES

Ben Garvie

MUNROCAMPAGNA.COM
E. steve@munrocampagna.com P. 312.335.8925
630 N State St #2109 Chicago, IL 60654

MUNROCAMPAGNA.COM
E. steve@munrocampagna.com P. 312.335.8925
630 N State St #2109 Chicago, IL 60654

Ben Garvie

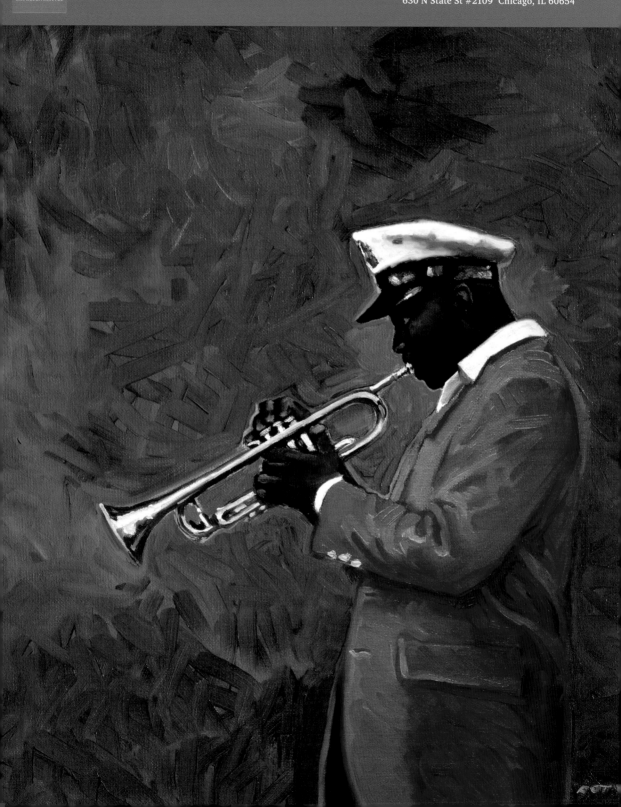

MUNROCAMPAGNA.COM
E. steve@munrocampagna.com P. 312.335.8925
630 N State St #2109 Chicago, IL 60654

Jason Mecier

MUNRO
CAMPAGNA
ARTIST
REPRESENTATIVES

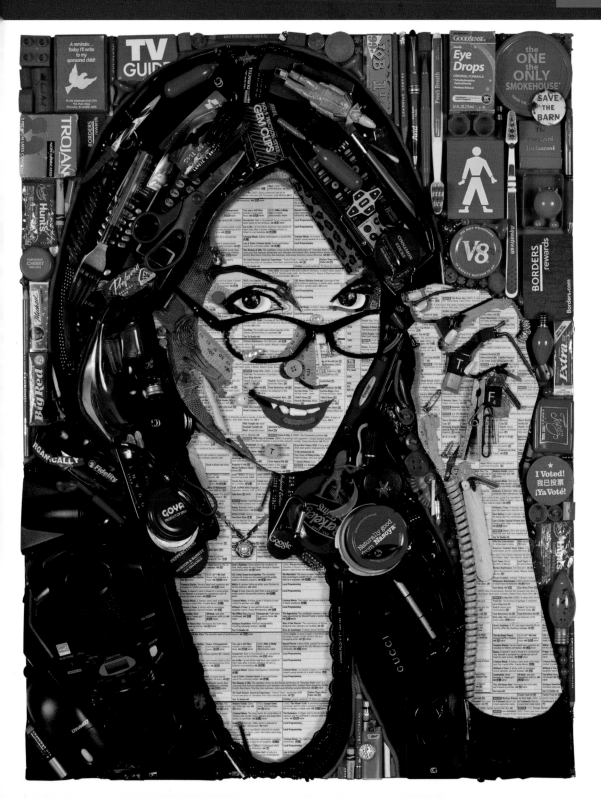

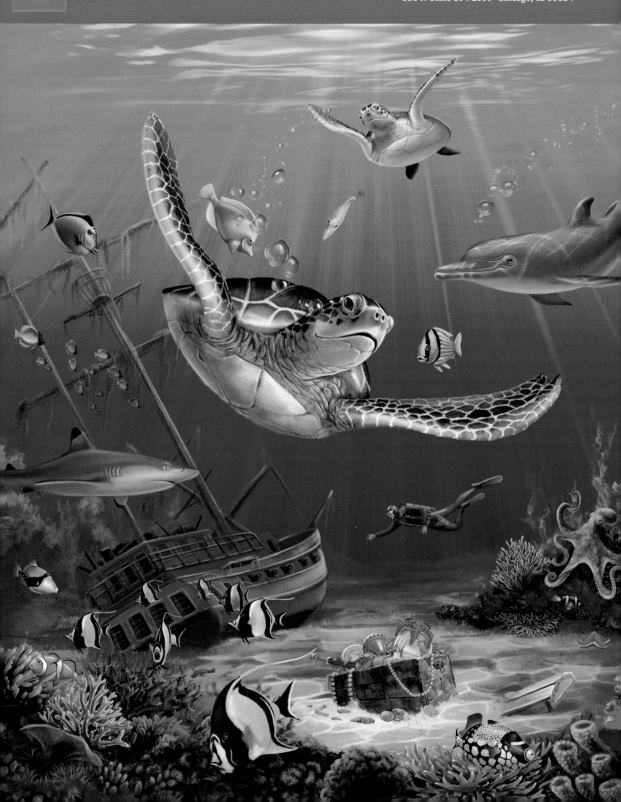

Anne Wertheim

MUNRO
CAMPAGNA

ARTIST
REPRESENTATIVES

MUNROCAMPAGNA.COM
E. steve@munrocampagna.com P. 312.335.8925
630 N State St #2109 Chicago, IL 60654

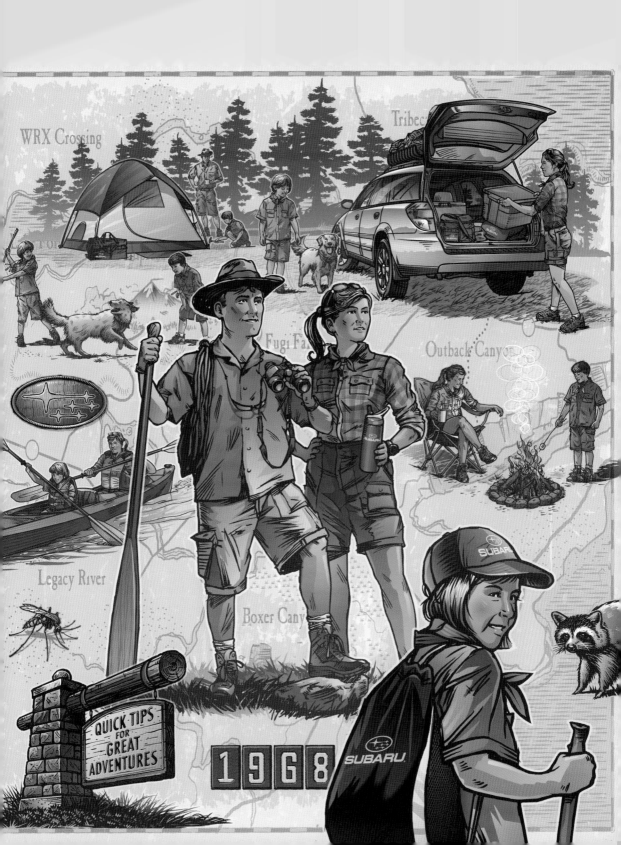

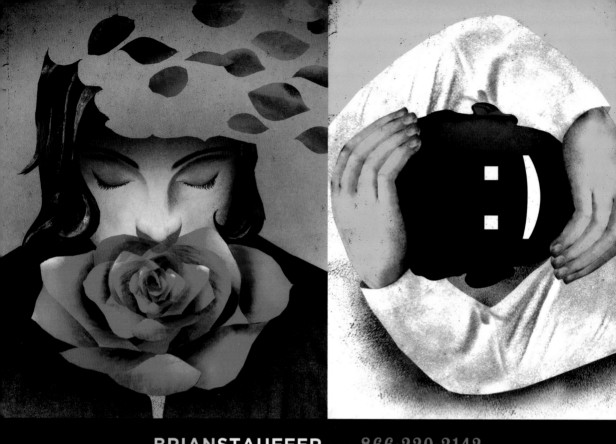

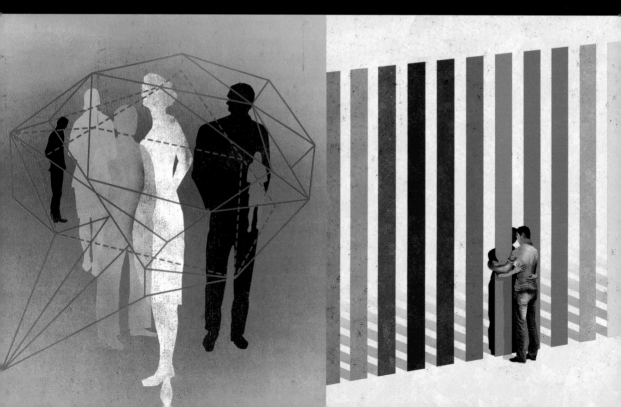

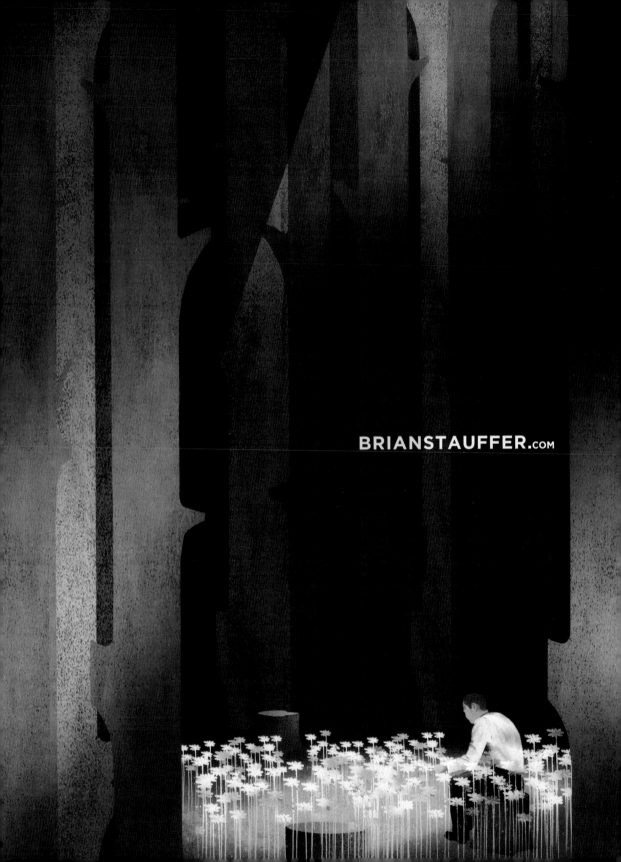

BRIANSTAUFFER.com

tom hennessy • www.hennessyart.com • tom@hennessyart.com • Tel: 415 388-7959
www.workbook.com/portfolios/hennessy

Michael Pallozzi
47 West 38th St., Suite 1001
New York, NY 10018

mike@pallozzidigital.com
office 212-290-0312
cell 973-769-3743

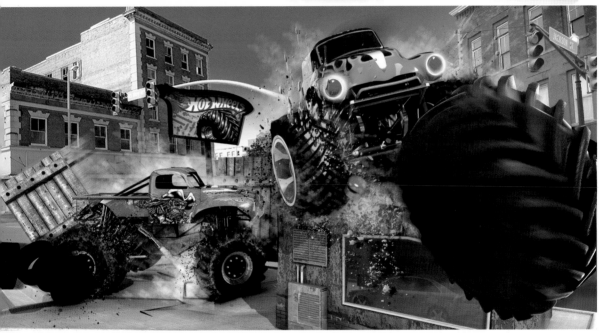

cocotos.com

ILLUSTRATION ▶ ANIMATION ▶ STOCK

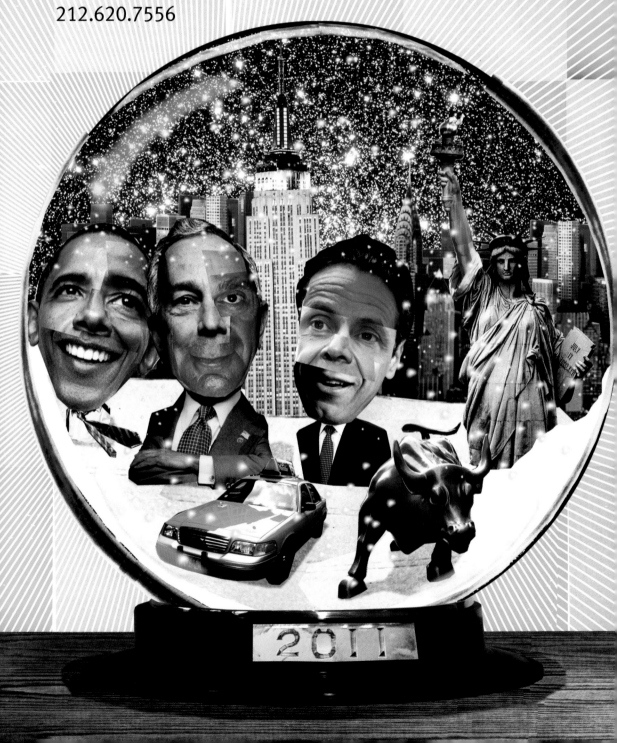

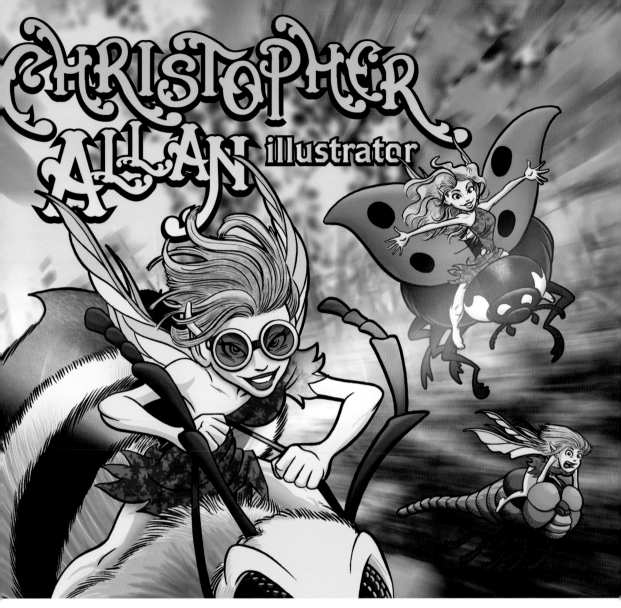

CHRISTOPHER ALLAN illustrator

www.cjksallan.com • 267-218-5787 • chris@cjksallan.com
2715 Line Lexington Rd, Hatfield, PA 19440

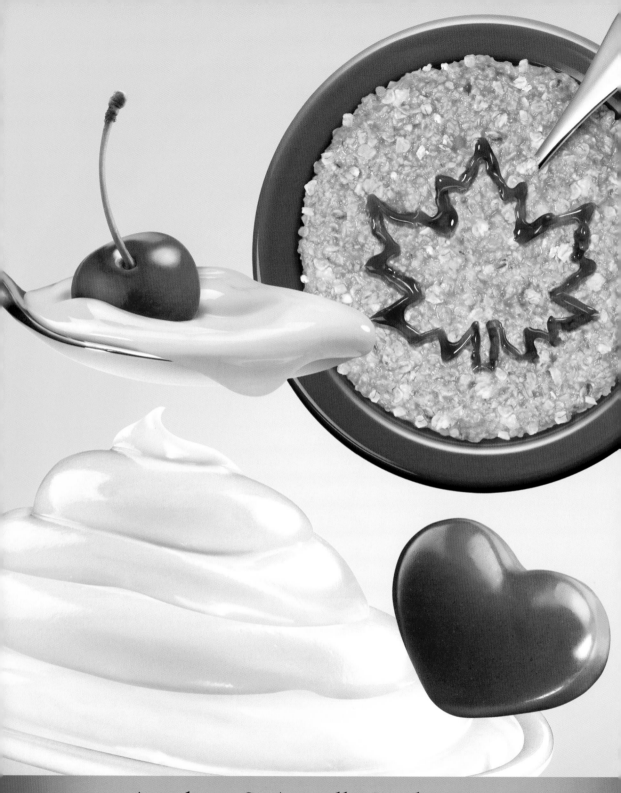

Anzalone & Avarella Studios LLC

973 300 9354 lori@lorianzalone.com lorianzalone.com avarella.com

Russ Charpentier
Classical Maps & Illustration

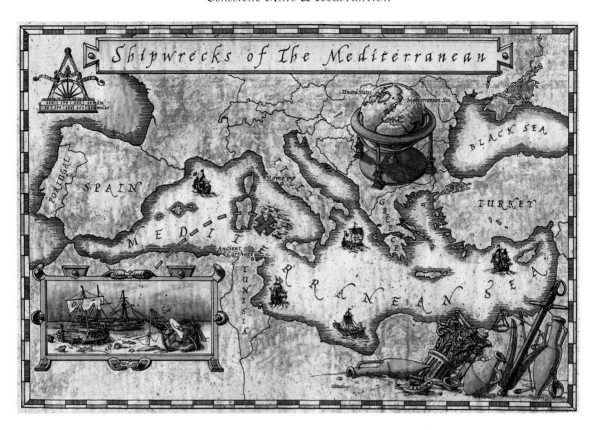

Shipwrecks of The Mediterranean

1445
NEW YORK
AVENUE

Ananas comosus

P I N E A P P L E

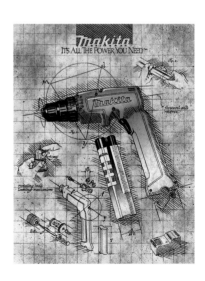

makita
ITS ALL THE POWER YOU NEED™

707.552.7094
russrc@earthlink.net

CHARPENTIER GRAPHICS
workbook.com/portfolios/charpentier

charpentiergraphics.com
theispot.com/artist/charpentier

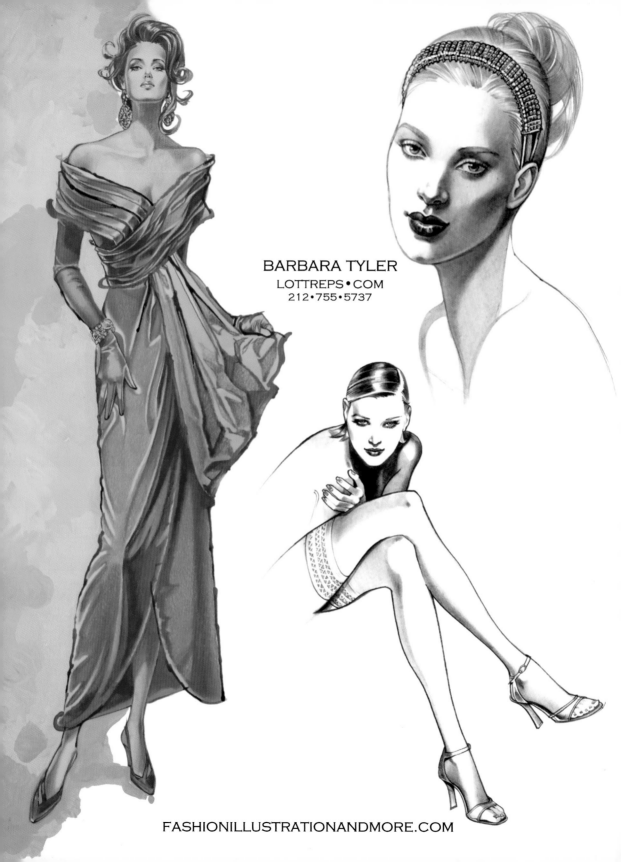

BARBARA TYLER
LOTTREPS•COM
212•755•5737

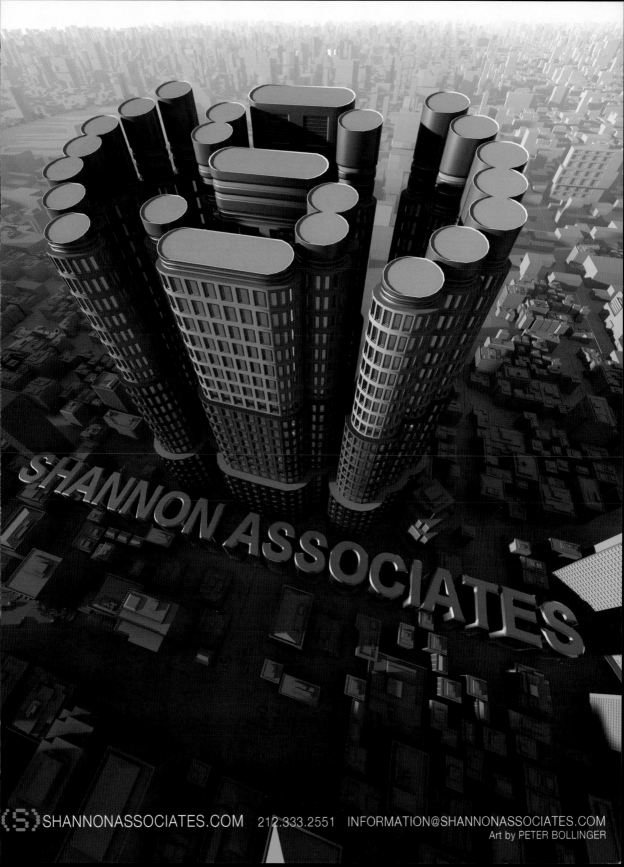

212 333 2551

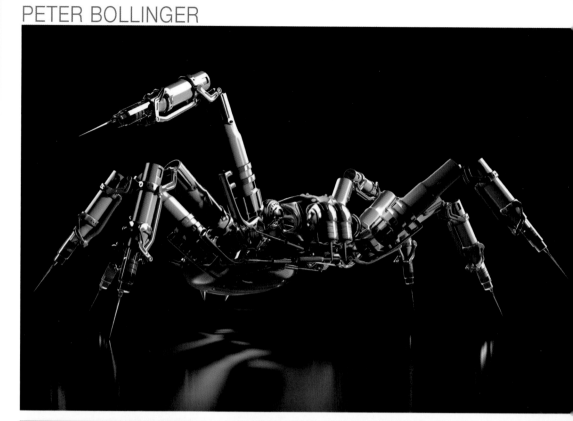

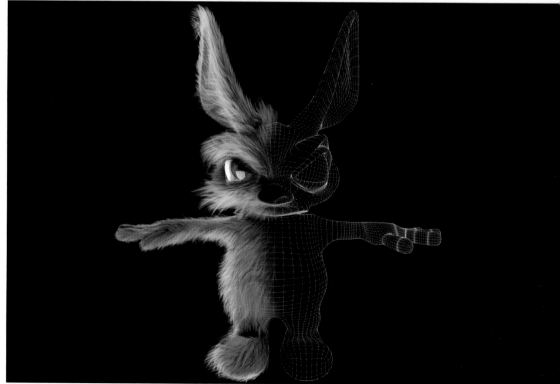

BARDO HOGENDOORN

THE ONLY WAY TO GET IN IS TO WIN

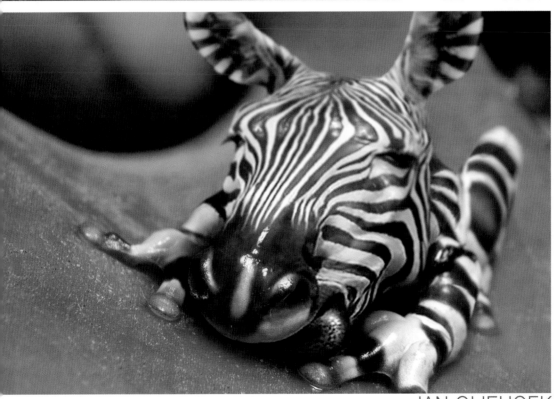

JAN OLIEHOEK

MURILO MACIEL

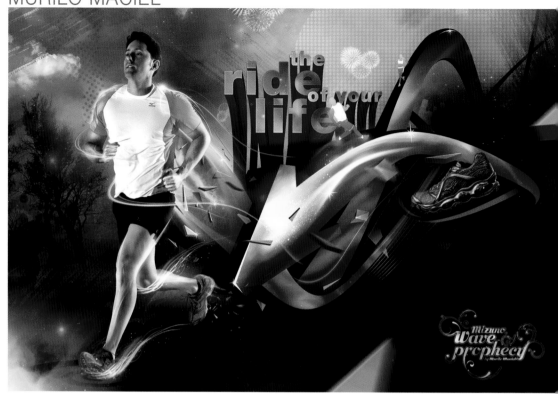

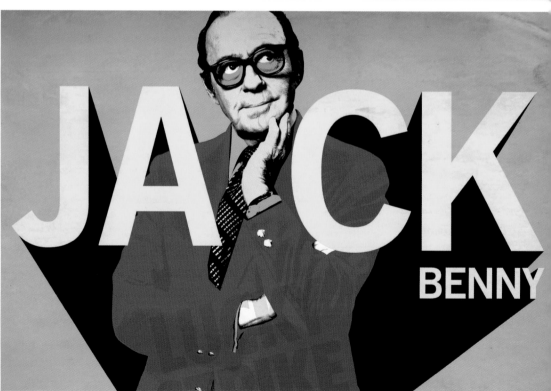

IAN KELTIE

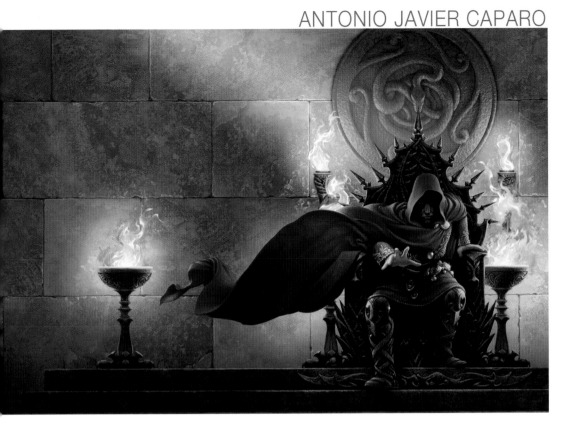

ANTONIO JAVIER CAPARO

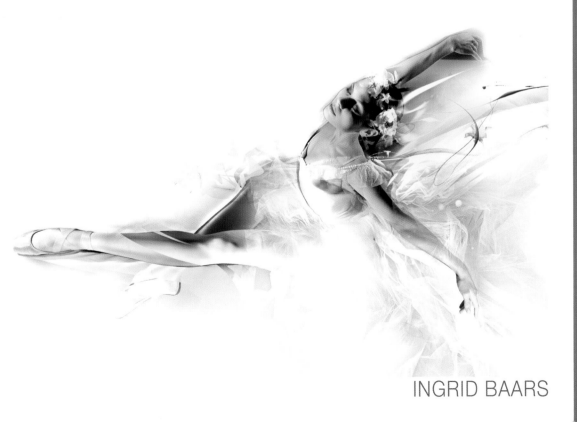

INGRID BAARS

JON PROCTOR

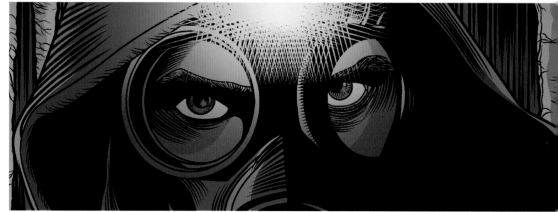

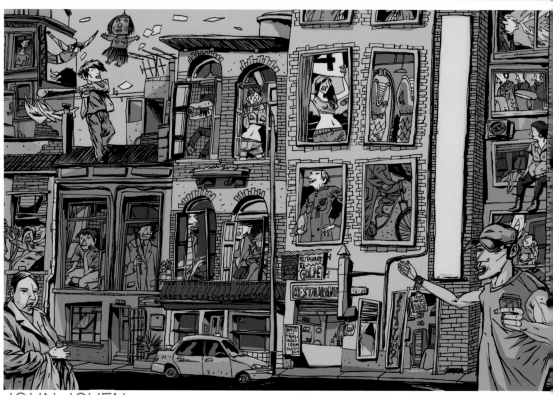

JOHN JOVEN

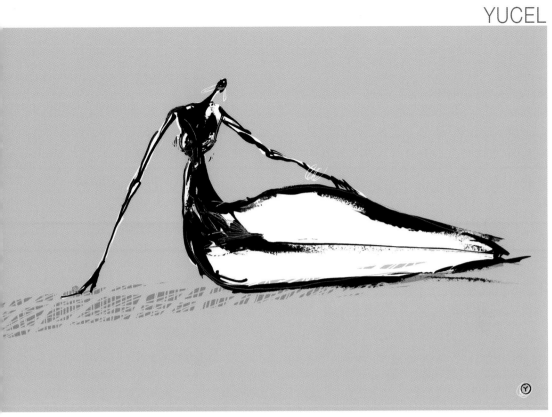

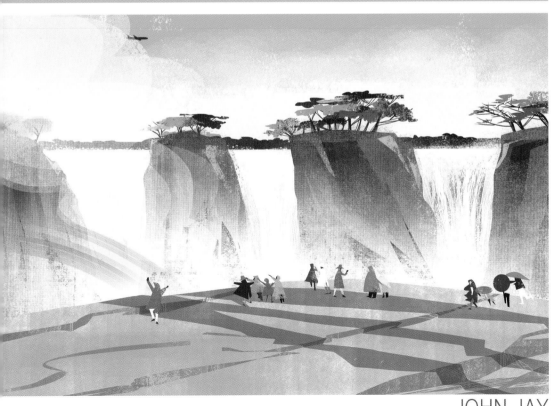

JOHN JAY

SHANE REBENSCHIED

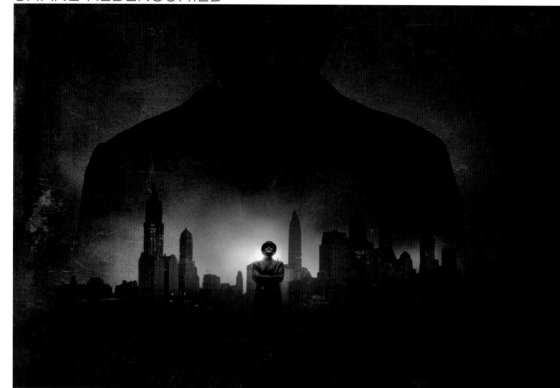

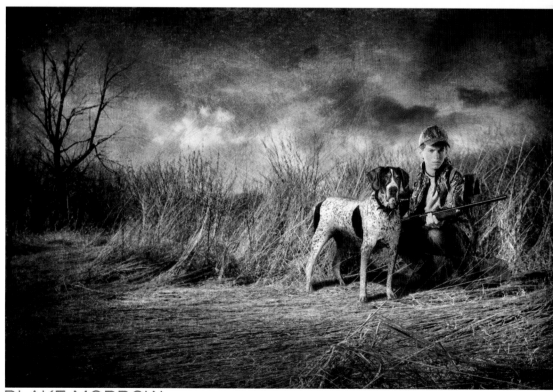

BLAKE MORROW

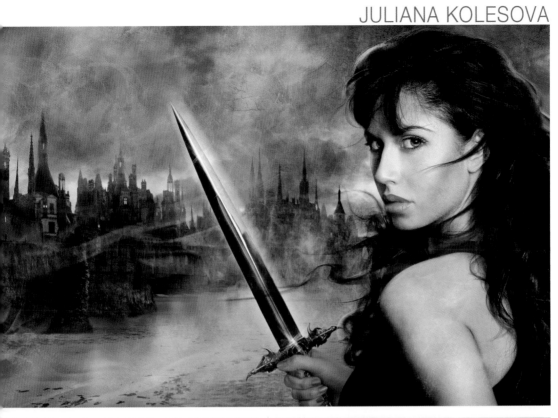

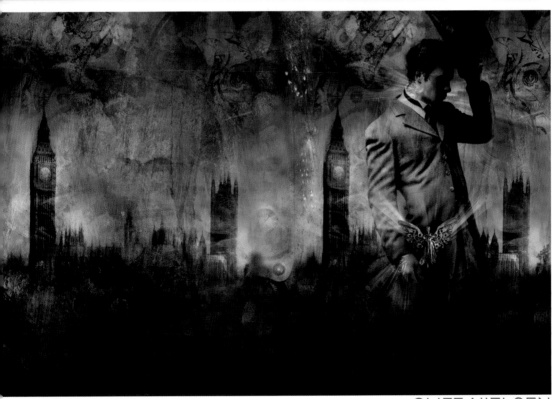

OWEN RICHARDSON

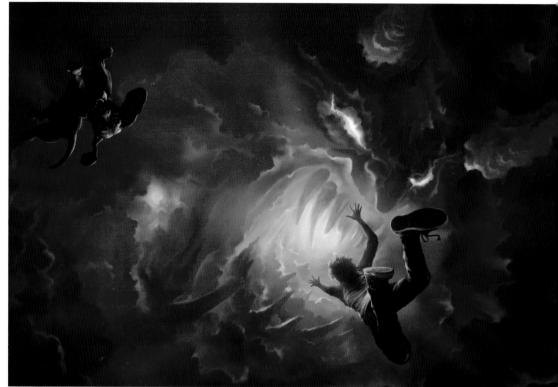

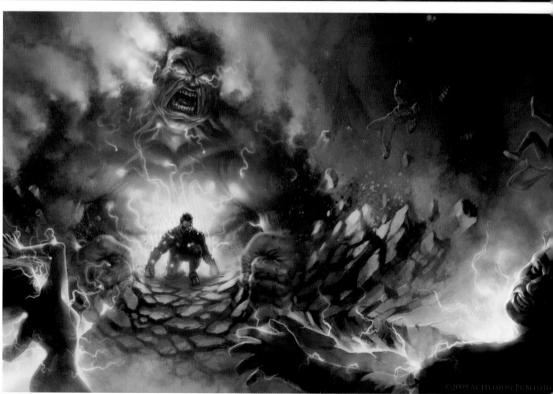

DAVE PHILLIPS

ALAN BROOKS

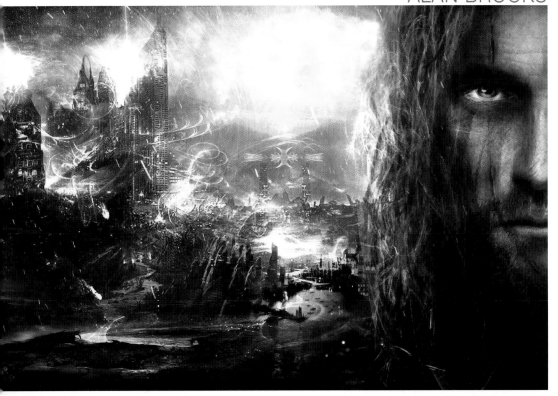

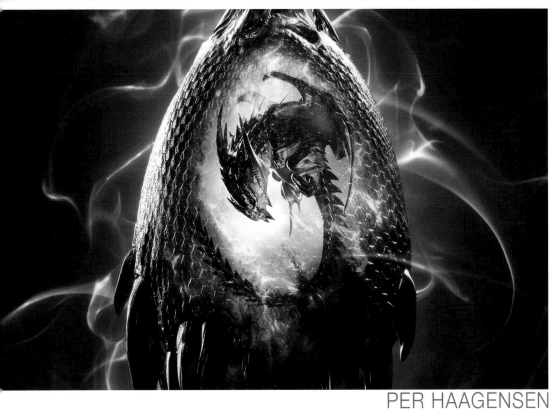

PER HAAGENSEN

GREG CALL

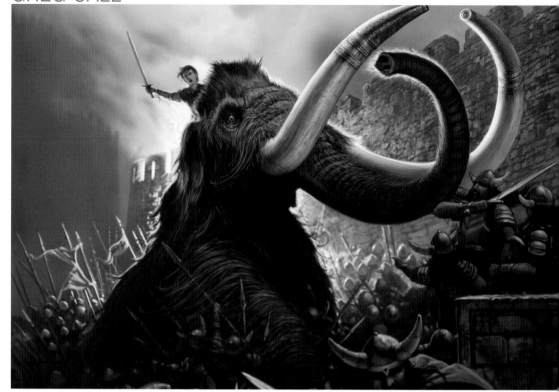

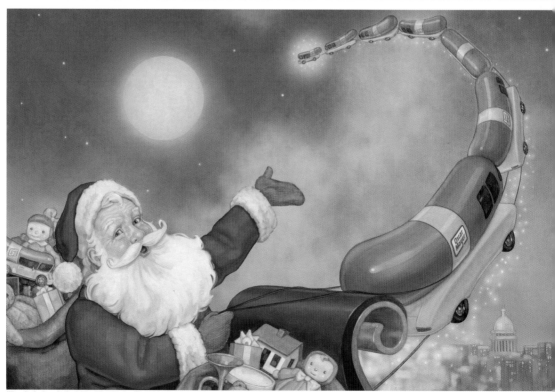

DAN ANDREASEN

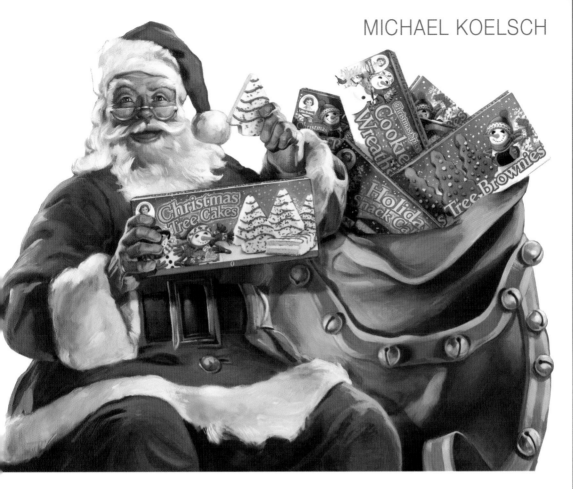

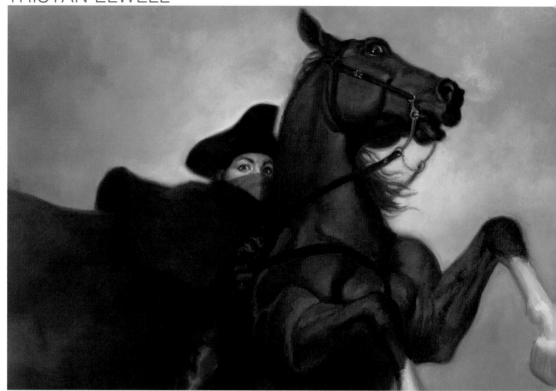

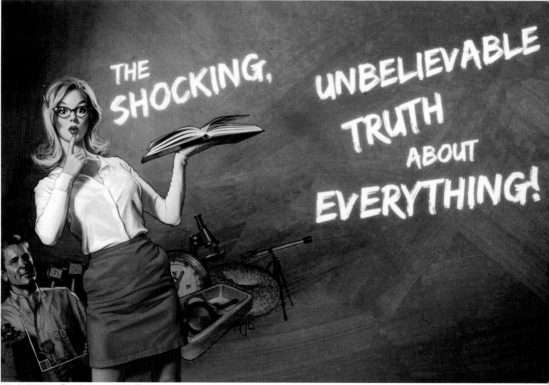

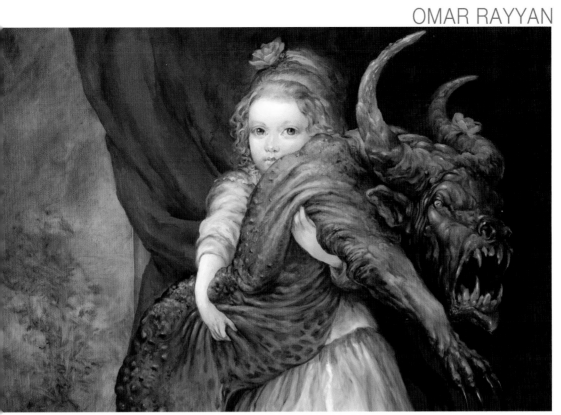

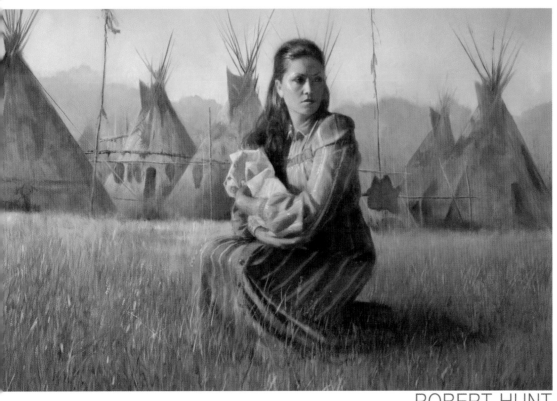

212 333 2551

DOUG HOLGATE

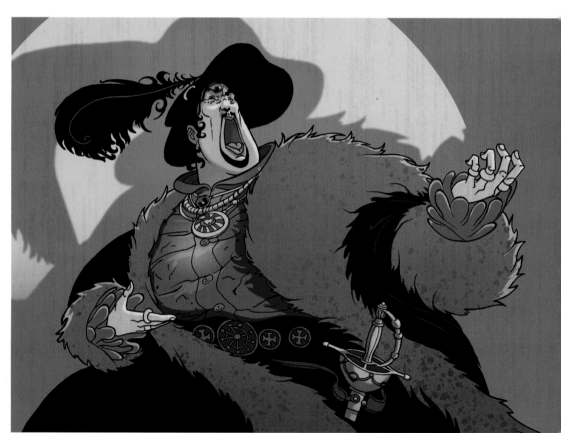

CRAIG PHILLIPS

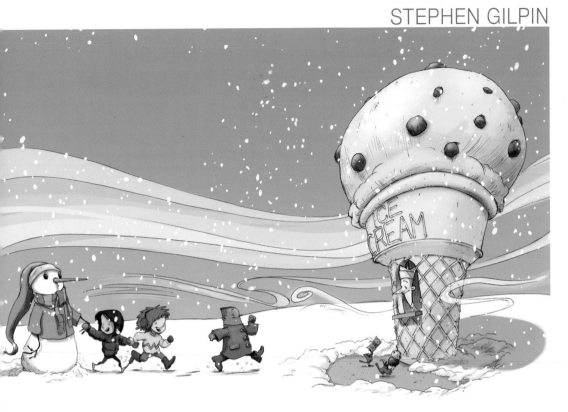

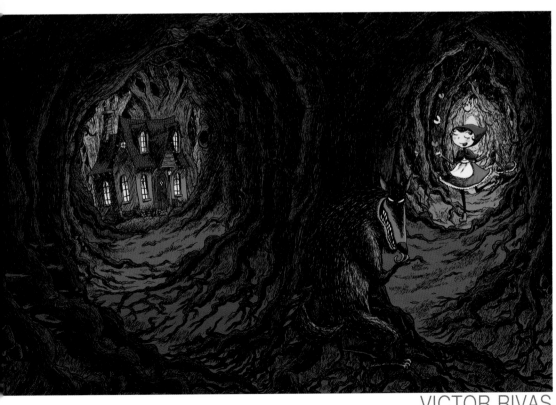

GUILHERME MARCONI

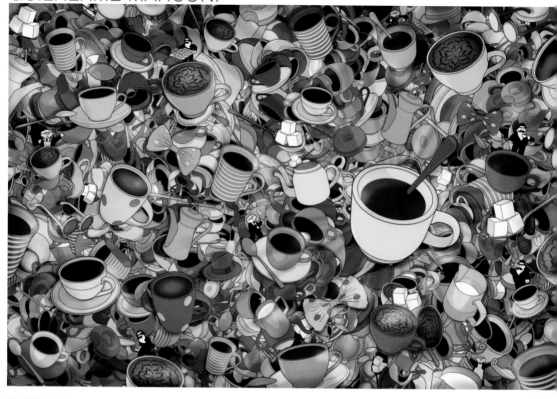

212 333 2551

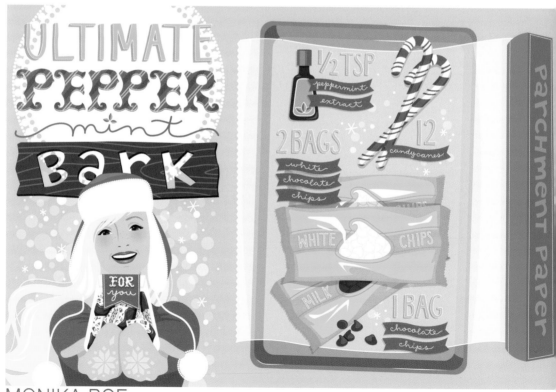

MONIKA ROE

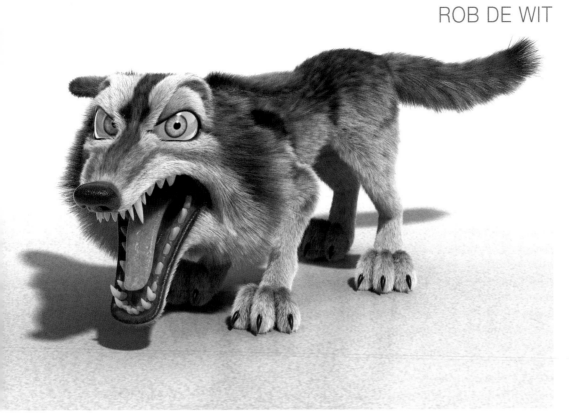

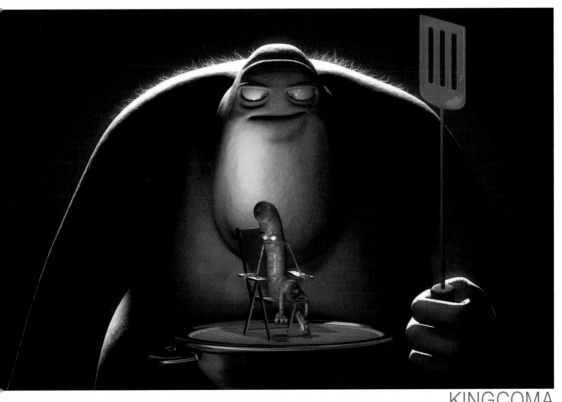

KINGCOMA

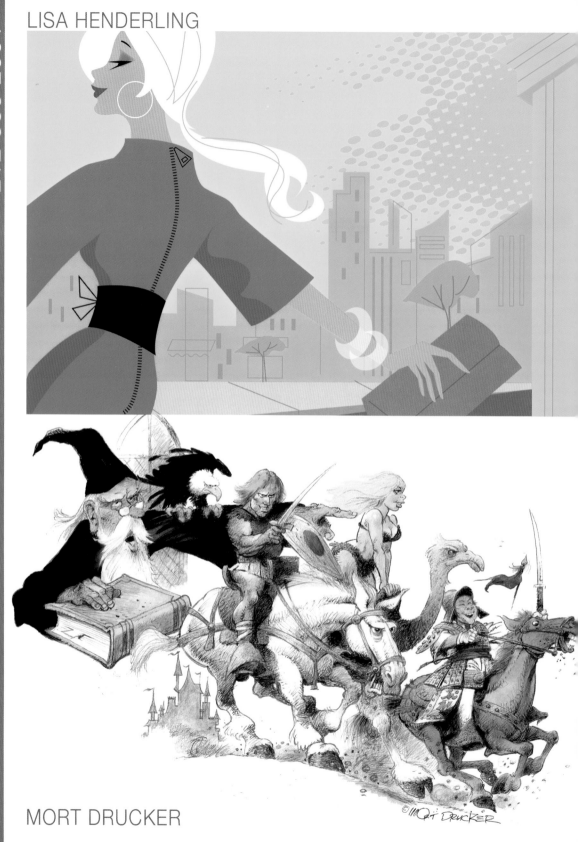

LISA HENDERLING

212 333 2551

MORT DRUCKER

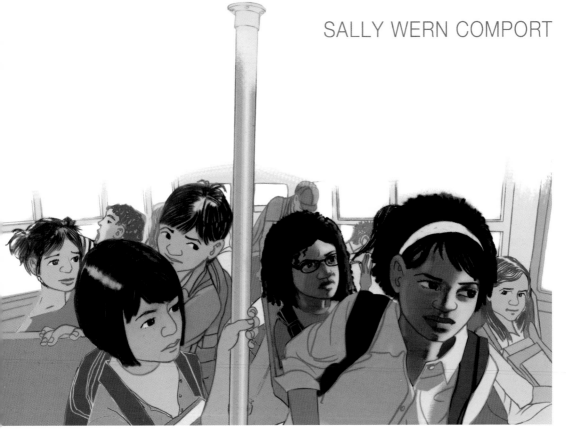

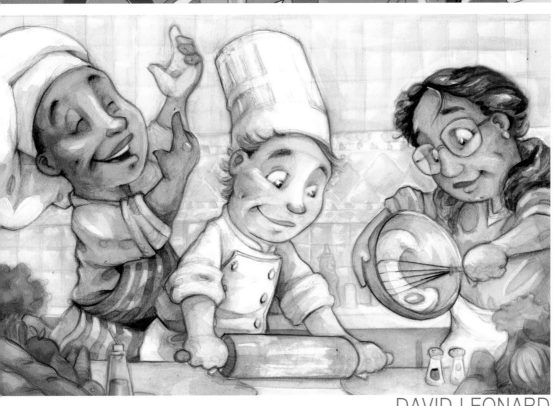

JIMMY HOLDER

212 333 2551

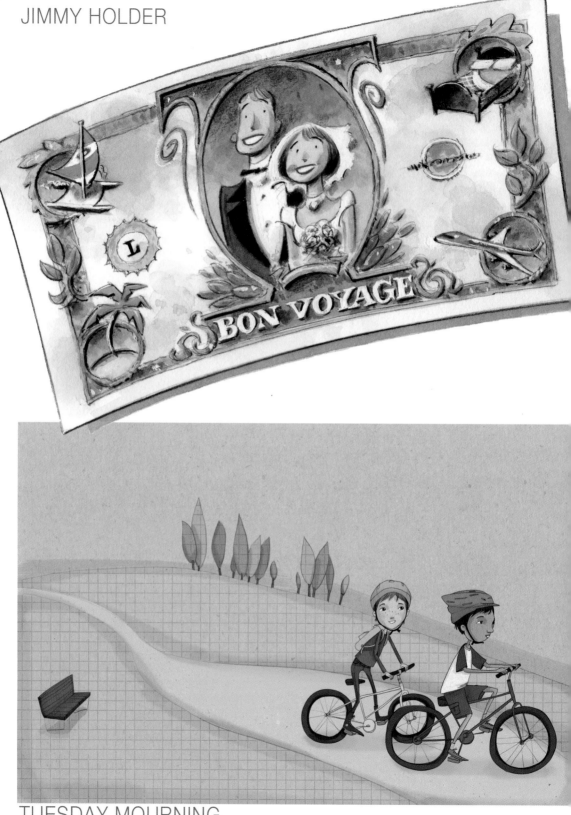

BON VOYAGE

TUESDAY MOURNING

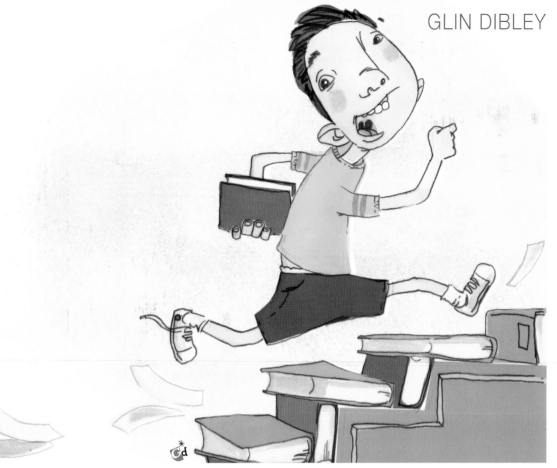

GLIN DIBLEY

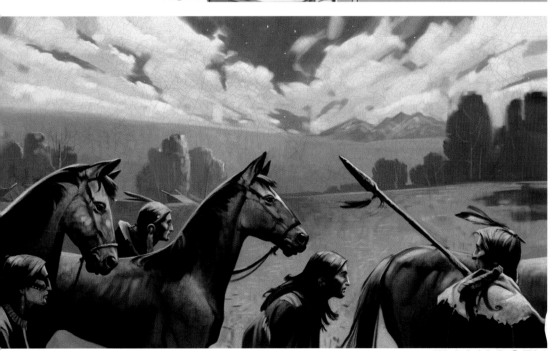

JIM MADSEN

ALEXANDERSEN

BARRETT

BATES

BELL

CALO

CASTELAO

CIMATORIBUS

CORTS

CURREY

CURTIS

FRANCIS

GUERLAIS

HAJDINJAK

HALE

HALEY

HALL

HANSEN

HENRY

HIBBERT

JACK

KIM

LAUGESEN

LEICK

LINTERN

MCGUIRE

MITCHELL

MONESCILLO

NGUYEN

O'KIF

OBERDIECK

OLSON

ONG

PARKS

ROOS

SAKAMOTO

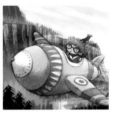

SCALES

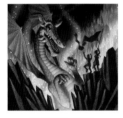

SHROADES

SIMON

SULLIVAN

WAKEFIELD

KID

shannon

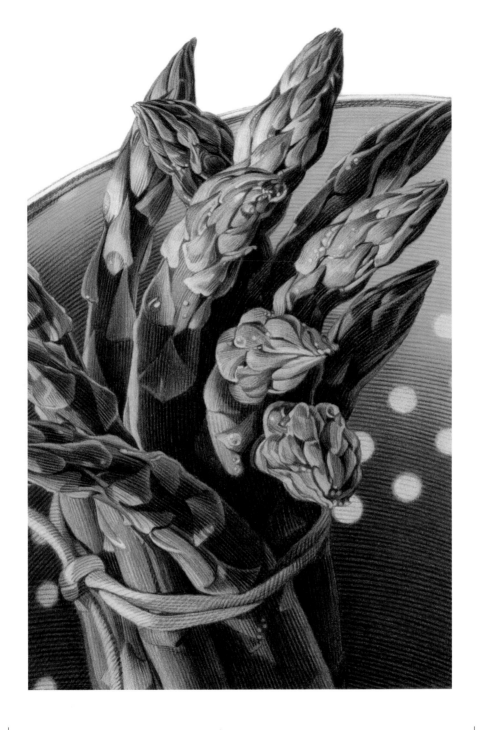

LINDA FENNIMORE | LZFENNIMORE@VERIZON.NET

(212) 866 - 0279 | WORKBOOK.COM/PORTFOLIOS/FENNIMORE

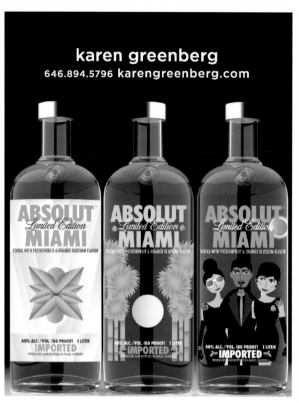

karen greenberg
646.894.5796 karengreenberg.com

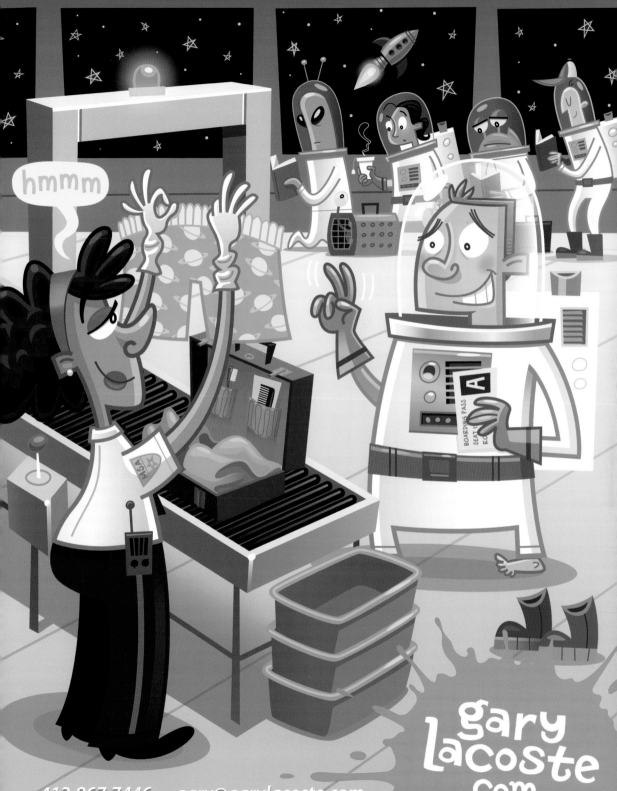

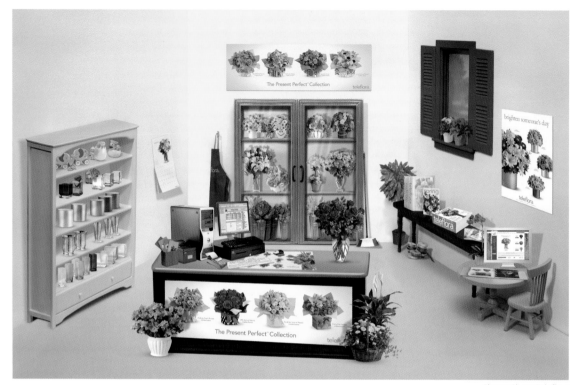

Flower Shop: *Teleflora*

Wish Upon A Bubble: *Orange Coast Magazine*

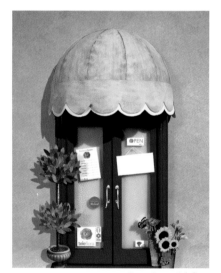

Front Door: *Teleflora*

www.pushart.com

meganBerkheiser@pushart.com mikeCaldwell@pushart.com 212.615.6707

RICHARD THOMPSON *ILLUSTRATION*

Visual problem solving, digital image creation and photo retouching services. I use Photoshop, 3D software and digital photography to create images for billboards, posters, transit shelters, point of purchase, packaging, magazine, corporate collateral, direct mail and anything else you can think of. With 20 years of experience, my specialty is short deadlines ;-) Visit my website to request a free printed portfolio, to see over 100 images and check out the section on how it's all done:

WWW.RTILLUSTRATION.COM

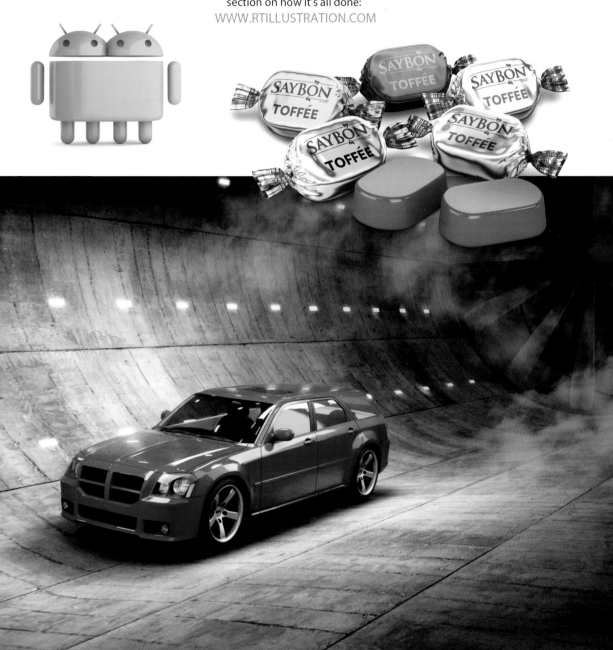

E-MAIL: RICK@RTILLUSTRATION.COM PHONE: 1-905-425-0093 CELL: 1-905-718-9633

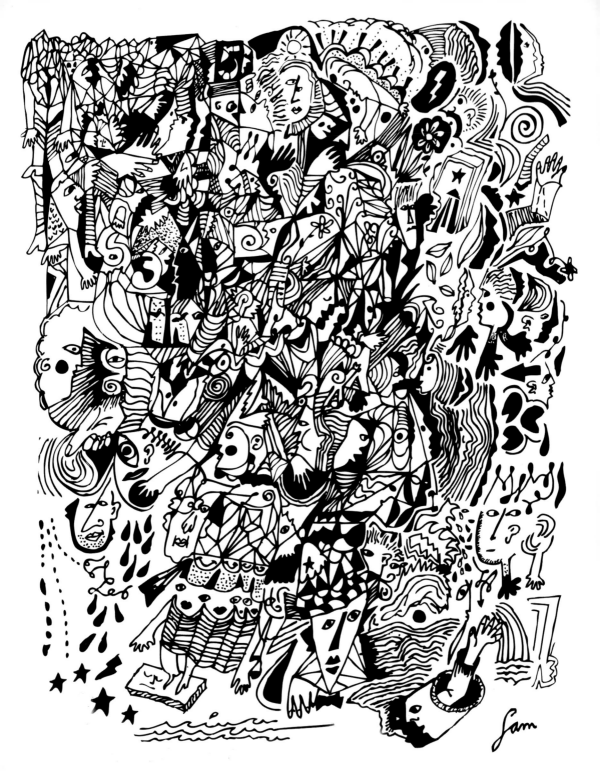

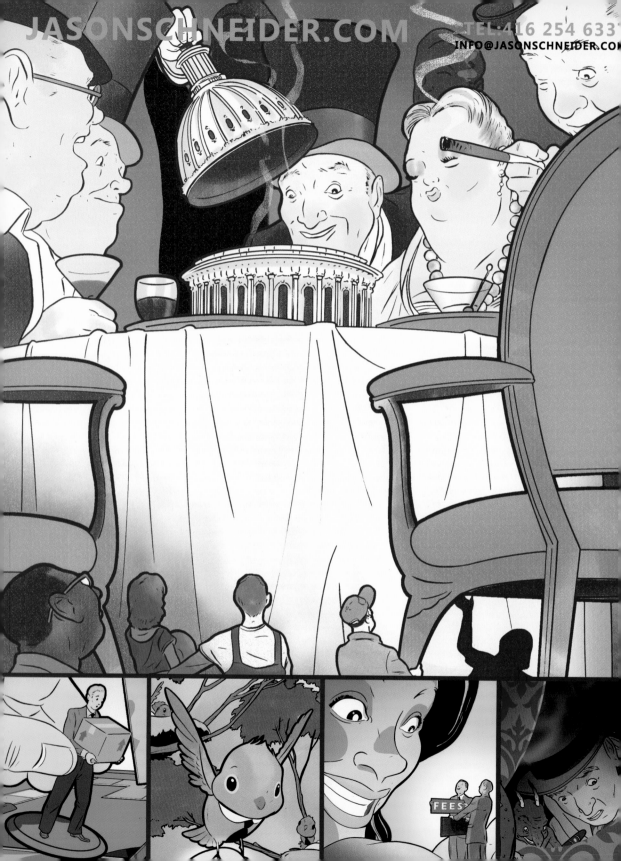

FEES

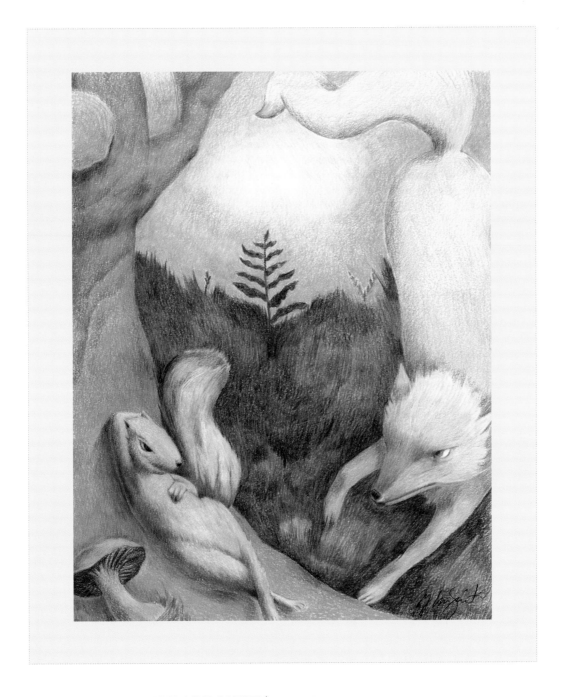

MARY ANN SMITH | illustration

(212) 691-3570 | maryann.smith14@verizon.net

90 Franklin Street, New York, NY 10013

view my portfolio at **www.maryannsmithwork.com**

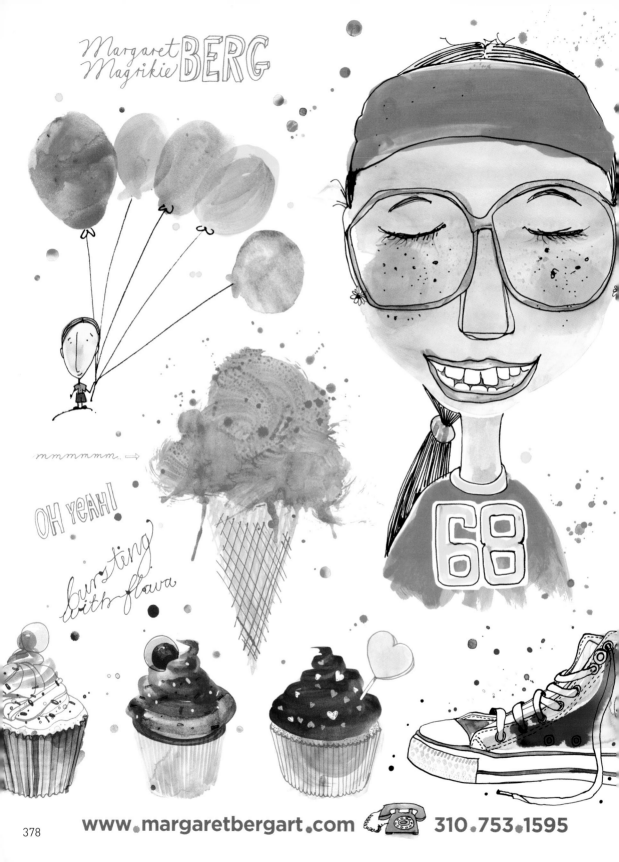

Margaret Magrikie BERG

OH YEAH!

bursting with flava

mmmmmm ⟶

www.margaretbergart.com ☏ 310.753.1595

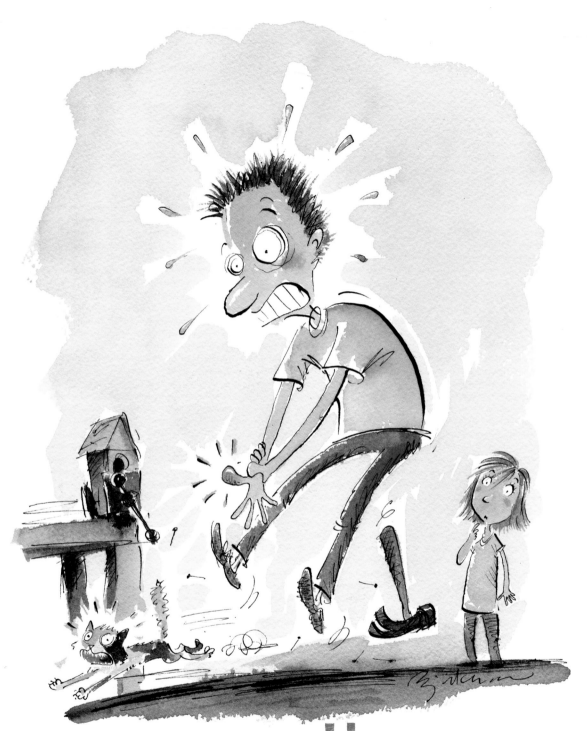

STEVE BJÖRKMAN

STEVEBJORKMAN.COM 949-349-0109 STEVEBJORKMAN@SBCGLOBAL.NET

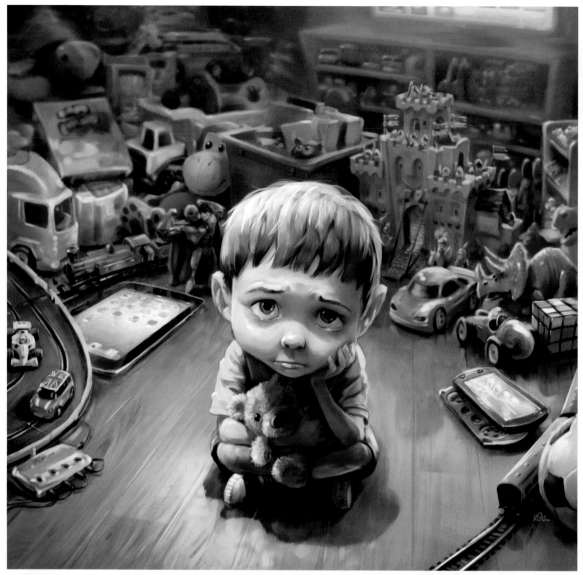

howard mcwilliam

blascocreative.com 312.782.0244

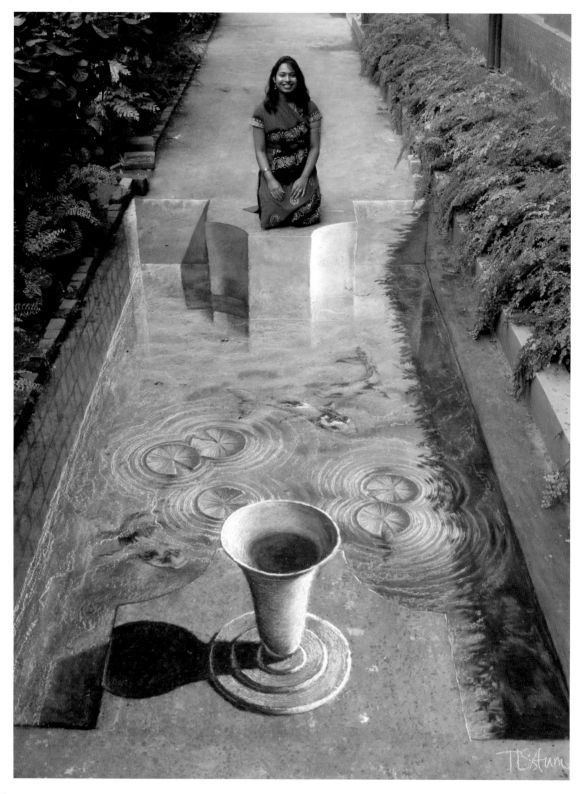

382

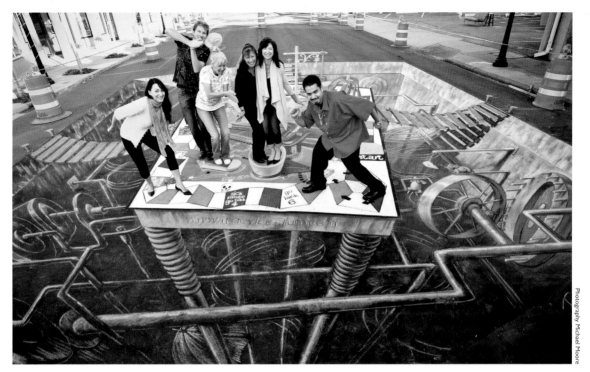

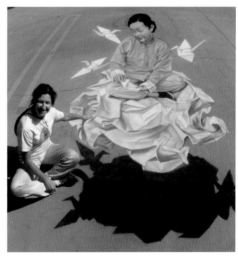

tracy lee stum | 3-d chalk art

3-d | advertising | marketing | events | commissions

contact Justin Sudds 604.734.5945 tracyleestum.com

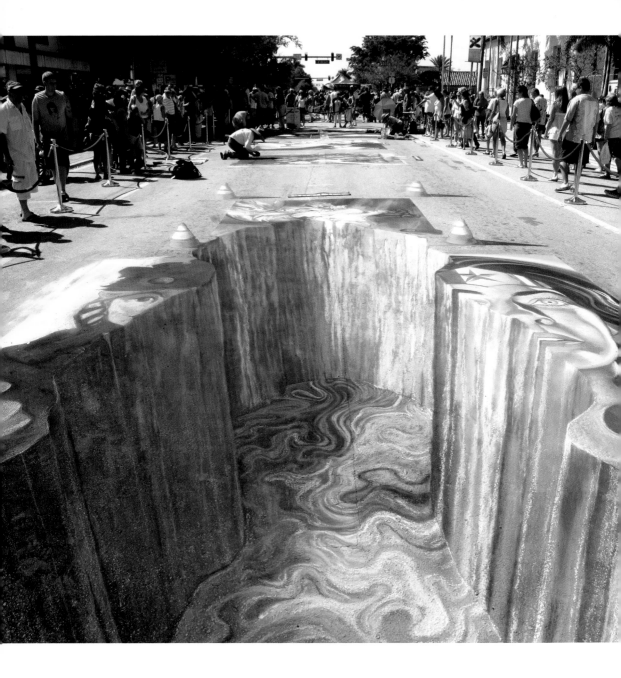

tracy lee stum | 3-d chalk art
3-d | advertising | marketing | events | commissions

contact Justin Sudds 604.734.5945 tracyleestum.com

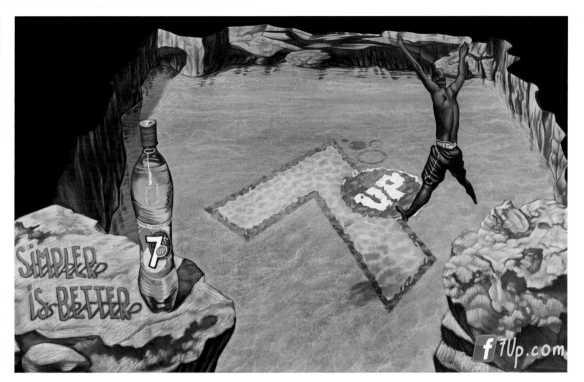

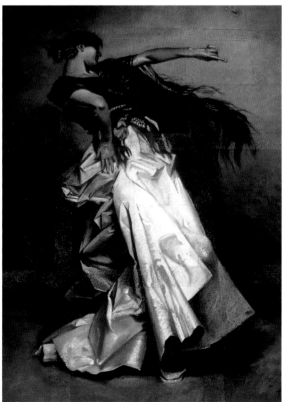

VALENTINA BELLONI

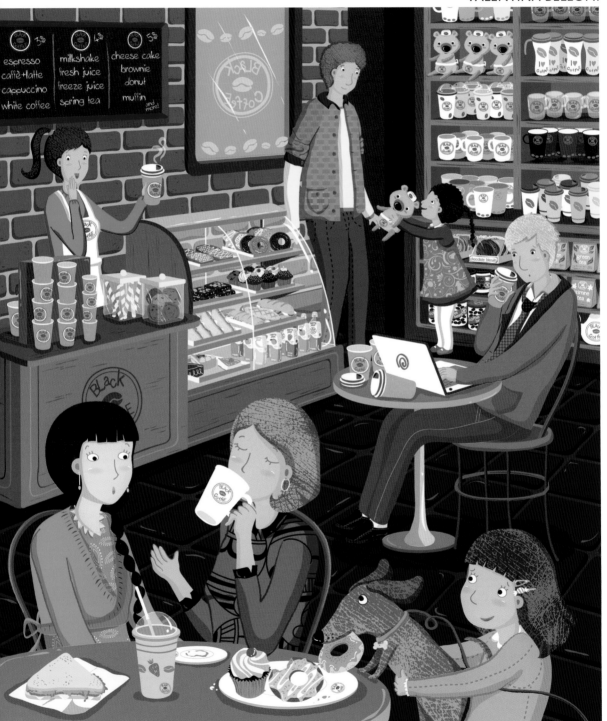

MELA BOLINAO T 212 689.7830 F 212 689.7829 www.mbartists.com

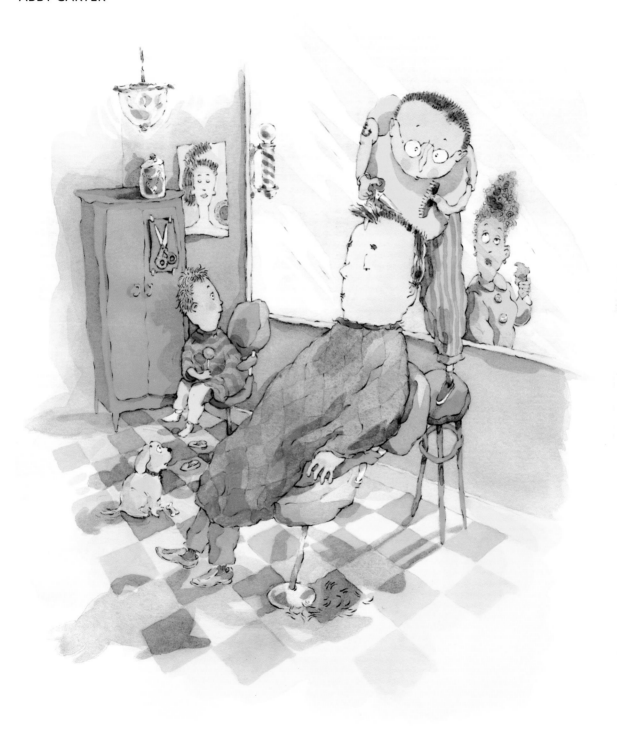

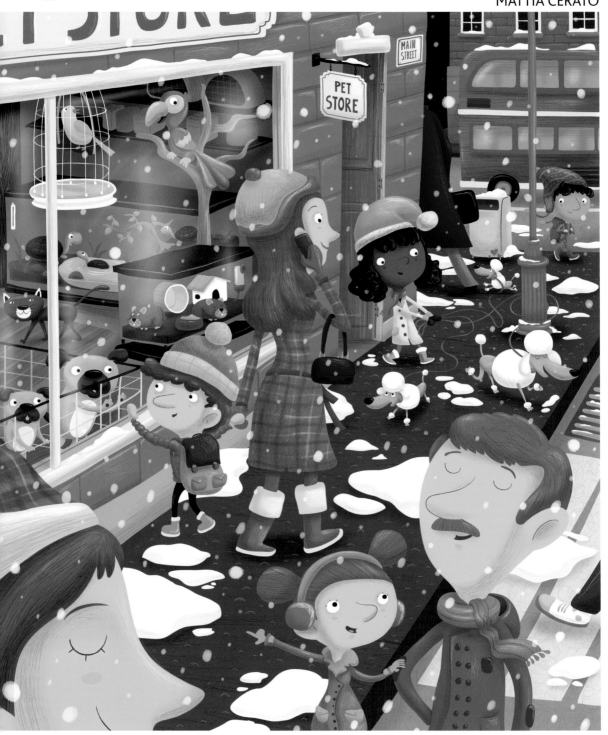

MELA BOLINAO **T** 212 689.7830 **F** 212 689.7829 www.mbartists.com

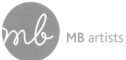

DANIEL GRIFFO

MELA BOLINAO T 212 689.7830 F 212 689.7829 www.mbartists.com

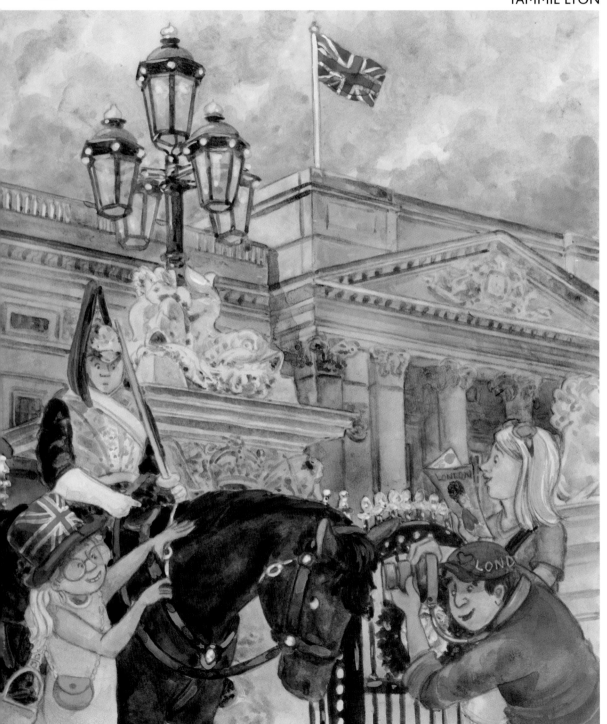

MIKE REED

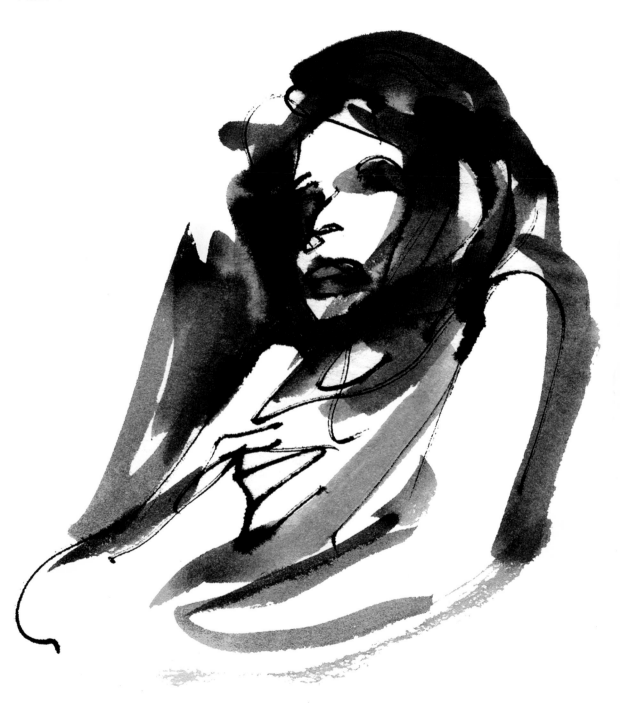

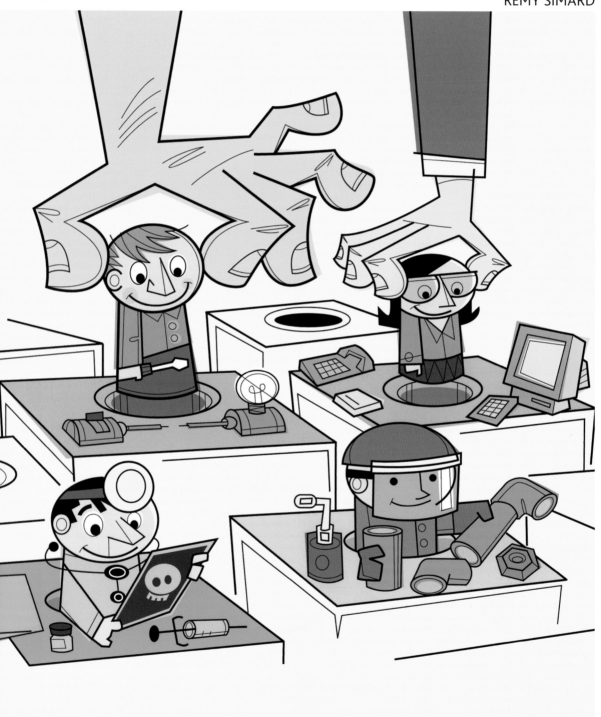

MELA BOLINAO T 212 689.7830 F 212 689.7829 www.mbartists.com

HECTOR BORLASCA

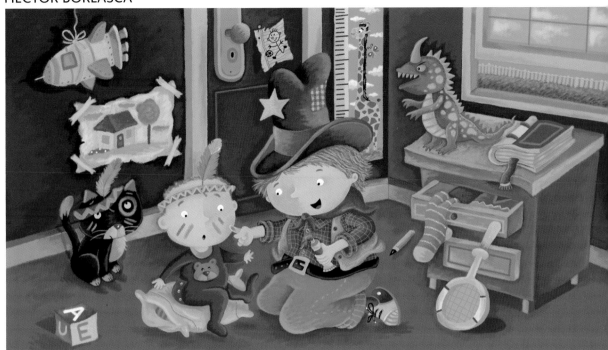

LINDA BRONSON

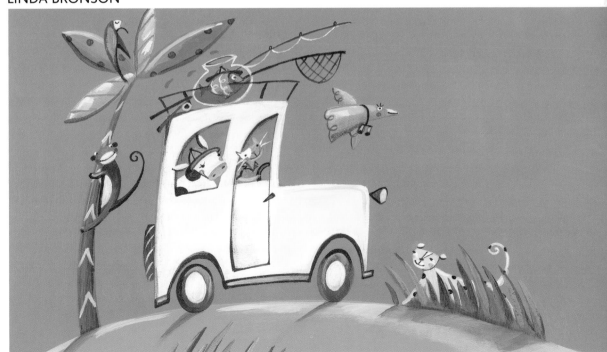

VALERIA CIS

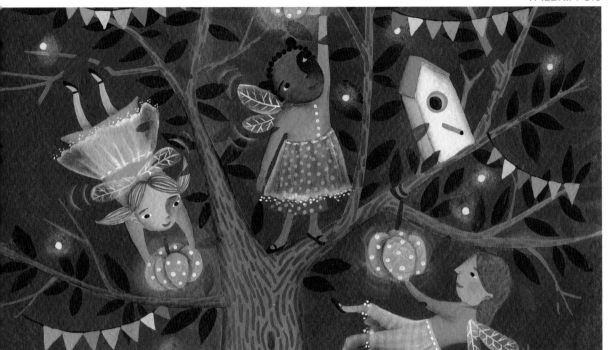

SERGIO DE GIORGI

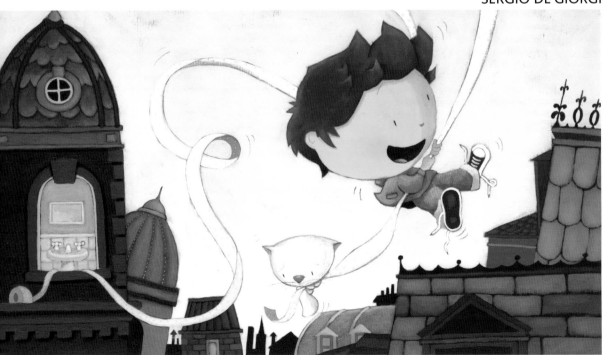

ELDON DOTY

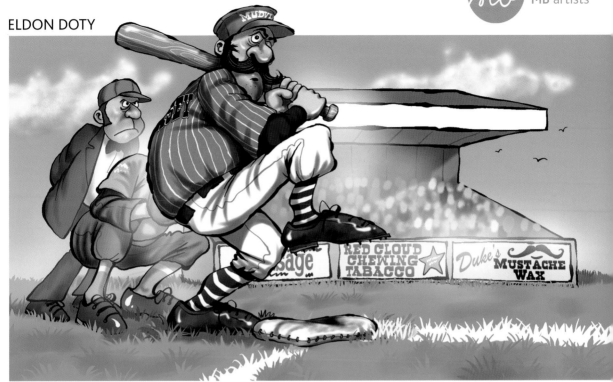

CAROLINA FARÍAS

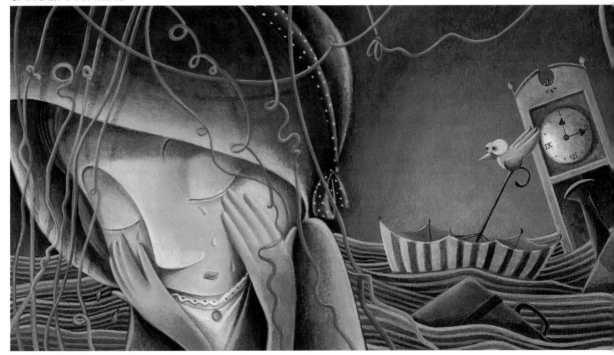

VIVIANA GAROFOLI

MONICA GUTIERREZ

MELA BOLINAO T 212 689.7830 F 212 689.7829 www.mbartists.com

JANNIE HO

LAURA HULISKA-BEITH

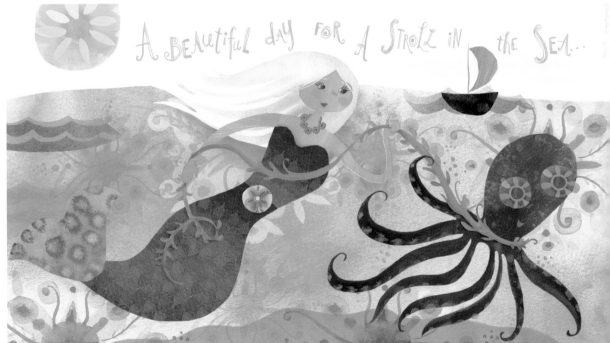

MELA BOLINAO T 212 689.7830 F 212 689.7829 www.mbartists.com

MB artists

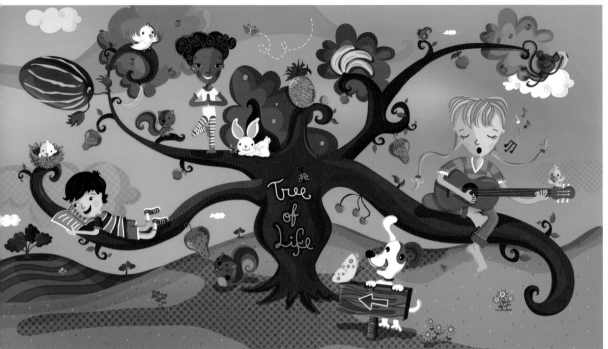

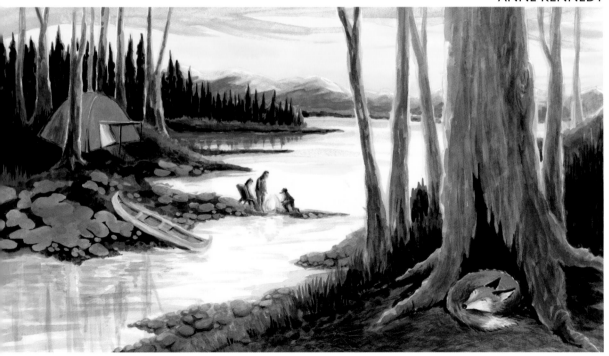

MELA BOLINAO **T** 212 689.7830 **F** 212 689.7829 www.mbartists.com

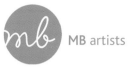

HIROE NAKATA

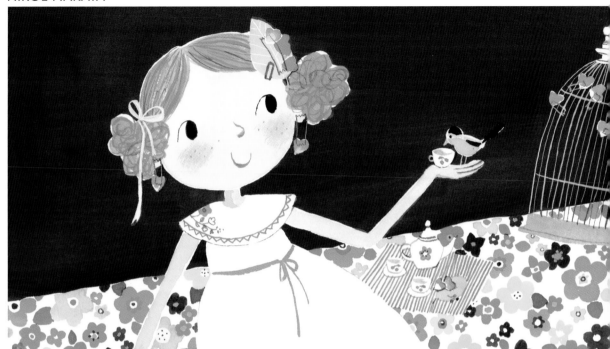

MACKY PAMINTUAN

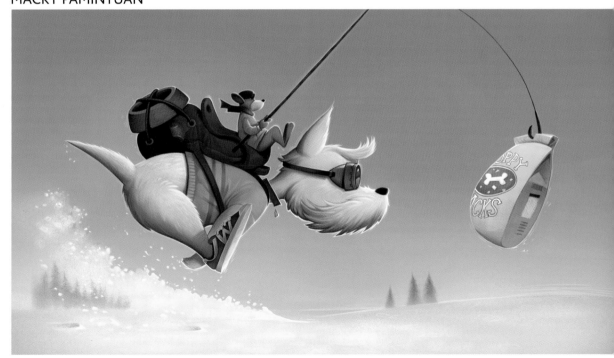

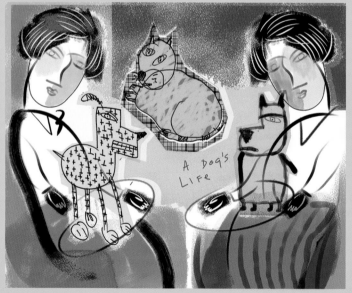
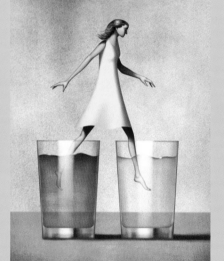
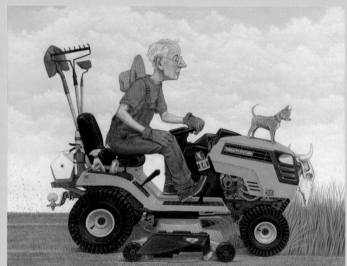
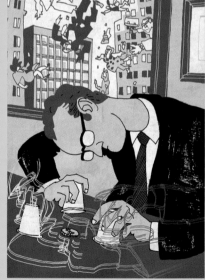

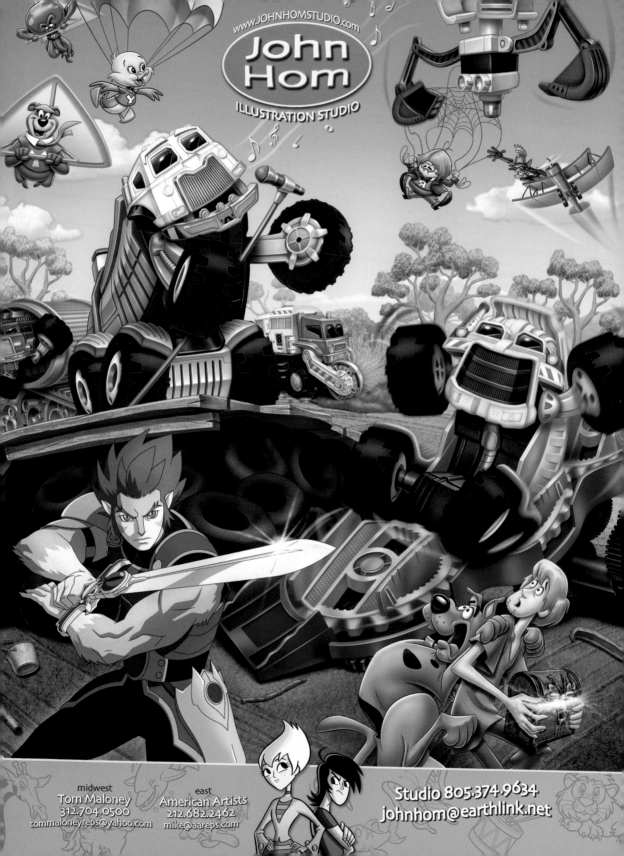

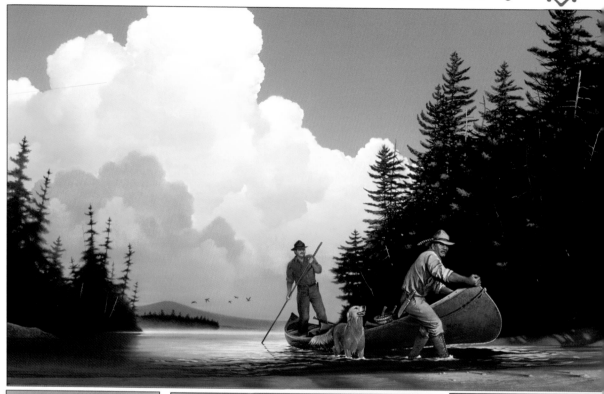

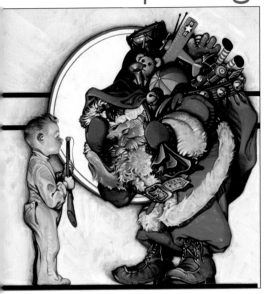

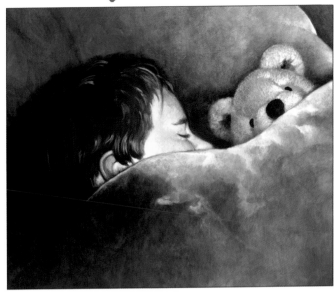

Children's Entertainment: Backstory, Character & Product Development & Design for Hasbro, Mattel, CBS

Trade Books: Abrams, Simon & Schuster, Lyons & Burford, National Geographic Books, Abbeville

Children's Books: HarperCollins, Zondervan, Little Brown, Knopf, Doubleday, Hyperion, Crown

Commercial: American Express, AT&T, Leupold Optics, Citibank, FedEx, Ford,

Time, Adidas, Burger King, Life, Newsweek, Cabela's, Parks Canada,

City of Chicago, CNN, Turner Broadcasting, Field & Stream

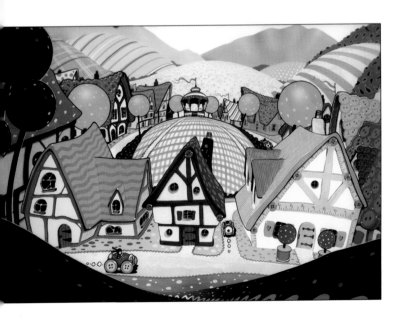

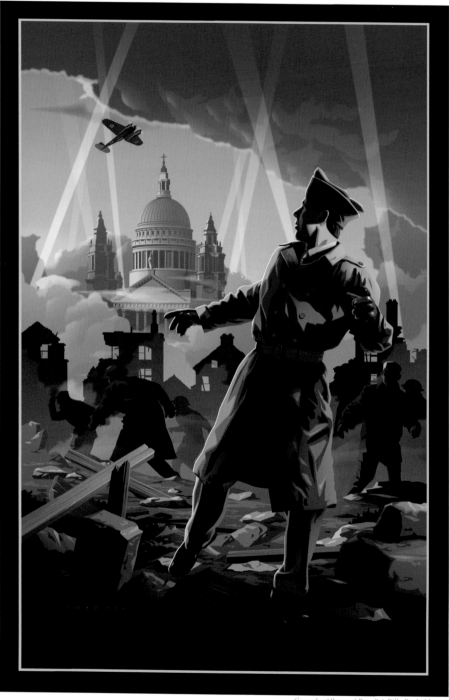

Cover for "Rag and Bone" A Billy Boyle Mystery

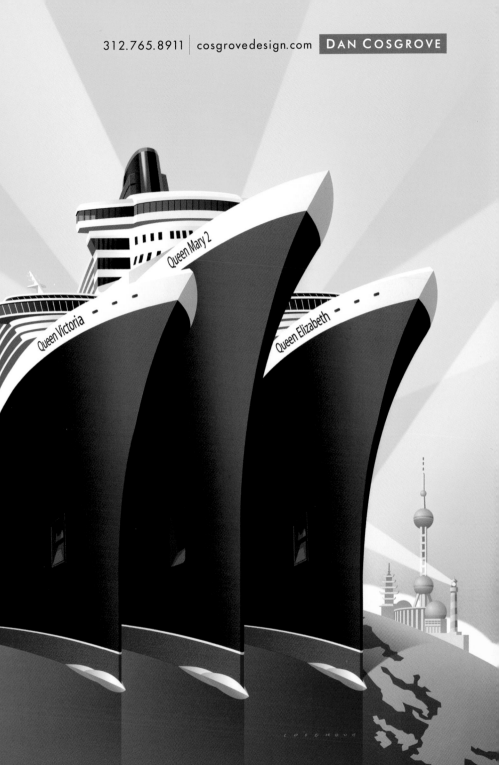

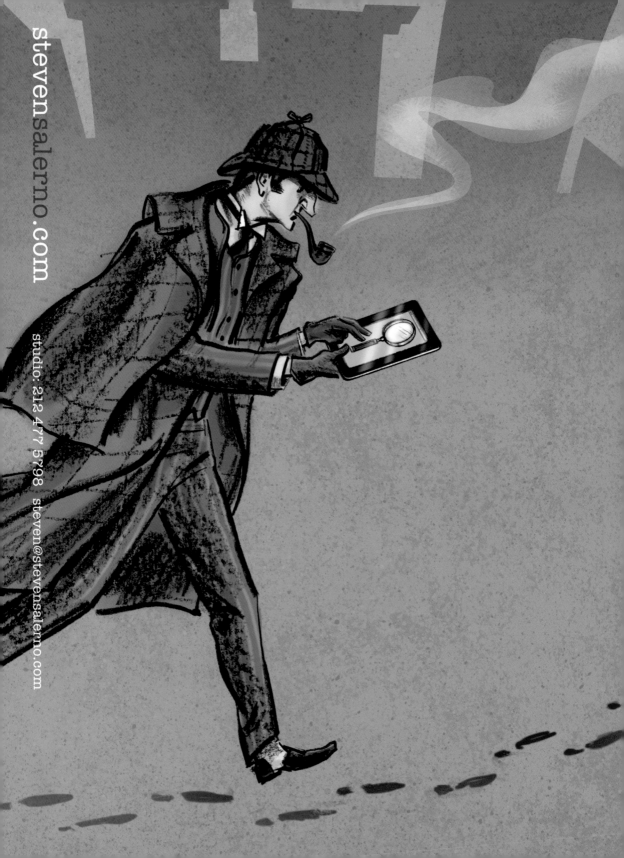

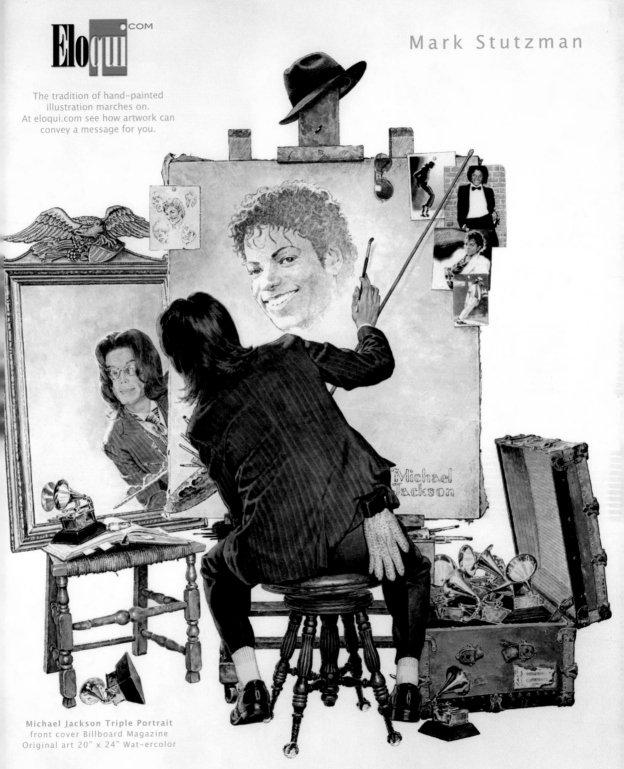

ELoqui.COM

Mark Stutzman

The tradition of hand-painted illustration marches on. At eloqui.com see how artwork can convey a message for you.

Michael Jackson Triple Portrait
front cover Billboard Magazine
Original art 20" x 24" Wat-ercolor

steve@stevennoble.com direct: 707-789-0166 mobile: 415-897-6961 www.stevennoble.com

© Copyright 2011 Freedom Farms

© Copyright 2011 Cayman Jack

CAPT. FAWCETT'S MOUSTACHE WAX

T.M. V.R.

AMERICAN EXPRESS

© Copyright 2011 American Express - scratchboard engraving

© Copyright 2011 Espolon Tequila

World Class Illustrations from over 3,500 images and over 1,000 stock illustrations for clients from all over the world!

2006 Rosey Awards • Mead Show Award Winner 2001 • Brand New 2009 • Ad Pulp 2009 • Communications Arts 1997 • National Addy Awards 2010

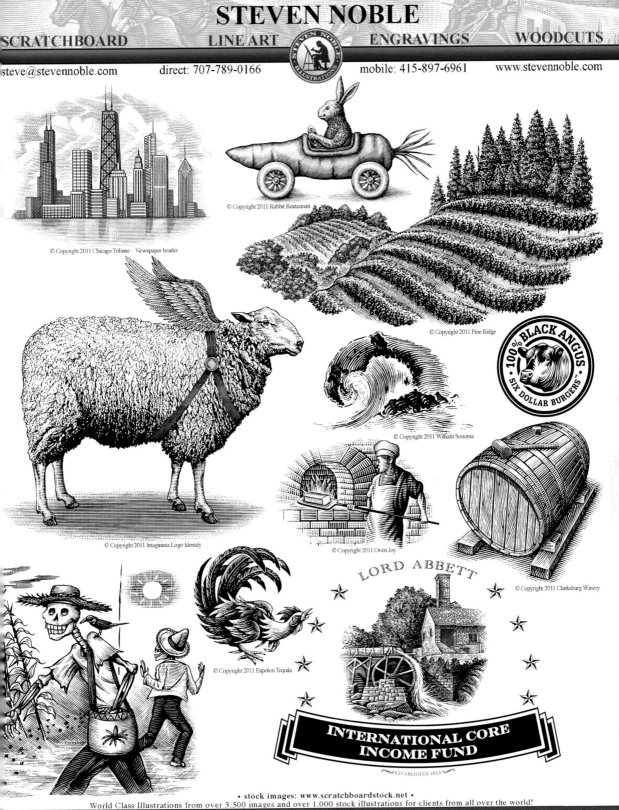

© Copyright 2011 Chicago Tribune - Newspaper header

© Copyright 2011 Rabbit Restaurant

© Copyright 2011 Pine Ridge

100% BLACK ANGUS
SIX DOLLAR BURGERS™

© Copyright 2011 William Sonoma

© Copyright 2011 Imaginista Logo Identity

© Copyright 2011 Oven Joy

© Copyright 2011 Clarksburg Winery

© Copyright 2011 Espolon Tequila

LORD ABBETT

INTERNATIONAL CORE INCOME FUND

ESTABLISHED 19XX

© Copyright 2011 Lava Cap Winery

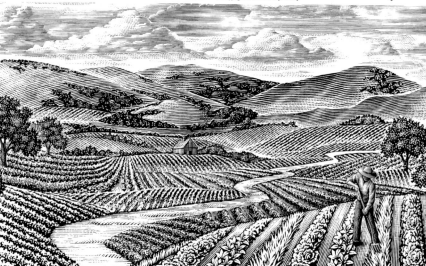

© Copyright 2011 Gardens of Democracy Book Cover

© Copyright 2011 Angel's Share logo

© Copyright 2011 Disney's Golden Oaks logo © Copyright 2011 Lion Brand Yarns logo © Copyright 2011 St. George Spirits

World Class Illustrations from over 3,500 images and over 1,000 stock illustrations for clients from all over the world!

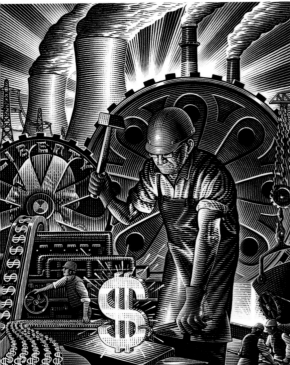

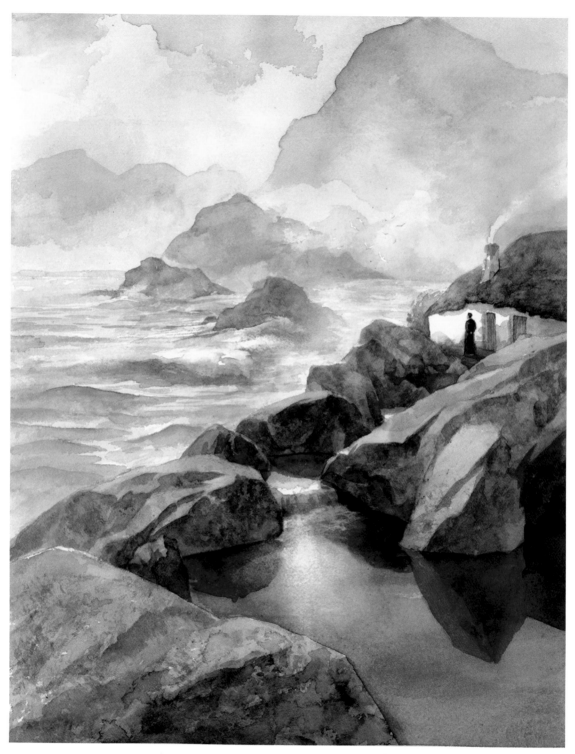

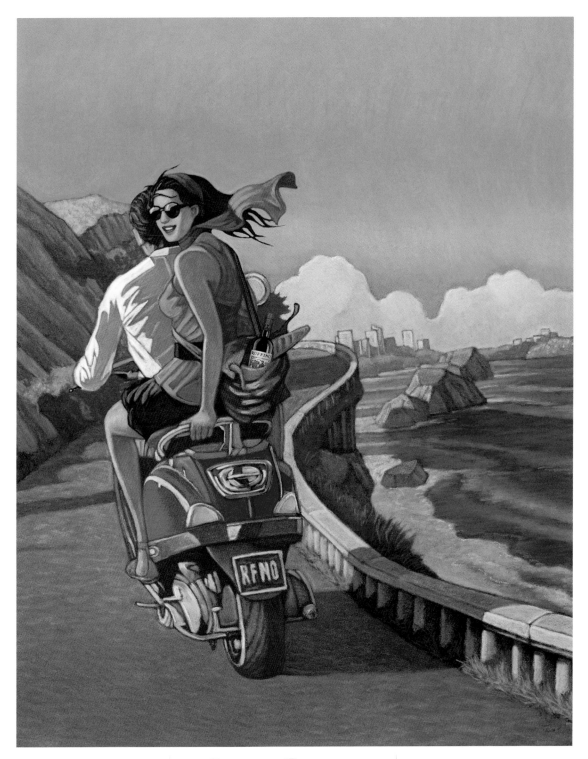

413

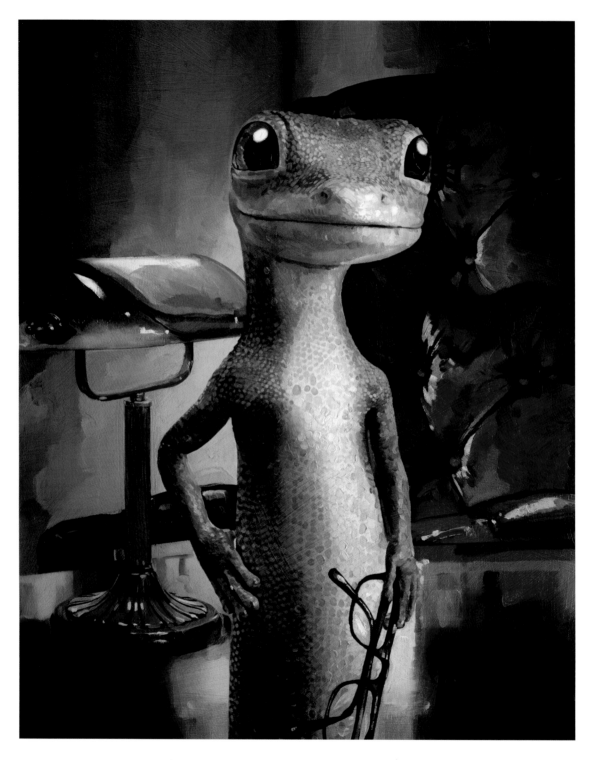

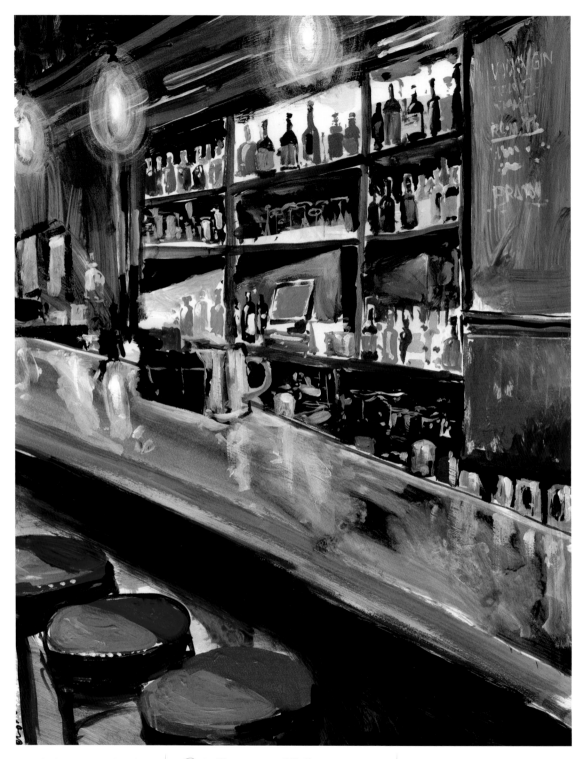

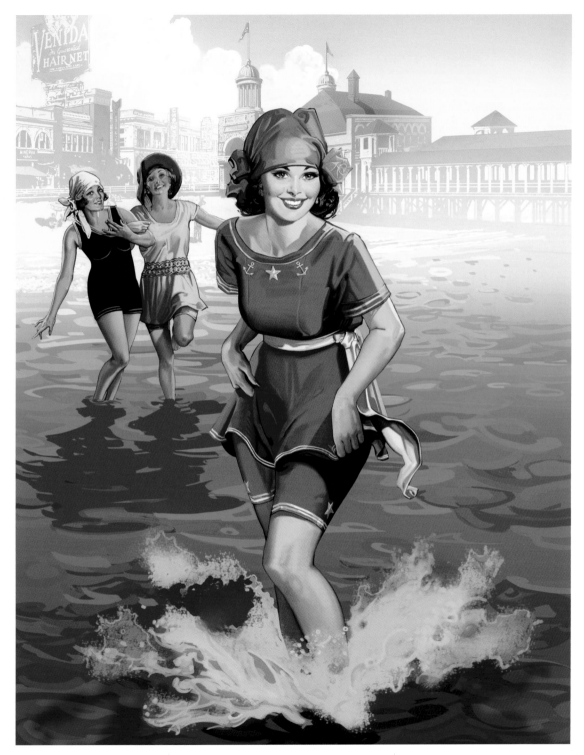

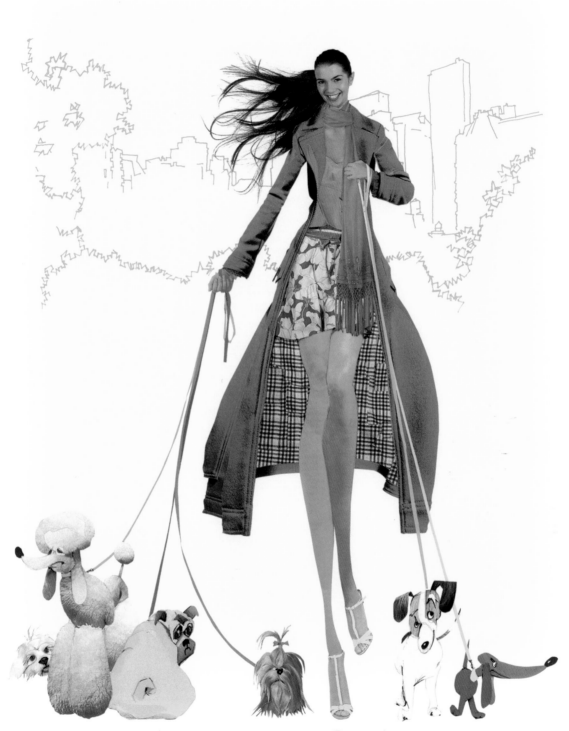

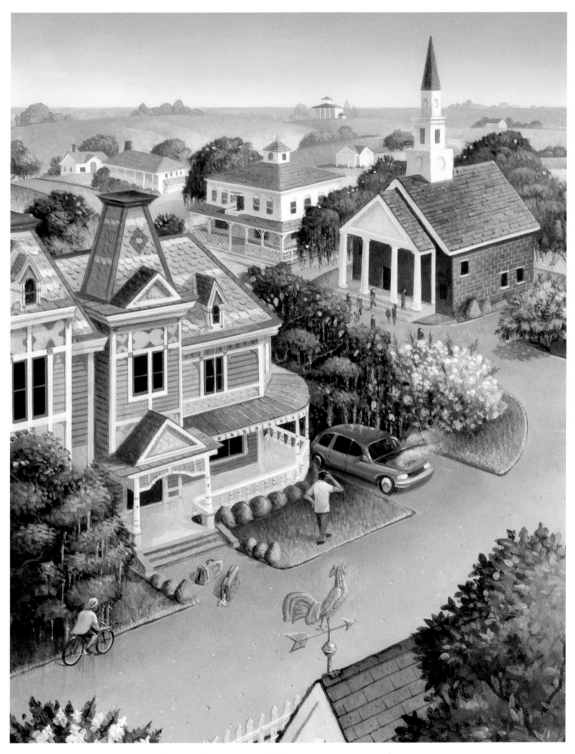

LINDGREN ◼ SMITH
LINDGRENSMITH.COM

Robert Crawford

NY 212.397.7330 SF 415.788.8552
INFO@LSILLUSTRATION.COM

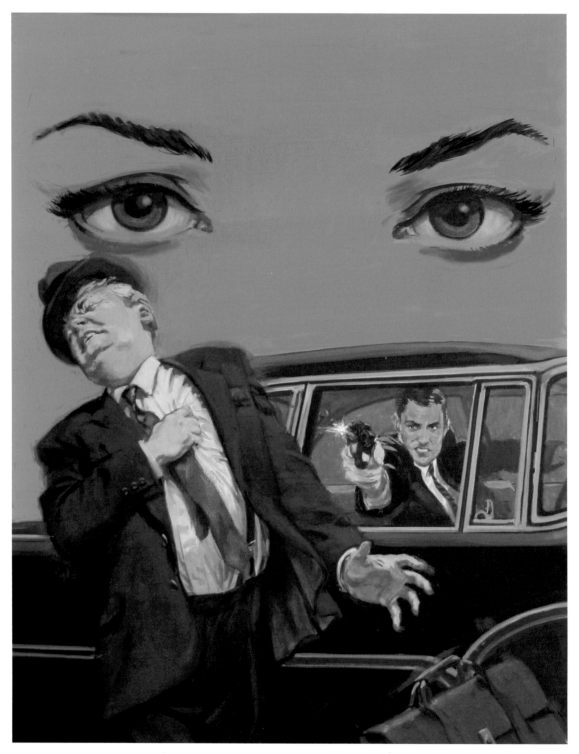

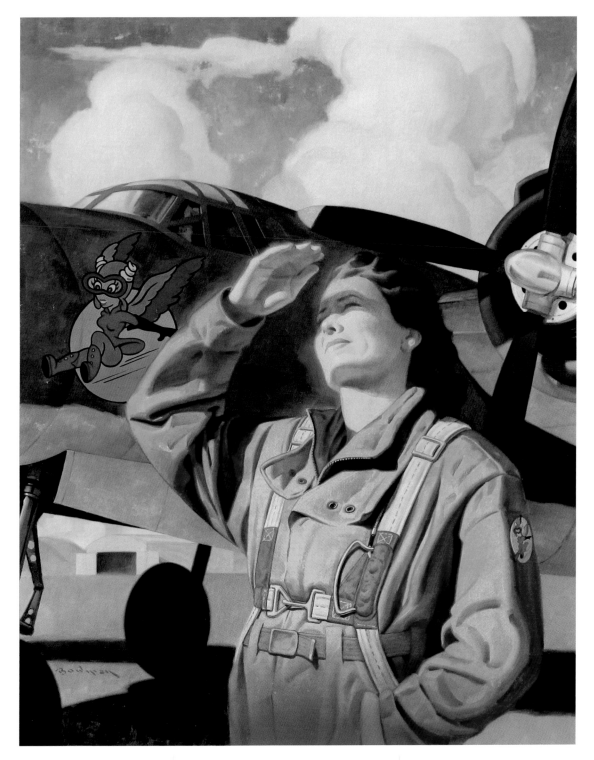

LINDGREN ◣ SMITH
LINDGRENSMITH.COM

Kim Johnson

NY 212.397.7330 SF 415.788.8552
INFO@LSILLUSTRATION.COM

LINDGREN ▬ SMITH
LINDGRENSMITH.COM

Jerome Studer

NY 212.397.7330 SF 415.788.8552
INFO@LSILLUSTRATION.COM

LINDGREN ◼ SMITH
LINDGRENSMITH.COM

Joe & Kathy Heiner

NY 212.397.7330 SF 415.788.8552
INFO@LSILLUSTRATION.COM

427

LINDGREN ■ SMITH
LINDGRENSMITH.COM

Chris Lyons

NY 212.397.7330 SF 415.788.8552
INFO@LSILLUSTRATION.COM